South of the Sahara

South of the Sahara

Selected Works of African Art

Constantine Petridis

2003 THE CLEVELAND MUSEUM OF ART

The Cleveland Museum of Art Board of Trustees

Published on the occasion of the opening of the newly reinstalled gallery of Art of Sub-Saharan Africa at the Cleveland Museum of Art. The reinstallation and this publication were made possible in part by a generous grant from The Cleveland Foundation.

Library of Congress Control Number: 2003110615

ISBN: 0-940717-76-x (paper)
ISBN: 0-940717-79-4 (cloth)

Distributed by the University of Washington Press
P. O. Box 50096
Seattle, WA 98145
www.washington.edu/uwpress

Editing: Barbara J. Bradley, Kathleen Mills
Design: Laurence Channing, Carolyn K. Lewis
Photography: Howard Agriesti, Gary Kirchenbauer
Digital scanning: David Brichford, Janet Burke, Bruce Shewitz
Production: Charles Szabla
Composition: Adobe Bembo and Univers Thin Ultra Condensed
Printing and binding: Great Lakes Lithograph, Cleveland

Contents

Foreword

I t is a pleasure to present this book to you in celebration of the opening of the Cleveland Museum of Art's reinstalled gallery of sub-Saharan African art. Our first substantial publication on the museum's holdings from this part of the world, this book is a tribute to the cultures of sub-Saharan Africa and the artists who created the faces and figures reproduced on the following pages.

The European avant-garde's "discovery" of African art in the early twentieth century dramatically changed the development of modern art. Iconic artists of European modernism, such as Modigliani, Picasso, and Matisse, acknowledged the debt they owed to their counterparts in Africa. What has often been overlooked, however, is that the avant-garde came across these works in museums. Ultimately, then, the first curators of early museum collections should also be recognized as contributing to the Western appreciation of African art as art. In the United States, the Cleveland Museum of Art played a pioneering role in this regard. Even though some African works were put on permanent display only in the early 1960s, the museum acquired its first African objects in 1915, before its doors opened to the public. In the following years, the museum was one of the very few of its kind to organize and host a number of significant exhibitions on the subject.

Cleveland's African collection contains important works from ancient Egypt and Islamic North Africa, but the focus of our new installation and this publication is on the vast region south of the Sahara. The arts of this region were first viewed and studied as "elements of culture" by anthropologists. As a result, the first collections of sub-Saharan art were established in anthropology and natural history museums. Only later did they enter art museums and claim their place in the encyclopedic survey of world art, gradually becoming the focus of attention and research by art historians. The current study of the varied arts of sub-Saharan Africa is indebted to this double heritage. It has greatly benefited from the combination of theories and approaches of both anthropology and art history. Stimulated by their experiences of living with the cultures that produced and used the works discussed in the following pages, African art scholars are especially sensitive to the fact that a work of African art constitutes an inseparable union of form and meaning. Therefore, any attempt to interpret African art should be grounded in the cultural context in which it is rooted.

Today, the arts of sub-Saharan Africa no longer need the stamp of approval of the European avant-garde to be truly appreciated. While there are interesting associations to be drawn with other artistic traditions, it is evident that these arts occupy their own place in the

survey of world art. Immensely rich in meaning and amazingly sophisticated in form, they are an integral part of the world's varied cultural heritage and equal to any artistic tradition.

The museum is particularly grateful to the Cleveland Foundation for its generous support in realizing this publication. We are also delighted that the University of Washington Press in Seattle will distribute this volume, allowing those who appreciate African art across the globe to learn about our collection. Finally, special thanks is due to Constantine Petridis, associate curator of African Art, who conceived the reinstallation and wrote this publication. In the introductory essay he discusses some broad concepts that are crucial to a better understanding of the arts of this part of the world. In the ensuing illustrated entries, which contain information on both form and content, he succinctly analyzes a selection of forty-two works by artists of some thirty different cultures. It is our hope that his endeavor will lead to a renewed interest in Cleveland's holdings of African art and that it will significantly contribute to this institution's ambition to reach the broadest possible audience.

Katharine Lee Reid
Director

Acknowledgments

The reinstallation and publication of selected African art works from the collection of the Cleveland Museum of Art was a collaborative effort, with many individuals contributing their talents and time to its realization.

First and foremost, Katharine Lee Reid, director, and Charles Venable, deputy director for Collections and Programs, offered continuous guidance on the project as well as constructive comments on the introductory essay. I am also grateful to Adrienne Jones, a museum trustee, for her thoughtful suggestions. Without the generosity of the Cleveland Foundation this publication would not have been possible. My thanks to Jack Stinedurf, associate director for Grants and Government Relations, for his efforts in that regard. I am particularly indebted to my colleagues in the Department of African Art: Carol Ciulla, senior assistant, and Lisa Binder, curatorial intern, for their involvement in many aspects of the reinstallation and the preparation of this publication. Special thanks are due to Sue Bergh, associate curator of the Art of the Ancient Americas, for many hours of dialogue and fruitful exchange of ideas.

I am indebted to Heidi Domine, head of the Exhibition Office, and her staff for coordinating the reinstallation. I also acknowledge the contributions of Mary Suzor, chief registrar, and her office as well as the expertise of Bruce Christman, chief conservator, and his staff. My sincere thanks go to Howard Agriesti, chief photographer, and Gary Kirchenbauer, associate photographer, for their handsome photography of the works reproduced on the following pages. The installation was designed with taste and imagination by Rusty Culp, assisted by the Design and Architecture Division under the leadership of Jeffrey Strean. I am grateful to Holly Witchey, manager of New Media Initiatives, who supervised the production of an innovative multimedia computer display based on a script by my colleague art historian Amanda Carlson. My thanks to Marjorie Williams, director of Education and Public Programs, and her staff for developing different programs to accompany the reopening of the gallery of Art of Sub-Saharan Africa. Ann Abid, head librarian, and her staff at the Ingalls Library and Archives provided generous assistance in gathering the bibliographical sources and arranging numerous interlibrary loans. Finally among museum colleagues, I would like to extend my thanks to Barbara Bradley, whose insightful editing greatly improved the quality of my manuscript, and to Laurence Channing, who created this book's appealing design and oversaw its production.

The insights offered by my students at Case Western Reserve University in the course "Exhibiting African Art: Theory and Practice," which I taught during the spring semester of 2003, were much appreciated. I am especially thankful to graduate student Alexandra Nicholis, who enthusiastically volunteered her time to conduct valuable research for this publication. I also thank Henry Adams, chair of the Department of Art History at Case, for his support and advice.

Many colleagues and friends contributed in a variety of ways to this project as well. Wilfried van Damme (Afrika Museum, Berg en Dal, Netherlands) meticulously read a draft of the introductory essay and offered many crucial suggestions. Arthur Bourgeois (Governors State University, Illinois), Amanda Carlson (University of Hartford, Connecticut), William Hart (University of Ulster, Coleraine, Northern Ireland), Lorenz Homberger (Museum Rietberg, Zurich), Hans-Joachim Koloss (Berlin), Bettina von Lintig (Munich), Anja Veirman (Ghent, Belgium), and Louis Wells (Harvard Business School, Boston) commented on the objects related to their respective area of expertise.

I am grateful to the individuals who granted me permission to reproduce the field photographs in conjunction with the selected works discussed in the following pages: Arthur Bourgeois, Herbert Cole (Santa Barbara, California), Eberhard Fischer (Zurich), Anita Glaze (University of Illinois, Champaign/Urbana), Luc de Heusch (Université Libre de Bruxelles), Pascal James Imperato (State University of New York, Brooklyn), Frederick Lamp (Baltimore Museum of Art), John Pemberton III (Amherst College, Massachusetts), Doran Ross (Los Angeles), Christopher Roy (University of Iowa, Iowa City), Angelo Turconi (Milan), and Susan Mullin Vogel (New York). My thanks also go to the institutions that shared important field documents of their collections and allowed their reproduction in this volume: Basler Missions-Archiv, Basel, Switzerland; Fonds P. J. Vandenhoute, Ghent; Musée de l'Homme, Paris; Eliot Elisofon Photographic Archives, National Museum of African Art, Smithsonian Institution, Washington; and Museum Rietberg, Zurich.

I dedicate this publication to those individuals at the Cleveland Museum of Art whose responsibilities included the art of sub-Saharan Africa and who helped to build the collection of African art since the museum's inauguration in 1916: Charles Ramus, William Wixom, Henry Hawley, Henry John Drewal, and Margaret Young-Sánchez.

Constantine Petridis
Associate Curator of African Art

AFRICAN NEGRO ART

THE MUSEUM OF MODERN ART

The artistic importance of African Negro art was discovered thirty years ago by modern painters in Paris and Dresden. Students, collectors and art museums have followed the artists' pioneer enthusiasm. This volume contains 100 plates reproducing sculptured figures and ceremonial masks in wood, bronze and ivory; three maps; a bibliography of 130 titles; descriptions of 600 works of art; and an introduction by the director of the exhibition,

JAMES JOHNSON SWEENEY

Faces and Figures of Sub-Saharan Africa

Fig. 1. Dust jacket of the Museum of
Modern Art's 1935 exhibition catalogue
African Negro Art, showing the Bamana head
of a hobbyhorse now in the collection of the
Cleveland Museum of Art [pl. 4].

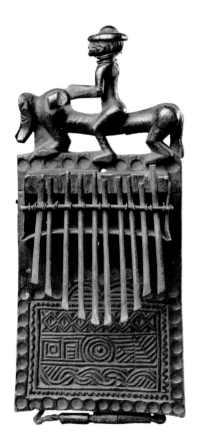

Fig. 2. Thumb piano, mid to late 19th
century. Chokwe people, Angola or
Democratic Republic of the Congo; wood,
iron; h. 19.1 cm. The Cleveland Museum of
Art, The Harold T. Clark Educational
Extension Fund 1915.495.

We have come a long way since the "discovery" of African
sculpture as art by the European avant-garde in the early
twentieth century. Pejorative terms such as "primitive" or
"tribal" once widely used to characterize the arts of African
and other non-Western societies have been rejected, at least by those
professionals who publish and lecture on this subject. Nevertheless,
many false assumptions and real myths regarding Africa and its
impressive civilizations persist, even in specialized circles of Western art
scholars. In fact, compared to other fields of art history, the discipline of
sub-Saharan African art studies is still in its infancy and knowledge
about the majority of identified art traditions, both surviving and
extinct, is scattered at best.[1]

The Cleveland Museum of Art acquired its first African objects in
1915, a year before its doors opened to the public, and organized its first
African art exhibition as early as 1929. A department of primitive art,
which included the arts of Africa, Oceania, and the Americas, was
created in 1929 and existed until 1940. The museum was also one of the
few venues to host a traveling version of the landmark exhibition
African Negro Art, conceived by curator James Johnson Sweeney for the
Museum of Modern Art in 1935 (fig. 1). The importance of this
exhibition has been summarized by Suzanne Preston Blier, professor of
African art history at Harvard University: "If today the vast majority of
art historians and fine arts trained curators specializing in African art are
American, it is in part because African art officially became 'art' to the
wider museum-going public in the United States in 1935 on the
occasion of the Museum of Modern Art's exhibition of African art."[2]

In 1915, a series of Kuba textiles and a group of Chokwe pieces
entered the collection. These first African objects were acquired with
funds allocated for education.[3] Although this collection grouped
different examples of the decorative or applied arts (in the strict
Western sense of the term) and included no figure sculptures or masks,
the artistic qualities of some of the Chokwe objects in particular are
recognized today and similar pieces have been part of more than one
exhibition of masterpieces (fig. 2 and pl. 34). The year 1929 saw a next
important step in the building of the collection, when the Gilpin
Players and the African Art Sponsors, two predominantly African
American groups associated with Cleveland's interracial settlement
house Karamu, donated a large collection of objects. Some of these
gifts, most notably a number of works from the Mangbetu peoples of
northeastern Congo, had apparently been acquired in Africa by the
Cleveland artist Paul Travis in the late 1920s (fig. 3).[4]

The exhibition of African art that the museum organized in 1929 further stimulated local interest in the arts of sub-Saharan Africa. Of the 126 objects included in the exhibition, 75 came from private and public sources such as the American Museum of Natural History in New York and the Cleveland collector Ralph M. Coe, whose widow later donated the Bamana Ciwara headdress [pl. 3]. William Wixom, then curator of medieval and Renaissance decorative arts who was also in charge of African and Oceanic arts, noted that the "exhibition undoubtedly served to give legitimacy to [the Cleveland Museum of Art's] African holdings, but it also served to point up its weaknesses and to suggest acquisitions for the future."[5]

The arrival of Thomas Munro as curator of education in 1931 must have played a major role in the growth of the African art collection. From 1924 to 1927, Munro had been closely involved with the collection of Albert Barnes in Merion, Pennsylvania, and wrote, with the French African art dealer Paul Guillaume, an influential book on African sculpture.[6] During his tenure, Cleveland acquired its first

Fig. 3. Bow harp, mid to late 19th century. Mangbetu people, Democratic Republic of the Congo; wood, animal skin, fiber; l. 74.4 cm. Field-collected by Paul B. Travis, 1928. The Cleveland Museum of Art, Gift of the African Art Sponsors of Karamu House 1929.344.

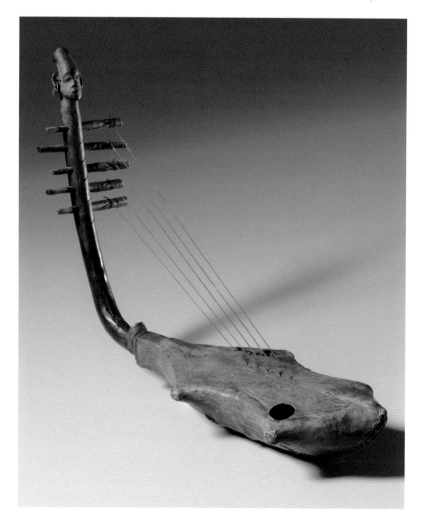

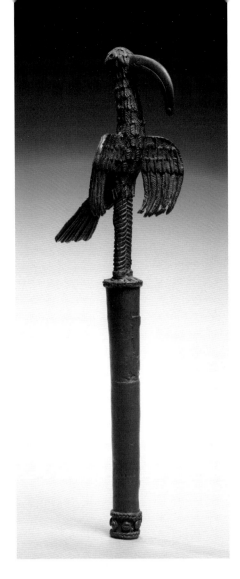

Fig. 4. Clapper, possibly 19th century. Edo people, Benin kingdom, Nigeria; brass; h. 36.2 cm. James Albert Ford Memorial Fund 1938.5.

sculptures "conceived in the round" for its permanent collection, one of which is the impressive mother-and-child figure of presumable Kwilu Pende origin [pl. 37] from the former collection of the Belgian African art dealer Guillaume De Hondt.

Undoubtedly, Munro was also instrumental in the presentation of the 1935 exhibition *African Negro Art* at the Cleveland Museum of Art.[7] Thanks to the James Albert Ford Memorial Fund and Dudley P. Allen Fund, Cleveland was able to acquire some of the finest pieces included in this exhibition, such as the Bamana hobbyhorse head [pl. 4], the Asante gold ornaments from the treasure of King Prempeh I [pl. 19], and the Kuba mask [pl. 35]. The *Exhibition of Ivories and Bronzes from the Ancient Kingdom of Benin,* held in Cleveland in 1937, led to the purchases of a clapper surmounted by a bird (fig. 4) and the magnificent brass head [pl. 25] from the collection of Louis Carré.[8]

Cleveland's African art collection also benefited from several gifts by a number of the museum's most generous supporters. Cleveland collector Katherine White was without doubt the most important of those donors. In 1968 the museum mounted an exhibition entirely devoted to her collection, which was accompanied by an annotated catalogue by William Fagg, then keeper of ethnography of the British Museum in London.[9] In subsequent years Cleveland hosted other major African art exhibitions: *African Textiles and Decorative Arts,* organized by the Museum of Modern Art in 1973; *Noble Ancestors: Images from Africa,* organized by the Philadelphia Museum of Art in 1989; *Yoruba: Nine Centuries of African Art and Thought,* organized by the Center for African Art, New York in 1990; and *Benin: Royal Art of Africa from the Museum für Völkerkunde, Vienna,* organized by the Museum of Fine Arts, Houston in 1994.[10]

The most recent installation of Cleveland's African art gallery was done in 1989, the work of Henry John Drewal who served as a consultant to the museum while a professor of art history at Cleveland State University. Drewal also wrote an enlightening and straightforward introduction to African art as a guide to the museum's collection.[11] His organization of the gallery according to three broad categories—the world, masks as mediators, and the otherworld—clearly derived from the five-part subdivision into body arts, decorative arts, masks, figures, and royal arts and regalia adopted by Wixom, his predecessor. Both Drewal's and Wixom's installations underscored the cultural contexts of African art, focusing on the works' functions and meanings. In contrast, the geographical progression of the current display places greater emphasis on forms and styles of the arts of different cultures in hopes of

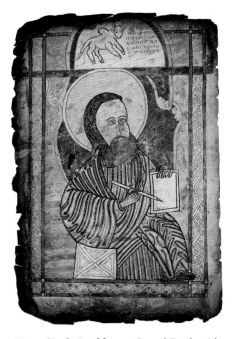

Fig. 5. Single Leaf from a Gospel Book with a Portrait of St. Luke, c. 1440–80. Ethiopia; ink and tempera on vellum; h. 37 cm. The Cleveland Museum of Art, Purchase from the J. H. Wade Fund 1999.212.

kindling an appreciation of the universal beauty of African art. Still, through object labels, supporting field photographs, and thematic gallery cards, the goal is to situate the works in their original cultural contexts and convey the message that African art is always more than merely "art for art's sake."

SOUTH OF THE SAHARA

Discussing the arts of Africa south of the Sahara in merely a few paragraphs is impossible, for the African continent as a whole, with its more than 600 million inhabitants and more than 1,000 different cultures and languages, is second only to Asia in size. The exclusion of the vast region of the Sahara—although it is in many ways connected to the sub-Saharan region—and the focus on sculpture to the detriment of other equally important visual art forms make the task just a bit easier. Yet, in light of the recent trend of expansion and inclusiveness in African art studies, this double narrowing of the subject needs some justification.[12]

In the historical formation and growth of Cleveland's collection, the emphasis has always been on works from sub-Saharan Africa. This situation is far from unusual in museum collections, both in the United States and in Europe. Nonetheless, some recent exhibitions and publications have advocated giving up the artificial division of the continent into Saharan and sub-Saharan parts. In the same vein, Egypt and ancient Nubia have been included in some of the most recent surveys of the arts of Africa. The civilizations of ancient Nubia and Egypt, however, are different in cultural terms from the major sub-Saharan civilizations in many ways. Scholars of sub-Saharan African art rarely, if ever, have either of these ancient civilizations in their portfolio.

In line with this argument, the Islamic civilizations of Mediterranean northern Africa should be related to the Islamic traditions of the Near and Middle East and southern Europe rather than to sub-Saharan Africa. Of course, such associations do not mean the impact of Islam on certain sub-Saharan West and East African cultures should be neglected. The same is true for Christian civilizations, which are not limited to the region of the ancient kingdom of Kongo on the Atlantic coast of Central Africa.[13] In this regard, one might argue that objects from present-day Ethiopia in eastern Africa also deserve a permanent space in Cleveland's sub-Saharan art gallery.[14] To date, however, the museum's collection contains only a single Ethiopian work—a fifteenth-century manuscript leaf portrait of St. Luke (fig. 5).[15] Still, it cannot be denied that Ethiopian

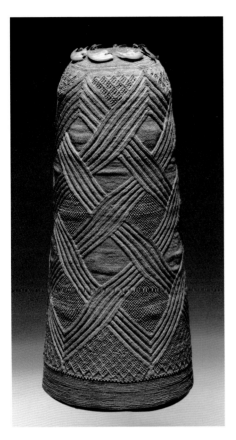

Fig. 6. Hat, late 19th century. Kongo people,
Democratic Republic of the Congo; fibers,
leopard claws; h. 42 cm. Field-collected by
Alfred Lens, 1891–1903. The Cleveland
Museum of Art, John L. Severance Fund
1997.180.

art, with its frescoes, illuminated manuscripts, and permanent stone
architecture, has little in common with the artistic production of sub-
Saharan peoples and societies, in style, meaning, or function.

The current emphasis of Cleveland's sub-Saharan collection is on
West and Central Africa—the two regions that have produced the most
important sculptural art traditions. While the long-overlooked arts of
both eastern and southern Africa have not produced the same number
of sculptural traditions—with a few notable exceptions—they have left
us a rich heritage of beadwork, costume/dress, jewelry, basketry, and
pottery. Although opportunities await exploration in these media, in
recent years the museum has acquired some fine examples of beaded
and textile headdresses from West and Central Africa, such as a tightly
woven Kongo chief's hat (fig. 6).

This publication follows the trend to list art works geographically
following culture zones or regions. Limited to West and Central Africa,
from the northwest to the southeast, the zones represented are the
Western Sudan, the Guinea Coast, Nigeria, the Cameroon Grassfields,
and the Congo Basin.[16] To a certain extent, the arts of the cultures
grouped in these five divisions also share stylistic affinities. The borders
of these culture regions are not absolute, however, and they are defined
in different ways in different publications. Nigeria, which is usually
incorporated in the Guinea Coast region, receives specific attention
here because it is better represented in Cleveland's collection than any
other contemporary African state. The Cameroon Grassfields region,
which is treated separately out of necessity, is in fact part of a broader
region known as Equatorial Africa, sometimes also called Atlantic
Equatorial Africa or Western Equatoria.

SCULPTURE, ENSEMBLE, PERFORMANCE

Cleveland's concentration on figurative sculptures and masks has long
been the norm in African art studies and collections in the West. In part,
this focus came about because at first, following a European hierarchy of
artistic value, only sculptures in more durable and supposedly valuable
materials—wood, ivory, stone, and different kinds of metal alloys—were
considered interesting and appealing enough to be collected, studied,
and exhibited. Figurative carvings and masks were also relatively close to
Western conceptions of "high art." It is generally known, however, that
the range of visual arts during the long and complex history of African
civilizations is much more varied than the narrow classical Western
interpretation of the term suggests. Some of the most common forms of
visual arts, including body arts and architecture, have not been studied

extensively either, while their nature has obviously prevented their collection and preservation in the West.

In many African contexts, different types of art works are combined to form an ensemble.[17] Rarely does a carved human figure appear alone in its original setting. More typical is a group of related figures in a shrine or a ritual procession. Equally important, the visual arts are most often combined with nonvisual art forms and constitute at best a secondary aspect of a more encompassing artistic event or experience. This is particularly true for the widespread art of masquerading, in which the wooden mask head is just part of a larger costume. The appearance of masked individuals is accompanied by song and dance. It has been rightly argued that many, if not all, African art forms are performative in nature, making their static exhibition in a museum all the more problematic. Whereas this seems obvious for masks, many figurative carvings also function in a ritual framework: they are mobile and meant to be manipulated and carried around rather than merely looked at.[18]

As a rule, traditional sculptures of sub-Saharan Africa—like the majority discussed in the second part of this publication—have little to do with the nineteenth-century Western notion of art for art's sake. Rather, they have varied roles to play in society and are linked to different aspects of human life, both materially and spiritually. Yet this does not imply that works produced by African sculptors should be labeled "crafts" rather than "fine arts," or that African art is devoid of an aesthetic dimension. After all, in Europe, too, at least up until the Renaissance, for example, the Italian "arte" and the German "Kunst" referred to practical skill and "know-how," and "art" was synonymous with what we call "craft" today.[19] Nevertheless, this functional view of works of African art has long been used to justify their exhibition in anthropology and natural history museums rather than in fine arts museums. In fact, a majority of African art collections in Europe are still not permanently displayed in museums of fine arts.

HISTORY

Much confusion and misunderstanding still exists about the age of African art. Because many African peoples are not concerned with preservation and because many of the works of art they create were not meant to live a long life, most of the African art objects in Western collections are relatively young and tentatively dated to the late nineteenth or early twentieth centuries. Because the life span of these objects is intended to be short and because most of the materials used

in their creation are ephemeral, dates for works of art are almost always based on their acquisition or collection history rather than on objective and scientifically supported dating techniques. Attempts to refine and improve the chronology of some art traditions on the basis of formal and stylistic changes have rarely led to convincing results. However, the idea that African art is "timeless" and without history is fundamentally wrong.

The antiquity of African art is not only proved by the rare examples of works collected in the seventeenth and eighteenth centuries, but especially by the important number of ancient civilizations that have come to light since the discovery of the art of Ife by the German explorer and ethnologist Leo Frobenius in 1910. Cleveland is fortunate to possess examples of two of the most magnificent of these venerable African art traditions, both in terracotta: a head from the site of Nok in Nigeria [pl. 28] and a seated figure from the site of Jenné in Mali [pl. 1]. The objects found in Nok and surrounding sites, which are considered the oldest sculptural forms of sub-Saharan Africa, have been dated from 600 BC to AD 250. The site of Jenné and its findings cover the period from approximately the eleventh to the seventeenth century.[20]

In addition to these and similar terracottas, important sculptures made of various copper alloys have been preserved that reveal other ancient civilizations. In fact, Cleveland is one of the few American art museums to hold a number of representative works of the celebrated kingdom of Benin, which was at its height from the fifteenth to the end of the nineteenth century—when it was defeated by the British and its treasures looted. Yet the Benin Kingdom maintains a cultural and ritual importance in present-day Nigeria. Among the Cleveland holdings is a beautiful three-figure brass plaque [pl. 27], acquired in 1999.[21] Obviously, both metal and terracotta are much less vulnerable to disintegration than wood and other commonly used vegetal materials. Thanks to exceptional climatic conditions, however, some very old wooden art objects have been preserved in situ as well. An animal head dating to the ninth century, found in a riverbed in Angola in 1929 and presently in the Africa-Museum, Tervuren, Belgium, is still considered the oldest example of African wood carving.[22]

Although some of the object types collected at the dawn of the twentieth century are still in use today, over the past century many art traditions have changed dramatically or even disappeared. Therefore, relying on data gathered at a time when a particular art form was active does not necessarily provide information about practices today, early in the twenty-first century. As a result, whether to use the past or present

tense in discussions creates a challenge.[23] In this publication, an effort has been made to respect historical facts where they are known. Yet the ongoing, or rather surviving, so-called traditional societies and their art forms constitute only one facet of today's sub-Saharan Africa. And as the late Roy Sieber pointed out, the term "traditional" has been challenged "because it is often falsely construed to mean precolonial or unchanging or extinct—none of which is true."[24]

Genuinely contemporary art with global references has emerged in urban and rural centers throughout the African subcontinent for more than half a century.[25] Some of Africa's contemporary artists, even those who enjoyed academic training, are more strongly rooted in local or ancestral traditions than others, be it on the formal or the semantic level. This is obviously the case with the elegant ceramics of Kenya-born artist Magdalene Odundo, whose work is today shown in many Western art museums.[26] To date, she is the only contemporary African artist represented in Cleveland's permanent collection (fig. 7). Nevertheless, in order to recognize the contributions of Africa's artists to the art of today, it is appropriate that they find their place in an encyclopedic art museum in those galleries that present the works of artists from all continents.

Fig. 7. Magdalene Odundo (British, b. Kenya, 1950). *Untitled B,* 1997; terracotta; h. 45.3 cm. The Cleveland Museum of Art, John L. Severance Fund 1998.4.

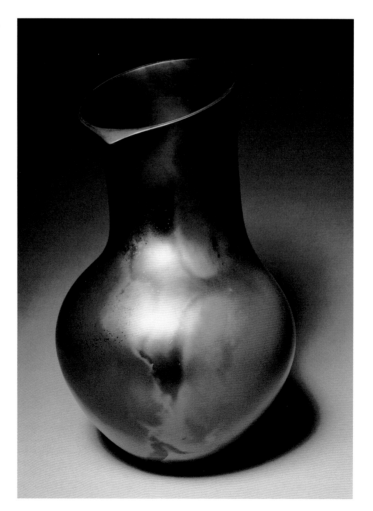

The forms and shapes of sub-Saharan sculptures, even if one considers only those made out of wood, are far too varied and complex to be described in simple terms. Undoubtedly, the human figure is the main subject matter and anthropomorphism is a key feature, but the animal world serves as an important source of inspiration in more than one artistic tradition. Often, particularly in the case of masks, animal and human features are combined with fantastic shapes. Many figurative sculptures in wood and other more durable materials are characterized by frontality, symmetry, balance, and a formal composition.[27] There are some notable exceptions, one example being the previously mentioned seated terracotta figure from Jenné [pl. 1]. Still, perhaps the most striking formal attribute of African figurative sculpture is that, even at its most "naturalistic," it relies heavily on visual conventions. In turn, these conventions, which are based on ideological factors and reflect different ways of interpreting reality, lead to proportions deviating from nature and exaggerated body features.

Styles in African art—the sum of formal parameters related to size, shape, emphasis, and relationships—range from extreme abstraction to near-to-life naturalism, although a degree of idealization occurs in almost every portrayal of the human body. Stylistic analysis and comparison is the technique most commonly used to identify an African art work with an ethnic or at least a geographic origin.[28] Until recently it was believed that every ethnic group had its own style, and that styles could be classified according to their geographical distribution. However, the notion of ethnic, or "tribal," styles has been repeatedly shown to be too narrow and somehow artificial, and therefore needs refining. In fact, the idea of discrete and hermetically sealed "tribes" has proved largely to be a colonial invention.[29]

As far as art works are concerned, some ethnic groups have simultaneously produced different styles, often limited to the media used, while others can be associated with styles that cross ethnic borders. Also, among some peoples, artists produce works for their neighbors. Thus, today the ethnic names given to sub-Saharan works of art merely refer to their style but do not necessarily offer a clue to their actual origin. Furthermore, it is clear that chronology cannot be ignored in explaining the diversity of sub-Saharan styles—more than 400 different styles have been identified to date.[30] Style changes over time are probably as frequent as style changes over geography, and this applies to both archaeological and more contemporary traditions, although the latter are much more difficult to define.

The impressive stylistic diversity that encompasses African sculpture must also take into account the input of the individual artist. Indeed, contrary to what has long been believed, artists searched for innovative ways to present ideas, rather than have their works reflect a communal, "tribal" style. Although existing works are copied in order to replace them, inventiveness is often recognized and even rewarded. Because of the small corpus of surviving wood carving, however, it is difficult to estimate the influence individual creativity has had on the development of styles. Most sub-Saharan works in durable materials are made by male artists, who are by and large informally trained, part-time specialists. Situations vary from region to region and even from village to village, making generalizations hazardous. Thus, while many cultures show much respect for talented sculptors, who often combine their carving with other functions such as smithing, divination, or healing, in some cultures they have a low rank. Our knowledge of African artists—their status, training, and work methods—remains superficial, although much progress has been made since the pioneering work of Hans Himmelheber, Pieter Jan Vandenhoute (fig. 8), William Fagg, and a few others.[31]

In its original context, African art is rarely anonymous. We do not know the names of the individuals who produced the objects that are today generally recognized as art mainly because early scholars and

Fig. 8. Tyimoko Gbayoko carving a mask in the village of Gbülow (Mau people), Côte d'Ivoire, 1939. Photograph by Pieter Jan Vandenhoute.

collectors did not gather that information. This lack of interest was caused in part by the conception of African art as "tribal" and the emphasis on its "communitarian" quality. Since the Belgian scholar Frans Olbrechts identified the Master of the Long Face Style in the large corpus of Luba figure sculptures in the late 1930s, a number of Western scholars have similarly attempted to identify the individual "hands" of artists on the basis of stylistic traits and provenance data. Although such efforts are laudable, more research needs to be conducted to recover the personalities and individual life-histories behind these named and unnamed artists.[32]

However, one should not overlook the fact that in many African societies the carvers' names have not been preserved. Often, the objects themselves rather than their makers are considered important. Also, the objects are related to their patrons or even their users, such as ritual experts or diviners, instead of the men who produced them. In many societies emphasis is placed on the powers and actions of the objects rather than on their origin or creation. Naming the artists who produced works of African art sometimes seems to be more a concern of art historians in the West than of the people who made and used them in their original settings.[33]

LEADERSHIP AND THE SUPERNATURAL

In sub-Saharan Africa, art occurs in a wide variety of contexts, ranging from the secular to the sacred. The categories of "sacred" and "profane," like those of the "natural" and the "supernatural," are not as rigidly defined in traditional African societies as they are in the West. It has been observed that more secular works of African art are highly visible and accessible, while the most powerful religious objects often lead a hidden life and are rarely if ever shown in public. Some types of African art also undergo a change in their degree of accessibility as they "grow older" and become more potent. It is ironic that some of the most admired and looked-at African art works in Western museums remain barely visible in their homelands.[34]

In order to evoke the vital and communicative role of art in sub-Saharan Africa, Herbert Cole, emeritus professor at the University of California, Santa Barbara, has proposed using the term "dimensions" to replace "functions."[35] Dimensions relate to the social, political, economic, religious, psychological, and aesthetic facets of human life. In practice, they are multiple and interrelated. It can be argued that the two most important dimensions of African art are those linked with beliefs in the supernatural and the exercise of leadership, although these

roles also often overlap in that political chiefs regularly draw on supernatural powers to rule effectively.

Many of the art works exhibited in Cleveland's newly installed African gallery refer to ideas of leadership in both the social and the political sense. The social dimension is reflected in works that signal prestige, affiliation, and wealth. Among the most notable of these status indicators are household objects, furniture, and dress. The same types of works become powerful objects in the hands of political leaders and their assistants. Further, in centralized states great emphasis is often placed on complex architectural structures and environments to celebrate and elevate kings and chiefs. Political and social art forms are often distinguished by their size, materials, and elaboration. Used in public, they are easily identified with the high status and esteem their users and owners enjoy in the community.

Leadership in sub-Saharan Africa is diverse and ranges from groups of men holding authority in small-scale societies to autocratic rulers in centralized city-states and kingdoms. The most dramatic art forms are undoubtedly those in use at the royal courts of peoples such as the Asante, Bangwa, and Kuba, for example. In these kingdoms, the men who exercise earthly power are frequently also credited with divine or even supernatural qualities. Often in kingdoms, a specialized group of artists works exclusively for the ruler, his court, and other high-ranking titleholders. In both centralized and noncentralized polities, art not only serves to confirm, celebrate, and enhance the authority of kings and leaders, it often also functions as an active instrument of policy.

Many African peoples believe in a distant god or supreme being, which they conceive of as the creator of the universe but to which no direct prayers or sacrifices are offered. More important are a variety of spirits and deities, some of which are associated with aspects of nature. Although many of these supernatural beings are conceived of in human terms, they are rarely portrayed as such in figurative sculptures. More frequently, the ancestors are commemorated by static sculptures and often appear in the community as masked characters. The ancestors exercise a direct influence on nature and on the lives of their descendants, and thus require attention—offerings and prayers in return for their benevolence and assistance.

Through masquerades, ancestral spirits are also present during transition rituals, such as those accompanying the initiation of boys into adulthood. Figurative sculptures referring to ancestral beliefs are most commonly found in association with altars and shrines and the ritual activities that surround them. Other sculptures are employed in the

contexts of divination rituals as well as physical and metaphysical therapies and treatments. The belief in a spiritual and depersonified energy or force inhabiting human beings, natural objects, and human-made artifacts lies at the core of the important category of "power objects," some of which use a figurative carving as a support for all kinds of medicines or substances. Often these power figures take the shape of complex assemblages made of composite materials that sometimes obliterate the wooden carving entirely [pls. 33 and 40]. Clearly, the aesthetic impact of an object can change dramatically through its use.

AESTHETICS

African aesthetics could be fully recognized only after the arts of Africa were truly considered "art."[36] The distance between the classical aesthetic ideal, which dominated the Western arts until the early twentieth century, and the unusual shapes and forms of many African arts, explains why the question of an African aesthetic was addressed relatively recently. Some scholars have also pointed out that the notions of both aesthetics and beauty are too culturally laden to be used in a cross-cultural way. Only a small number of cultures have been studied in some depth as to their aesthetic notions and predilections. The Belgian art historian and anthropologist Pieter Jan Vandenhoute, who conducted field research among the Dan and related peoples of Côte d'Ivoire in 1938–39, is arguably the first to have properly studied "native" African aesthetics. What is clear from his and other scholars' investigations, however, is that aesthetics are important even in those art forms that, from an anthropological perspective, seem to be functional in nature.

Research revealed that many African societies apply well-defined aesthetic criteria to evaluate and judge their arts and to distinguish good from bad art. Often, they have a refined vocabulary to discuss such matters, as in the case of the Yoruba people of Nigeria whom Robert Farris Thompson, professor of African art history at Yale University, studied in depth.[37] A more important insight, though, is that the tastes of African cultures do not necessarily coincide with those of Western societies. For the local producers and users, aesthetic evaluations and experiences are most often determined by the performance context and the grouping of different art forms.

One of the aesthetic criteria recorded among several African cultures is the representation of people in the prime of life. Other dominant principles of beauty that have been revealed by aesthetic

investigations include balance, moderation, clarity, delicacy, smoothness, completeness, and novelty.[38] Research has also pointed out the equation of ethical and aesthetic qualities and the use in many African languages of a single term to denote both goodness and beauty. Another scholarly avenue has explored the fundamental and intimate relationship between aesthetic values and sociocultural ideals.[39] Like styles, aesthetics are grounded in a broader cultural context and refer to a combination of aspects of form and meaning or content, acknowledging the belief that there is no such thing as "pure form."

The selection of works illustrated in this publication was dictated at least in part by considerations of aesthetic quality and beauty. However, because of our limited knowledge of the aesthetics of many of the peoples who made and used these works, this choice of objects reflects a Western taste of African art, rather than an indigenous African one. Although there seems to be a consensus in the West among collectors and curators of African art as to what constitutes excellence and quality, rarely if ever are African opinions taken into consideration. Some have suggested that the fact that a particular work was actually used or preserved a long time by the culture that made it proves the object met an aesthetic minimum, but such conjecture cannot be confirmed with hard data. The challenge of the future for encyclopedic art institutions such as the Cleveland Museum of Art is to include as many "native voices" as possible in their presentations of African and other non-Western arts. In the meantime, however, the sheer beauty of the works themselves will no doubt confirm the equality of the arts of all peoples and all times.

1. This introductory chapter owes a debt of gratitude to the work of a number of colleagues, including Suzanne Preston Blier, Robert Brain, Herbert M. Cole, Wilfried van Damme, Henry John Drewal, Till Förster, Hans-Joachim Koloss, Judith Perani, Louis Perrois, Roy Sieber, Fred T. Smith, and Susan Mullin Vogel. I would also like to express my sincere thanks to Herman Burssens, emeritus professor of art history at Ghent University, who introduced me to the arts of sub-Saharan Africa, and whose unpublished student textbook of the academic year 1987–88 has remained a useful reference tool.

2. Blier 2001, 31.

3. This and most of the other information on the museum's history of collecting and exhibiting African art stems from the article by William D. Wixom, former curator in charge of African art, published in *African Arts* in 1977. The museum's Archives and its *Bulletin* have been very useful to verify and specify certain data. Some of the objects acquired for what was called the Extensions Collection until the late 1990s were later transferred to the permanent collection; some still remain in the education collection, which is now called the Art To Go program.

4. Travis had been entrusted with $1,500 for purchasing objects in the field while he was traveling and painting in Africa. An exhibition about Travis's African travels of 1927–28 organized by the Cleveland Museum of Art was on view in 1982–83; see Boger 1982. For more information on Travis's life and work, and his travels in Central Africa, see also Adams 2001.

5. Wixom 1977, 18.

6. Guillaume and Munro 1926. Munro divided his time between the museum and Case Western Reserve University, where he was professor of art history, until his retirement in 1967. For more information on Albert Barnes's theories of African art and his intellectual relationship with Thomas Munro, see Clarke 1997.

7. The Metropolitan Museum of Art's recent exhibition *Perfect Documents*, curated by Virginia-Lee Webb, shed new light on the portfolio Walker Evans made for that occasion and provided some useful background information on the 1935 MoMA exhibition and its traveling derivatives; Webb 2000.

8. See Milliken 1937. Apparently, this sales exhibition had been organized by the dealer Louis Carré and first shown in New York in 1935. Some years earlier, an exhibition on the same subject, co-organized by curator Georges Henri Rivière and art dealer Charles Ratton, had opened on 15 June 1932, at the Musée d'Ethnographie, the former Trocadéro, in Paris; Paudrat 2000, 46–47.

9. Fagg 1968. Although Katherine White made many important gifts to the Cleveland Museum of Art in the years following this exhibition, she bequeathed the majority of her African art collection to the Seattle Art Museum in 1981; see McClusky 1984 and McClusky 2002.

10. For *African Textiles and Decorative Arts*, see Sieber 1972; for *Noble Ancestors: Images from Africa*, see Wardwell 1986; for *Yoruba: Nine Centuries of African Art and Thought*, see Wardwell 1989; for *Benin: Royal Art of Africa*, see Duchâteau 1994.

11. Drewal 1989.

12. Two of the most recent and influential publications that propose such an expansive view of African art are *Africa: The Art of a Continent* (Phillips 1995) and the textbook *A History of Art in Africa* (Visonà 2001).

13. For more information about interactions among sub-Saharan and northern Africa, the Muslim world, and southern Europe, see Mark 1996.

14. The Cleveland manuscript leaf was acquired in 1999 for the museum's department of medieval art. In 1995–96, at the behest of then director Robert P. Bergman, the museum hosted the exhibition *African Zion: The Sacred Art of Ethiopia* (Grierson 1993), which had opened its eight-city U.S. tour at the Walters Art Gallery in Baltimore in 1993. Other art museums, most notably the Metropolitan Museum of Art, the Art Institute of Chicago, and the Detroit Institute of Arts, exhibit Ethiopian manuscripts and other art forms in their African art galleries.

15. See Fliegel 2000.

16. Discussion of African art according to such culture zones, which goes back to the four-volume *Centres de style de la sculpture nègre africaine* (Kjersmeier 1935–38), is found in a large number of catalogues and books: *For Spirits and Kings* (Vogel 1981), *Art and Life in Africa* (Roy 1985), *African Art from the Barbier-Mueller Collection, Geneva* (Schmalenbach 1989), and *Masterworks of African Art at the Detroit Institute of Arts* (Kan and Sieber 1995). Arthur P. Bourgeois, Jeremy Coote and John Mack, Frederick Lamp, Patrick R. McNaughton, Anitra Nettleton, and Leon Siroto wrote paragraphs on regions for the 1996 edition of *The Dictionary of Art* (Turner 1996). Aside from these publications, Siroto 1995 and Bickford and Smith 1997 provide the most recent discussions of Equatorial Africa and the Western Sudan respectively, while I have done the same for the Congo Basin (Petridis 2000). For a critique of the concept of culture regions, see Kasfir 1984, 167–69.

17. The notion of ensemble was the subject of one of the first exhibitions of New York's Museum for African Art; see Preston 1985. Closely related to this idea is that of assemblage, referring to the combination of different heterogeneous materials in one single object, which was theorized under the term "accumulative sculpture"; see Rubin 1974. For further information on these concepts, see Blier 2001, 18–19.

18. The performative nature of African art and the importance of nonvisual aspects in African masquerades were emphatically brought to our attention in Robert Farris Thompson's *African Art in Motion* (1974) and further developed in Herbert Cole's *I Am Not Myself* (1985).

19. On the definition of the term "art" and its history, see Blier 1996, 30–31; Blier 2001, 22–23.

20. Up to this day, Mali is still the only sub-Saharan African country with which the United States has signed a treaty regarding the protection of its cultural heritage; this agreement prohibits the import of Malian archaeological objects that were taken out of their homeland after 1993; see McNaughton 1995.

21. As mentioned earlier, the museum's first Benin works were acquired after the exhibition of Benin ivories and bronzes of 1937. The appeal of the court arts of the Benin Kingdom also led the Cleveland Museum of Art to be one of the American hosts of the exhibition of Benin materials from the Vienna Museum of Ethnology in 1994; see Duchâteau 1994. As Hans-Joachim Koloss (1999, 9) pointed out, the first appreciation of African art on the part of Europeans was accorded at the end of the nineteenth century to works from Benin. In fact, people initially could not accept that Africans had been able to make such technically accomplished and aesthetically refined works of art in brass and ivory. Around the turn of the twentieth century, however, one of the earliest scholars of Benin art, Felix von Luschan (1901, 10), a curator at the Berlin Ethnological Museum, considered the Benin brasses to be truly authentic African creations as refined as any European work of art.

22. This object has alternatively been identified as a headdress or a bowl; see Van Noten 1972; Bastin 1997, 119. Another archaeological wood carving is the post topped with a human head now in the Museum of Dundo in Angola, which was excavated along the Upper Kwango River in northeastern Angola. Tentatively dated around AD 1000, this sculpture has attracted much less attention than the Tervuren Museum's animal head. From an art-historical point of view, it is perhaps more interesting, however, since this object type has been produced up to this day and occurs in a wide geographical area in Central Africa; see Petridis 1999, 142–44.

23. The use of the ethnographic present and the ahistorical approach of the arts of sub-Saharan Africa largely resulted from the close association of the study of African art with anthropology. Kasfir (1984, 165–67), has argued that the ties between the two disciplines also lie at the basis of the tribal approach of African art; see also Drewal 1990, 38–39; Blier 1996, 26–27, 29–39.

24. Sieber 1999, 11.

25. For some recent sources on contemporary African art, see Magnin and Soulillou 1996 and Kasfir 1999.

26. Odundo was arguably first brought to the attention of a broader audience of African art lovers in Susan Vogel's *Africa Explores,* where her work was classified under the category "International Art"; Vogel 1991, 223, nos. 105–7. For biographical data on the artist, see Berns 1995.

27. Some recent discussions of these and some other general formal traits of African figurative sculpture are to be found in Koloss 1999, 23–24, and Blier 2001, 14–17.

28. On the history of stylistic studies of African art and the important contribution of the Belgian scholar Frans Olbrechts, see Petridis 2001.

29. The notion of "one tribe, one style," of which William Fagg (1965, 1968) was one of the most influential advocates, has been refuted by many scholars, including Bravmann 1973 and Kasfir 1984.

30. On the issue of art and history in Africa, see Vansina 1984, 1–4, 33–40. In an article that was first published in Dutch in 1941 and later appeared in an English translation in the journal *Africa,* Olbrechts (1943) was one of the very first to propose a number of techniques to introduce chronology in African art studies.

31. On the significance of the development of the study of the individual artist and the complex relationship between tradition and creativity, see Biebuyck 1969 and d'Azevedo 1973. For some general remarks about the African carver, see also Herman Burssens's essay in the catalogue *Utotombo* (1988). The Italian art historian Ezio Bassani, formerly a lecturer at the Università Internazionale dell'Arte di Firenze, has continued Olbrechts's early attempts to identify artists' hands on the basis of stylistic analysis in the arts of different peoples; Bassani 1976, 1978, 1982, 1990. Most recently, he also contributed essays to an exhibition catalogue on the subject "Masterhands"; see Grunne 2001.

32. This interest in artists' biographies is what distinguished the exhibition on Yoruba carvers organized by Alisa LaGamma for the Metropolitan Museum of Art in 1998. The same concerns are reflected in the articles in the double *African Arts* issue on "authorship" (LaGamma 1998–99). Vandenhoute is perhaps the first African art scholar to have devoted serious attention to the personalities of the artists he researched among the Dan and neighboring peoples; see Vangheluwe 2001. Among contemporary scholars, Sarah Brett-Smith's work on Bamana carvers (1994) deserves citing.

33. For an extremist viewpoint on this matter, see Vogel 1999.

34. On "visibility as an index of power," see Cole 1989, 28–31.

35. Cole 1989, 26.

36. For an in-depth analysis of "aesthetics and the impediments to its study in anthropology," see Damme 1996, 12–30.

37. Thompson (1968, 1973) also introduced the concept of the "philosophy of the cool" in the study of African aesthetics; see also Koloss 1999, 24–26. Referring to an underlying "concert of opposites," this concept has been recognized by other scholars in different sub-Saharan cultures, most recently by Thompson's former student Z. S. Strother (1998, chap. 5) in Central Pende theories of physiognomy and gender as reflected in their mask faces.

38. For a brief discussion of these criteria of beauty, see Damme 1987, Damme 1990, 27–29. Aside from Thompson's pioneering contributions on this topic (1968, 1973), Susan Mullin Vogel's work on Baule aesthetics also deserves mentioning (1979, 1980).

39. This relationship between aesthetic preferences and sociocultural ideals is the core of Damme's central thesis in his *Beauty in Context* (1996), esp. chap. 5.

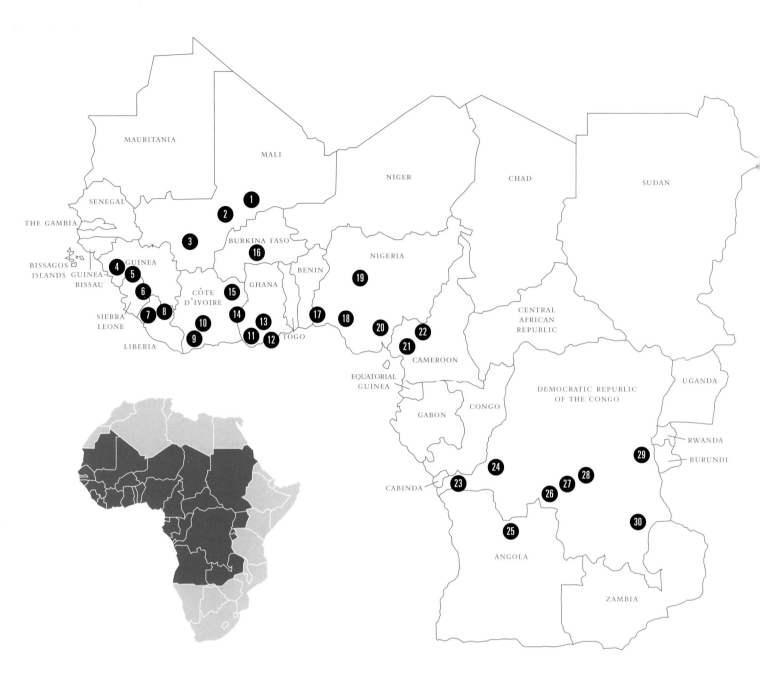

Legend

Akan 11	Edo 18	Mano 7
Asante 13	Ejagham 20	Nok region 19
Baga 4	Fante 12	Kwilu Pende 27
Bamana 3	Hungaan 24	Pre-Bembe 29
Bangwa 21	Jenné region 2	Senufo 15
Baule 10	Kissi 6	Wè 8
Bondoukou region 14	Kom 22	Yaka 26
Bwa 16	Kuba 28	Yaure 9
Chokwe 25	Landuma 5	Yombe 23
Dogon 1	Luba 30	Yoruba 17

Plates

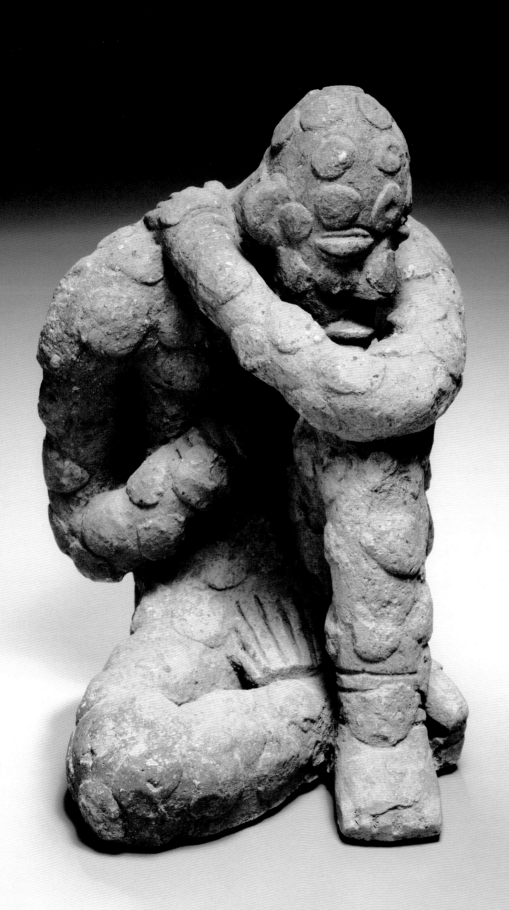

1

MALE FIGURE; JENNÉ REGION, INLAND NIGER DELTA, MALI

POSSIBLY 14TH TO 17TH CENTURY; TERRACOTTA; HEIGHT 19.7 CM

JOHN L. SEVERANCE FUND 1985.199

The human form is the dominant theme in sculpture from the Inland Niger Delta. This seated male figure belongs to a large group of ancient terracottas that were unearthed in the area around the modern city of Jenné in Mali beginning in the late 1970s. They were all modeled freehand, without molds. Most are solid, polished, and covered with a red slip, and most also have areas of yellow, red, and black. The decorations on their bodies are appliquéd and incised. Their sizes vary considerably, and the range of gestures and attitudes is equally striking. Because of the limited archaeological research conducted in the region, the contexts in which these sculptures were made and when they were created are uncertain. Research in the mid 1980s with people who now live in the region where most of the figures were found, however, has led to some hypotheses.

Used in rituals by ancestors of the present-day peoples of the Inland Niger Delta, such figures represent gods—deified ancestors and founding kings or queens of the various peoples who inhabited the now-abandoned mounds containing the remains of previous settlements in the area. These figures were venerated through prayers and offerings in exchange for their support. Some praying positions correspond exactly to those of the ancient terracottas and are intended for specific purposes, while others can serve any purpose. The seated position of the Cleveland figure has been interpreted as a harmful pose intended to bring death to someone. While the types of clothing shown on the figures differ and some are portrayed naked, this figure wears a loincloth and its adornments are limited to what seem to be bracelets. The meaning of the appliquéd disc-shaped lumps on the body is not clear, but they may imitate a form of body painting.

Further reading: Grunne 1988, 52–55; Grunne 1995, 72–79.

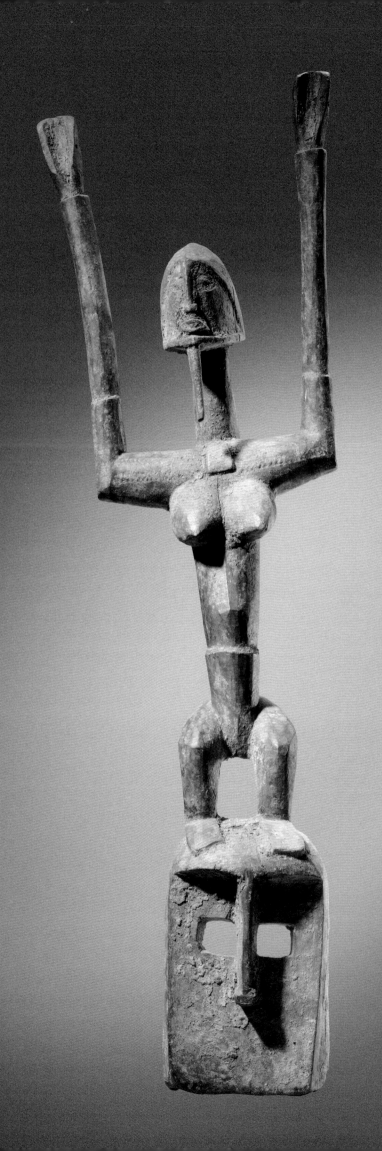

FACE MASK (*satimbe*); DOGON PEOPLE, MALI

EARLY TO MID 20TH CENTURY; WOOD; HEIGHT 111.1 CM

JAMES ALBERT AND MARY GARDINER FORD MEMORIAL FUND 1960.169

The variety of Dogon masks is extraordinary. Made of either carved and painted wood or plaited and dyed fibers, they incarnate ancestors that can be human, animal, or vegetal. Colors, costumes, and accessories point to the four basic elements: water, fire, air, and earth. White, the dominant color of the Cleveland mask, refers to air. Ultimately, Dogon masks represent the entire universe and all its inhabitants.

Dogon masks were the subject of one of the earliest field studies of African art, by a team of French anthropologists headed by Marcel Griaule. Having multiple meanings, these masks can be interpreted on two fundamentally different levels: in keeping with *giri so* (front speech), which reflects an early stage of knowledge and consists of an anecdote or tale that is enigmatic in form and intended to arouse curiosity; or in relation to *so day* (clear speech) or *aduno so* (speech of the world), which refers to Dogon cosmogony and is reserved for highly instructed men and women.

Interpreted according to the uppermost level of Dogon knowledge, the figure topping the Cleveland mask identifies it as of the *satimbe* type. Its iconography refers to the Dogon creation myth, with the female figure with raised arms representing Yasigine, who played a key role in the very first *sigi* celebration and is remembered as its first dignitary. Held every sixty years, the sigi ritual commemorates the arrival of death. Masks perform, either individually or in groups of men wearing the same type, at the commemorative "end of mourning" rituals called *dama,* whose goal is to escort the souls of deceased family members on their way to the afterlife. For the dama of an important elder, several hundreds of masked dancers may perform. During the dama ritual, the satimbe mask recalls the role of Yasigine in the first sigi.

In more recent times, masked dances have also been organized for visiting tourists and dignitaries. New mask types are continuously being invented, such as "madam," "tourist," or "policeman," as masked dances reflect changes in Dogon society.

Further reading: Beek 1991, 56–58, 69–73; Dieterlen 1989, 34–35, 37–38; Ezra 1988, 22–25; Ezra 1996, 67–68; Griaule 1983, 343–89; Ndiaye 2001, 138–43.

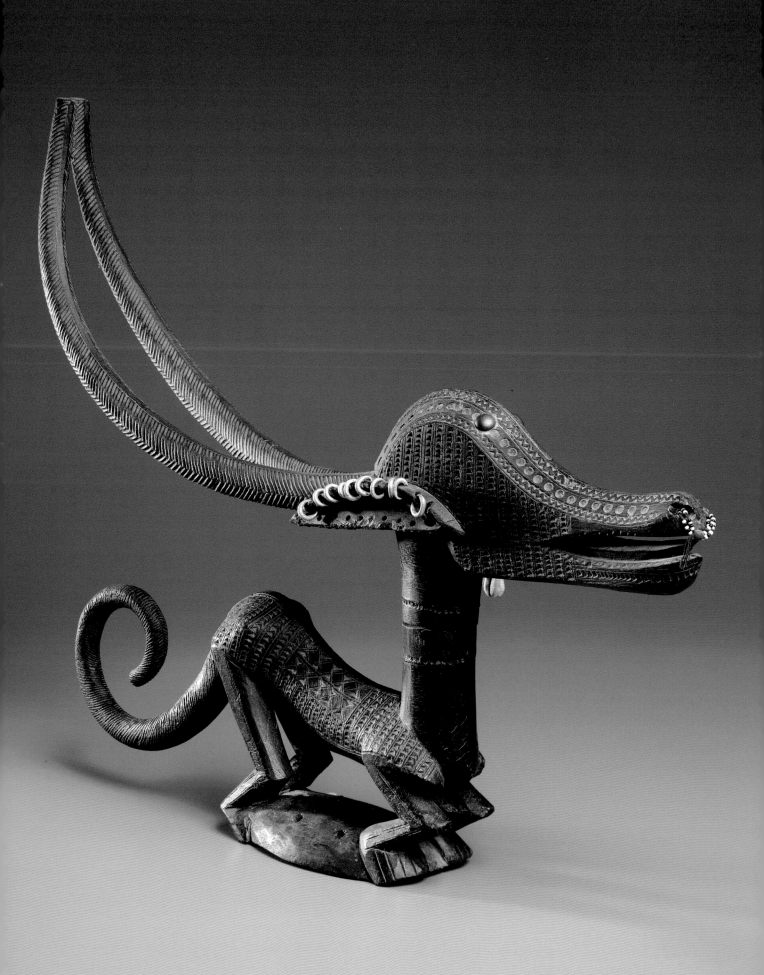

3

FEMALE ANTELOPE HEADDRESS (*n'gonzon koun*); BAMANA PEOPLE, MALI

EARLY 20TH CENTURY; WOOD, BEADS, SHELLS, METAL; HEIGHT 44.5 CM

GIFT OF MRS. RALPH M. COE IN MEMORY OF RALPH M. COE 1965.325

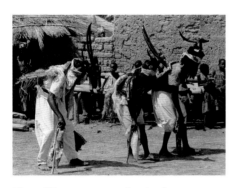

Fig. 9. Ciwara masqueraders in the Djitoumou region, Mali, 1969. Photograph by Pascal James Imperato.

P eople who claim to be Bamana persist in the religion of their ancestors and do not pray to Allah. Religion is at the core of Bamana culture, finding expression in initiation societies that function as intermediaries between human and spirit worlds. These societies have both social and political influence, and one of the most popular is a male society called Ciwara.

The Ciwara society celebrates and promotes agriculture, and instructs its members in cooperative farming practices. Crest masks, or headdresses, such as the Cleveland example serve as the society's mobile shrines. Such headdresses, attached to a basketry skullcap, are worn during the dry season in dance performances by "champion farmers"— young men who have shown excellence in agricultural labor. One of three distinctive regional types, this crest mask originates from the Djitoumou region in western Bamana country. It is of the female horizontal type, carved from two pieces of wood joined together with metal nails or stitches. Combining the features of different animals, including a roan antelope and an aardvark, the headdress represents the mythic farming beast that introduced agriculture to the Bamana and thus embodies the qualities of an ideal farmer.

One of the main tasks of the Ciwara is to promote cooperation between young men and women in farming. Usually appearing in pairs, male and female, the headdresses symbolize the ideal union of man and woman, essential to both human reproduction and agricultural fertility. The union of the two sexes is also reflected in the Ciwara costume and the actual dance performance. By infusing energy into agricultural work, the Ciwara performance ensures a good harvest and ultimately contributes to the survival of the Bamana people.

Further reading: Brink 1981, cat. 8; Colleyn 2001, 201–8; Imperato 1970, 13, 71–80; Wooten 2000, 19–2; Zahan 1980, 44–88; Zahan 2000, 39–42.

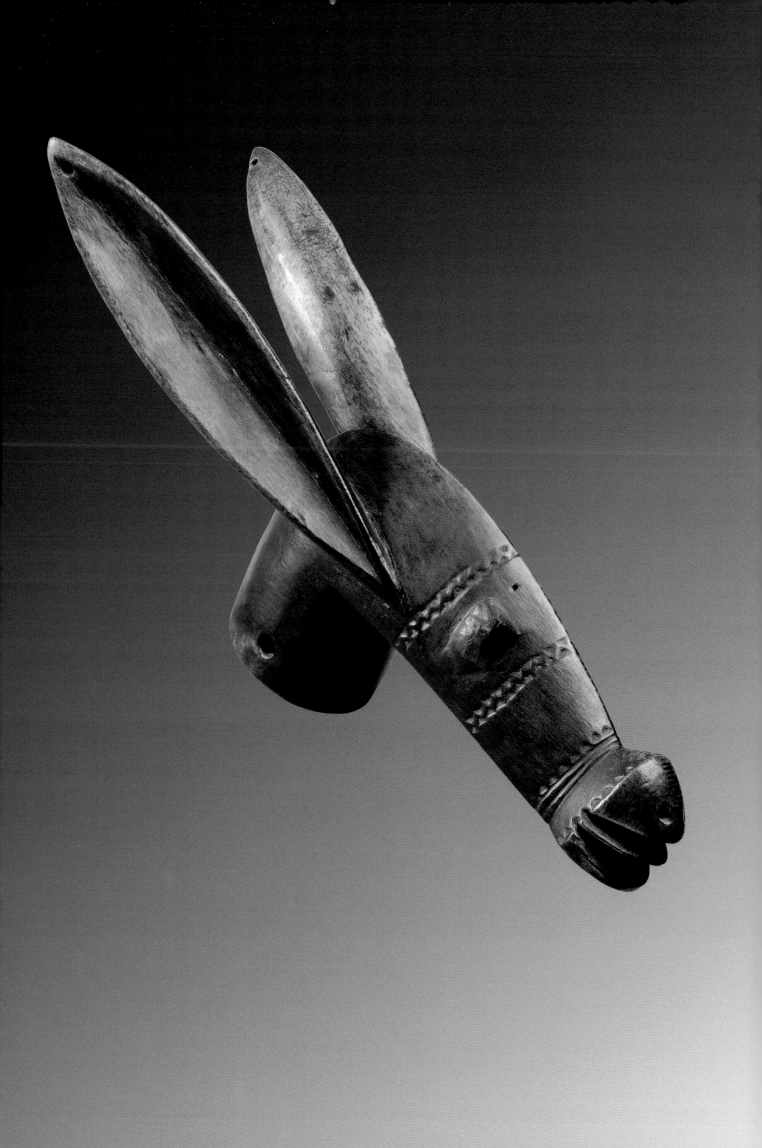

4

HEAD OF A HOBBYHORSE (*korèduga so*); BAMANA PEOPLE, MALI

LATE 19TH TO EARLY 20TH CENTURY; WOOD, METAL; HEIGHT 40.7 CM

JAMES ALBERT FORD MEMORIAL FUND 1935.307

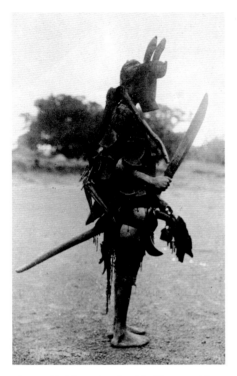

Fig. 10. *Korèduga,* the ritual buffoon, on his hobbyhorse in the Sikasso region, Mali, 1931. Photograph by Marcel Griaule.

This sculpture was featured on the cover of the catalogue published in conjunction with the landmark exhibition *African Negro Art,* organized by the Museum of Modern Art in 1935 (see fig. 1). Misidentified as the head of a donkey and erroneously related to the well-known puppet masquerade performances of the Bamana people, it actually pertains to the Korè society. In fact, it represents the head of an aardvark and is part of a wooden hobbyhorse mounted by a ritual buffoon.

The Korè is the most important male initiation society of the Bamana and incarnates the highest level of sacred knowledge. It is also responsible for the initiation of young boys into adulthood. Like many other initiation societies in sub-Saharan Africa, the Korè organizes a rite of passage, in which the neophytes undergo a symbolic death and rebirth in a sacred bush outside the village.

After their initiation, members can increase their power by joining other societies. Initiates are divided into different classes, each of which has its proper mask. One of these classes is associated with a ritual buffoon, called *korèduga* or *korèjuga* (pl. *korèdugaw* or *korèjugaw*). Sometimes, however, they form an autonomous society independent from the Korè. Appearing on different public occasions in pantomimes—often with their identity hidden by a wooden mask representing the head of a hyena, the mythical patron of the Korè— korèdugaw generally poke fun at different types of village authorities and other powerful individuals. In putting the carved head of a horse or an aardvark on a hobbyhorse (*korèduga so*), the korèdugaw ridicule the prestigious figure of the warrior on horseback. This satiric behavior, coming from those who embody the most profound spiritual knowledge, functions as a kind of spiritual catharsis for the community.

Further reading: Cissé 1995, 184–88; Cissé 2000, 142–44; Colleyn 2001, 99.

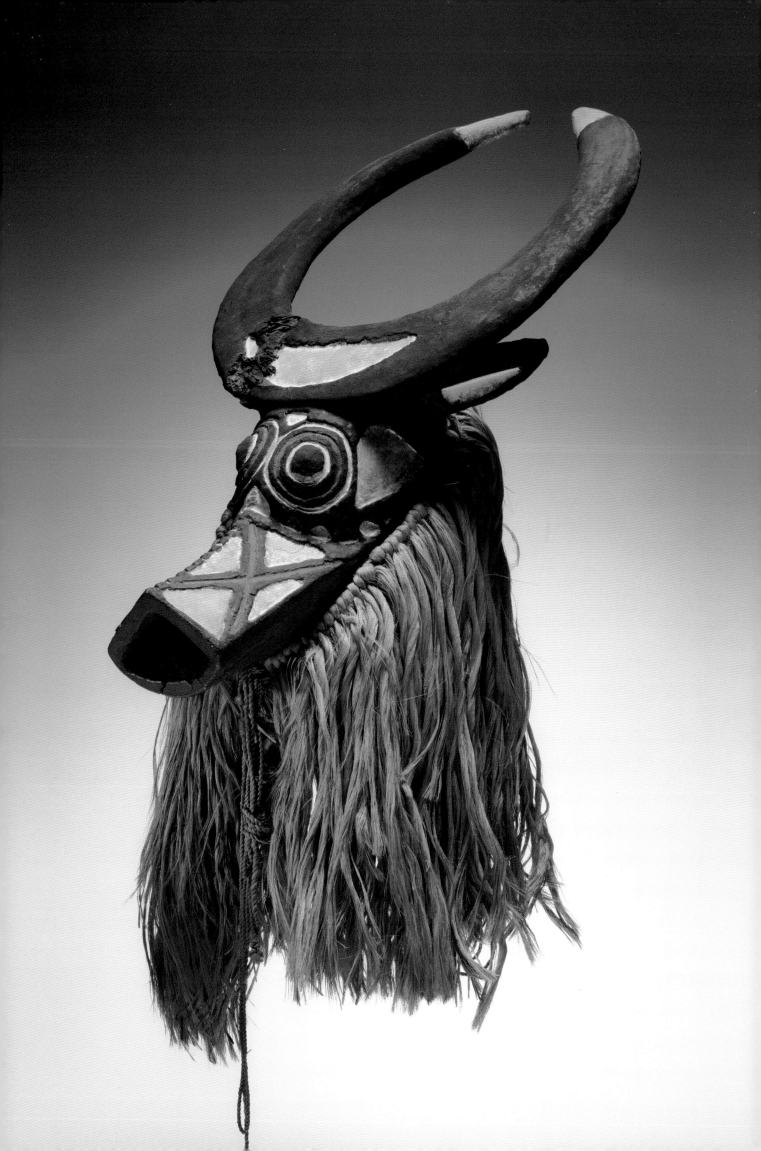

5

BUSH BUFFALO MASK; POSSIBLY BWA PEOPLE, BURKINA FASO
EARLY 20TH CENTURY; WOOD, CORD, FIBERS; HEIGHT 69.8 CM
GIFT OF KATHERINE C. WHITE 1969.2

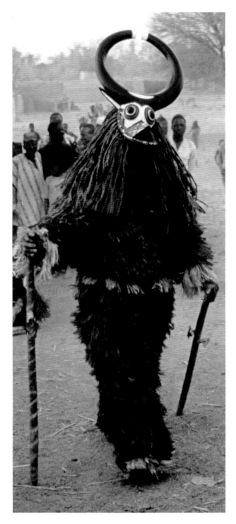

Fig. 11. Nuna bush buffalo masquerader posing at a funeral in the village of Tissé, Burkina Faso, 1985. Photograph by Christopher D. Roy.

Bush buffalo masks with colorful geometric surface decoration in red, black, and white are made by the Nuna, the Ko, and the Lela peoples, three of the so-called Gurunsi groups—a collective name for a number of farming groups. The Gurunsi are thought to have created the typical polychrome sculptural style of the basin area between the Red Volta and the White Volta Rivers. Because the Bwa have purchased masks from their Nuna neighbors, it is almost impossible to distinguish between the styles of these two peoples. Still, the Cleveland mask's large size and relatively simple decorative patterns point to a Bwa origin. The formal qualities and stylistic variety of wooden Bwa masks testify to their sculptors' desire for innovation and change.

Masks like this one represent protective bush spirits, which have human, animal, and fantastic traits, and refer to specific characters of clan and family myths. Some masks are more abstract or entirely nonrepresentational in appearance. The horns and muzzle of the Cleveland mask identify it as a bush buffalo. Other animal masks in the same style are known to represent antelopes, crocodiles, snakes, fish, butterflies, vultures, hawks, and bush pigs. Each mask character performs with its own musical accompaniment and choreography, its body concealed by a thick fiber costume. Holding two wooden canes suggesting forelegs, the buffalo masquerader imitates that animal's vigorous movements through an energetic dance of bounds and leaps.

Throughout the Upper Volta basin, masqueraders wearing headpieces of this type appear on several occasions during the dry season, including initiations for boys and girls, funerals of elders, market days, and harvest celebrations. For annual renewal rituals they are charged with chasing away evil spirits and safeguarding the well-being of the community, while thanking the spirits and the ancestors for their benevolent support.

Further reading: Roy 1987, 254–68; Roy 1996, 328–30.

41

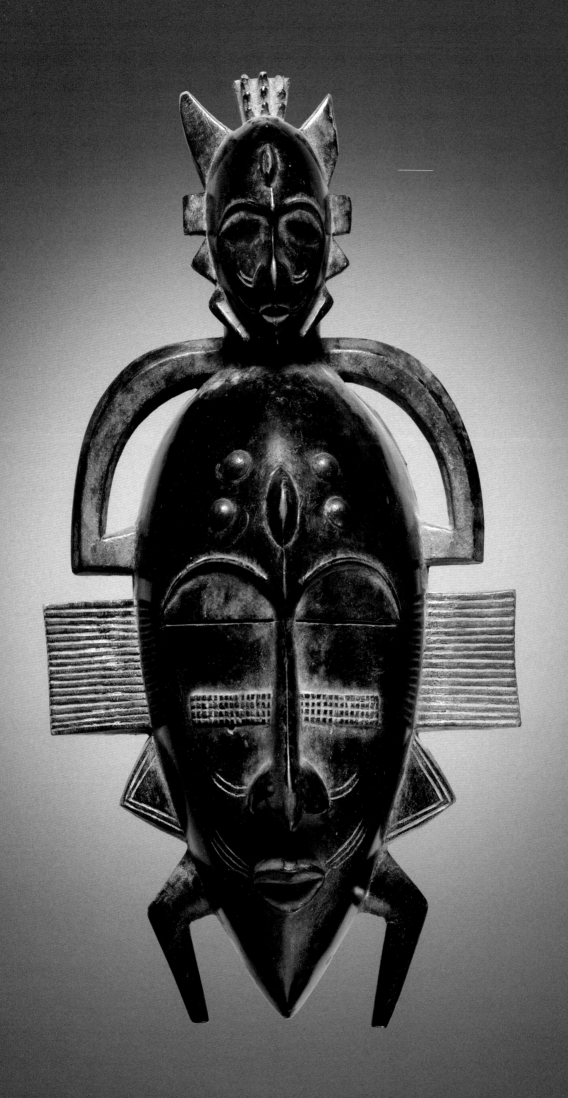

6

FACE MASK (*kpeliyehe*); SENUFO PEOPLE, CÔTE D'IVOIRE

ATTRIBUTED TO SABARIKWO OF OUAZUMON VILLAGE

EARLY 20TH CENTURY; WOOD; HEIGHT 31.1 CM

JOHN L. SEVERANCE FUND 1989.48

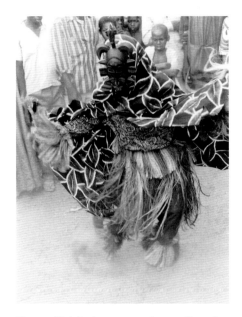

Fig. 12. *Kodoliyehe* masquerader at a funeral for a young man of the blacksmith group in the village of Sonzorisso, Dikodougou region, Côte d'Ivoire, 1970. Photograph by Anita J. Glaze.

The Senufo people live in the north of Côte d'Ivoire, as well as in neighboring parts of Mali and Burkina Faso. In fact, the name Senufo refers to some twenty-five farmer groups and five artisan groups, including the blacksmiths (*fonobele*) and the woodcarvers (*kulebele*). This face mask was carved by Sabarikwo, a master sculptor from the village of Ouazumon in the Patoro dialect area of the Boundiali region. Sabarikwo enjoyed great fame in many different dialect areas and traveled widely throughout the region.

An example of the *kpeliyehe* type (also known as *kodoliyehe*), this mask was possibly made for the kulebele. Kpeliyehe masks are worn in both public and private performances of the secret Poro association, during initiation and funeral rituals, and in non-Poro contexts. Poro is both an age-grade authority structure that expresses male social and political control, and a religious initiation system that educates and guides initiates of both genders. The delicacy of detail and the structure proper to the kpeliyehe face masks stand in contrast with the massive forms and aggressive imagery of the animal-shaped helmet masks. The difference is also translated in the pairing of both mask types in performances. The mask duo expresses the complementary roles of men and women.

Kpeliyehe masks are seen as essentially female, which is suggested by both the stylized hip movements in dances and the masks' individual titles, such as "Koto's girlfriend." In Senufo thought, female imagery and symbolism are closely associated with female sexuality and fertility, and allude to ideas of productivity, continuity, and unity. An oblique symbol of female genitalia, the scarification mark on the mask's forehead is an explicit reference to female sexuality. The members of the woodcarvers' Poro association are able to interpret this symbol once they have been exposed to the secret entry ritual of the association's senior grade, in which they must perform an act of union with mother earth. The lustrous black surface of the mask, imitating oiled, smooth skin, and the ornamental side projections that frame the face are hallmarks of feminine beauty.

Further reading: Glaze 1981, 79–81, 127–32; Glaze 1986, 30–34.

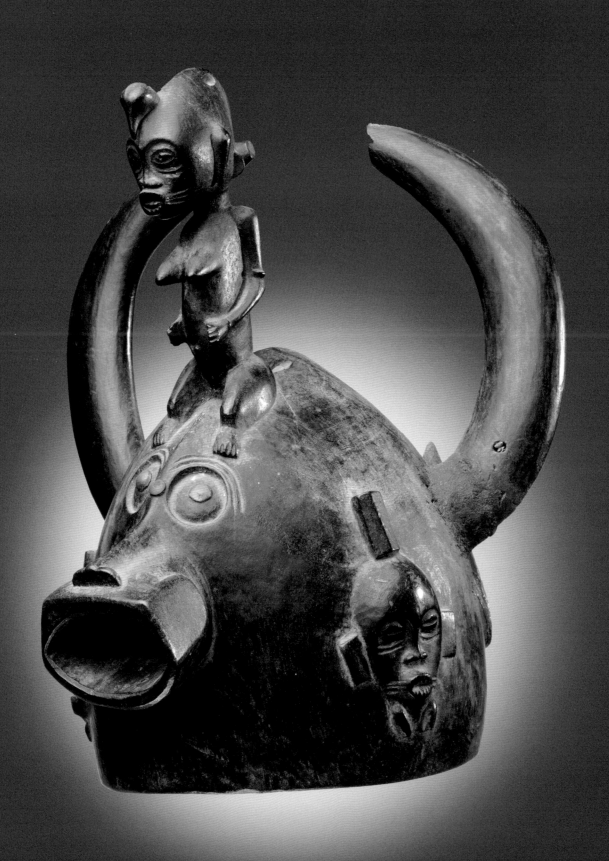

HELMET (*dagu*); SENUFO PEOPLE, CÔTE D'IVOIRE

EARLY TO MID 20TH CENTURY; WOOD, METAL; HEIGHT 34.9 CM

GIFT OF KATHERINE C. WHITE 1975.152

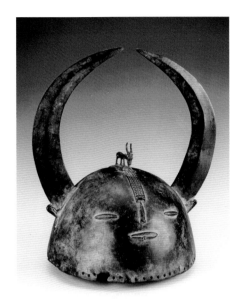

Fig. 13. Helmet, late 18th to early 19th century. Possibly Senufo people, Côte d'Ivoire; copper alloy; h. 24.8 cm. National Museum of African Art, Smithsonian Institution, Washington, Museum purchase, 91.16.1.

Many if not all Senufo masks and headdresses are or were made and used in the context of initiation into the Poro society. Yet the Poro is not a monolithic organization: its customs and artistic traditions show considerable regional variation, and some object forms vary even within the same dialect group. Shaped like a deep bowl with horns and decorated with a female figure carved from the same piece of wood, the Cleveland helmet seems to be a rare example of a crest mask or helmet type called *dagu* that was confined to the Boundiali region. Decorated with cowrie shells, feathers, and other accessories, such helmets were worn in rituals emphasizing the transition from one age group to the next, but before the actual seven-year initiation cycle into the Poro society. On these occasions, older or younger age groups are lampooned through songs, plays, and masquerades.

Depicted in relief on both sides of the Cleveland helmet is a face mask of the kpeliyehe type (see pl. 6). The theme of the female figure points to the special powers of women, specifically their supernatural resources assuring the well-being and security of Poro society members. The horns refer to cattle horns since the young men about to be initiated were considered unknowing and anxious oxen. Further, the curving horns of the bush buffalo constitute the most important insignia of the Nookaariga, an elite society of healers of the southwestern part of Senufoland. There the mythical bull had revealed his secret knowledge of healing and magical powers of transformation to the Senufo hunter who founded the first Nookaariga society. Members wear a horned helmet called *noo* during secret initiation and healing rituals. The Cleveland crest mask can also be related formally, and possibly contextually, to the equally rare cast copper-alloy horned helmets attributed to the Senufo, an example of which is in the collection of the Smithsonian Institution's National Museum of African Art (fig. 13).

Further reading: Förster 1988, 15–19; Förster 1996, 420–21; Glaze 1993, cats. 9–11; Ravenhill 1999, cat. 27; Veirman 2002, 119–20.

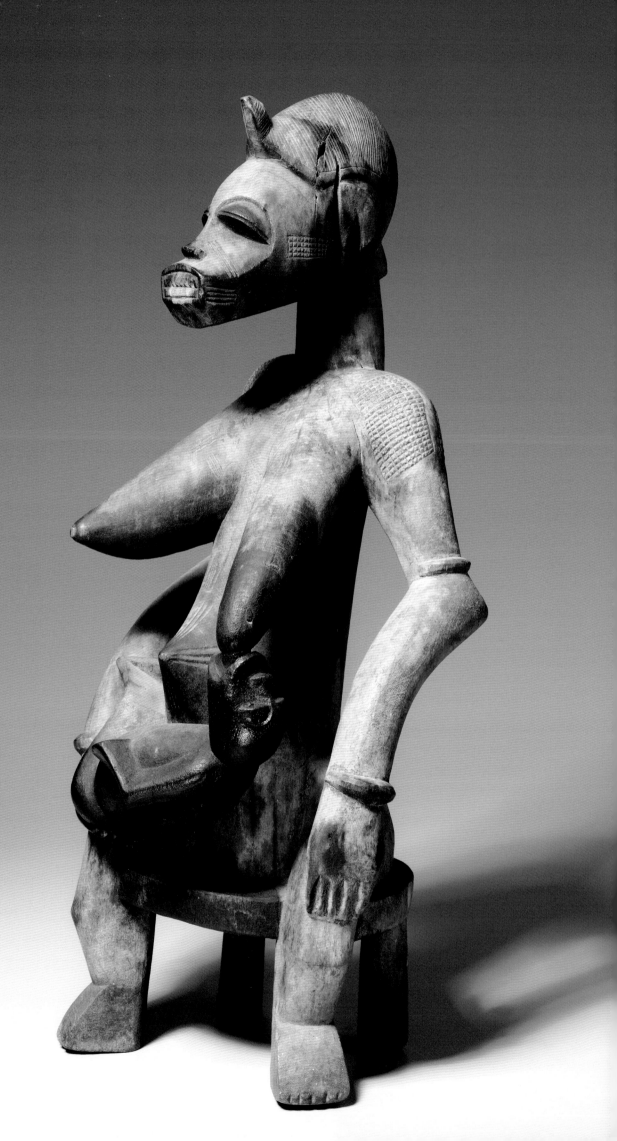

8

MOTHER-AND-CHILD FIGURE; SENUFO PEOPLE, CÔTE D'IVOIRE

LATE 19TH TO MID 20TH CENTURY; WOOD; HEIGHT 63.6 CM

JAMES ALBERT AND MARY GARDINER FORD MEMORIAL FUND 1961.198

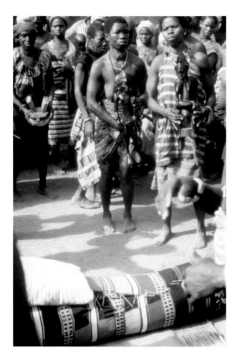

Fig. 14. Women carrying mother-and-child figures in a funeral procession of the Tyekpa society, the female counterpart of the men's Poro, in the Dikodougou region, Côte d'Ivoire, 1979. Photograph by Anita J. Glaze.

While the arts of the Senufo people have been the subject of ample scholarly research, relatively little information is available about their female figures. Among the Fodonon Senufo subgroup, mother-and-child figures are related to the female Tyekpa association—the Fodonon's "women's Poro" (the Poro itself is actually called Pondo among this subgroup)—and play a role in funerary ceremonies, where they are carried on the participating women's heads. The four-legged stool on which the Cleveland figure is seated may help balance it on a dancer's head. Among the central Senufo, however, similar female figures were used as stationary display sculpture for the Poro society. Although economy of detail and spareness of form sometimes indicate a specific function, in practice it is impossible to determine the use of a particular figure based only on its style and degree of elaboration.

Both types of figurative carvings belong to a broad category of sculptures designated with the class name *pombibele* (children of Poro). These large figures are collectively owned by a Poro society. It is also possible, however, that mother-and-child figures were used in divination by women of the Sandogo society among the central Senufo. In the context of the Poro and its female counterpart, mother-and-child figures probably refer to Ancient Mother, the central deity of the Poro initiation cycle. She is responsible for the protection and instruction of the initiates, who are her "children," nursing them with the milk of knowledge and thus transforming them into perfect human beings.

Further reading: Bochet 1981, cat. 21; Förster 1988, 45; Glaze 1975, 26–27; Glaze 1983, unpaginated; Veirman 2002, 118–26.

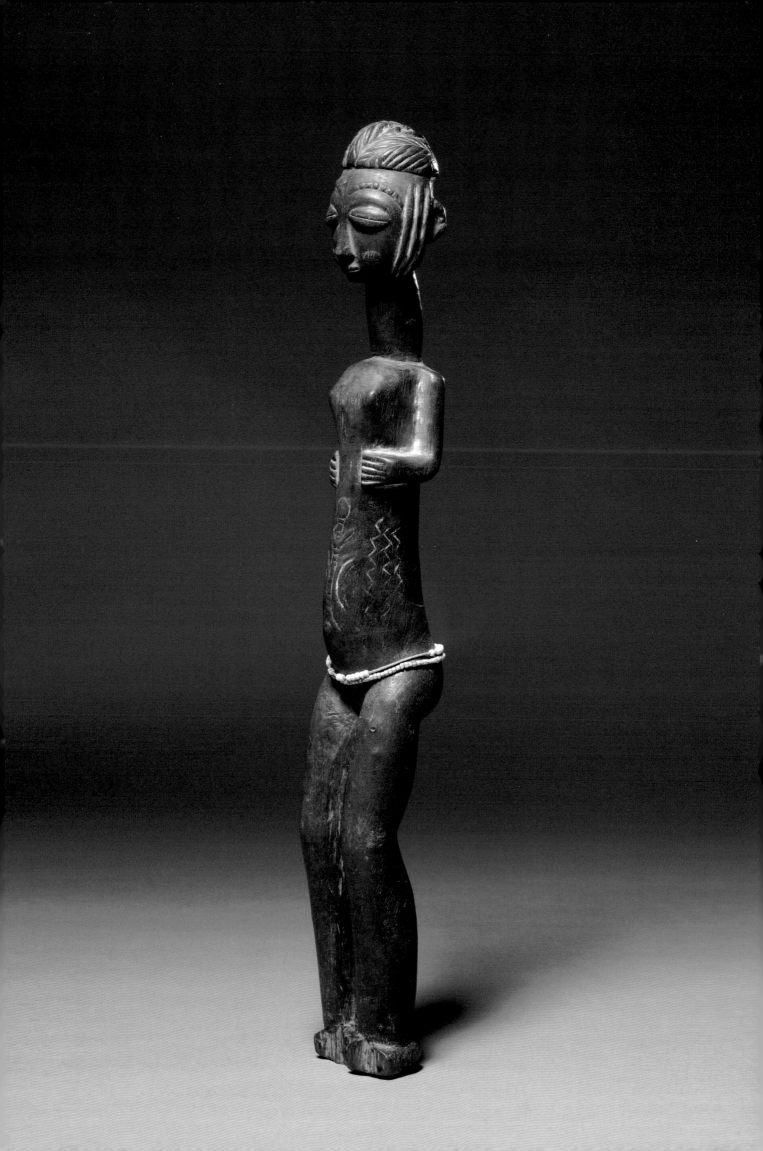

9

FEMALE FIGURE; POSSIBLY BONDOUKOU REGION, CÔTE D'IVOIRE

LATE 19TH TO EARLY 20TH CENTURY; WOOD, METAL; HEIGHT 52.7 CM

GIFT OF KATHERINE C. WHITE 1972.343

Although this female figure was reported to have been field-collected at Wenchi in Ghana, it probably comes from the Bondoukou region in northeastern Côte d'Ivoire, near the border with Ghana and about 75 km to the west of Wenchi. This region is an artistic melting pot, inhabited by several ethnic groups whose cultures often intermingle. Therefore, the previous attribution of the Cleveland figure to the Kulango, one of the Gur-speaking farming peoples of the region, cannot be confirmed. Stylistically, however, it combines the naturalism proper to the Guinea Coast and the stylization proper to the Western Sudan. In its rounded shapes and delicate surface decoration, which seems to imitate body scarifications, it closely resembles the figurative style of carvings of the neighboring Baule and Anyi peoples. The figure's meaning and function remain a mystery.

Further reading: Bravmann 1974, 80–87; Garrard 1995, cat. 5.112.

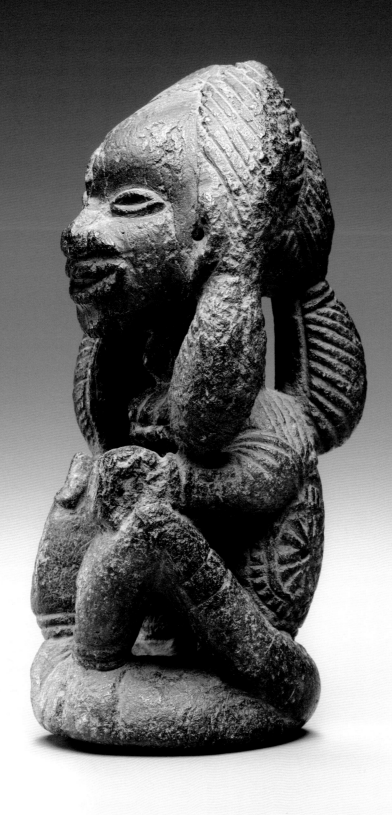

10

FIGURE; POSSIBLY SO-CALLED SAPI PEOPLE, SIERRA LEONE OR GUINEA

POSSIBLY EARLY 15TH CENTURY; SOAPSTONE; HEIGHT 23.8 CM

GIFT OF LUCILE MUNRO IN MEMORY OF HER HUSBAND, THOMAS MUNRO 1976.29

Fig. 15. Ancestral altar in a Kissi village, Guinea, 1946. Photograph by Denise Paulme.

Human figures and heads in soft soapstone or steatite have been found among different peoples living near one another in present-day Guinea, Sierra Leone, and Liberia. While clearing fields or digging for diamonds, the contemporary inhabitants of this small part of the Upper Guinea coast discovered these sculptures buried in the soil or in watercourses. The most varied group has been found in the homelands of the Kissi, where they are generally called *pomdo* (pl. *pomda*), meaning "the dead" or "images of the dead." Stylistically, the Cleveland figure belongs to this group. Similar sculptures have been found among the Mende, who call them *nomoli*.

These sculptures seem to be centuries old and are believed to have been made by the ancestors of the present inhabitants of these areas. In the fifteenth century the Portuguese gave the name Sapi to different peoples speaking related languages along the Upper Guinea Coast, but their descriptions made no reference to stone sculptures. The exact date when they were made, however, is still the subject of debate. They may predate the mid fifteenth century, and some are perhaps much older, having been buried well before the arrival of the Portuguese. The only major carving tradition to which these sculptures can be related stylistically is that of the so-called Sapi-Portuguese ivories, which were made for the Portuguese by African artists in Sierra Leone in the late fifteenth and early sixteenth centuries.

The Kissi identified the figures they found as manifestations of their ancestors and placed them in ancestral shrines. On holidays, the figures were offered the first fruits of the harvest. Yet their original purpose is not clear. Likewise, despite the depiction of what appear to be indications of rank in body decorations and accessories, whether the figures represent chiefs or notables cannot be confirmed.

Further reading: Hart 1995, cat. 133; Paulme 1981, cat. 28; Siegmann 1989, cat. 42.

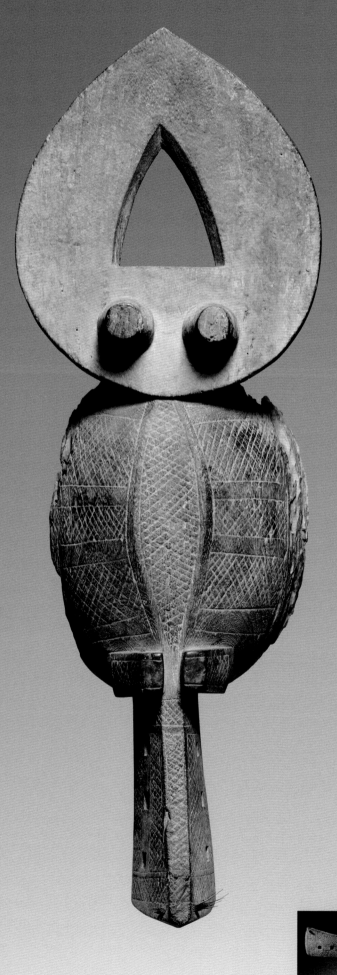

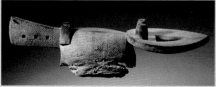

HEADDRESS (*tabakän*); POSSIBLY LANDUMA PEOPLE, GUINEA

EARLY 20TH CENTURY; WOOD, FIBERS; HEIGHT 76.2 CM

GIFT OF KATHERINE C. WHITE 1969.3

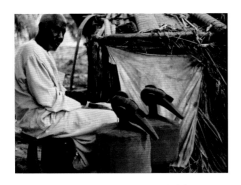

Fig. 16. Clan elder with two *a-tshol* figures in front of his shrine, which may have contained a *tönköngba* headdress and other power-endowed objects, in a Baga Sitemu village, Guinea, 1992. Photograph by Frederick Lamp.

Little is known about the function and meaning of this type of headdress because of the secrecy surrounding it and because such objects were used in different ways by different peoples, serving as both shrine figures and dance headdresses. During his fieldwork, Frederick Lamp saw a shrine in a Baga Sitemu village that contained such a headdress along with two sculptures of the *a-tshol* type and other power-endowed objects. The shrine was a small shelter with mud-built walls on three sides. In addition to being kept in small outdoor shrines, such headdresses could also be placed on an altar in a sacred house maintained by an elder. As dance headdresses, they were worn with a long raffia costume that concealed the man underneath. They were danced with only occasionally, when a sacrifice to the ancestors was needed, at a funeral, or during a male initiation. Their frightful appearance made the public run away.

While its form derives from examples of the animal world, the headdress represents an invented composite being that contemporary Baga spokespersons describe as a creature of the sea with a wide flat tail and a cow-like head. Nevertheless, some suggest the headdress resembles the dolphin, a species that exists in abundance in the area. In one Baga Sitemu village, dolphins are actually considered sacred, and they are said to bring fish to shore on their backs. Most often attributed to the Landuma, this type of headdress was also made and used by the neighboring Nalu and northern Baga peoples. Among the Baga Sitemu subgroup, it is commonly called *tönköngba*, but the Landuma call it *tabakän*. Just as the a-tshol sculpture mentioned earlier, the main functions of the tönköngba/tabakän headdress were to prosecute evildoers, heal the sick and injured, and protect boys and young men during their initiation into adulthood.

Further reading: Lamp 1996a, 138–44; Lamp 2000, cat. 2.

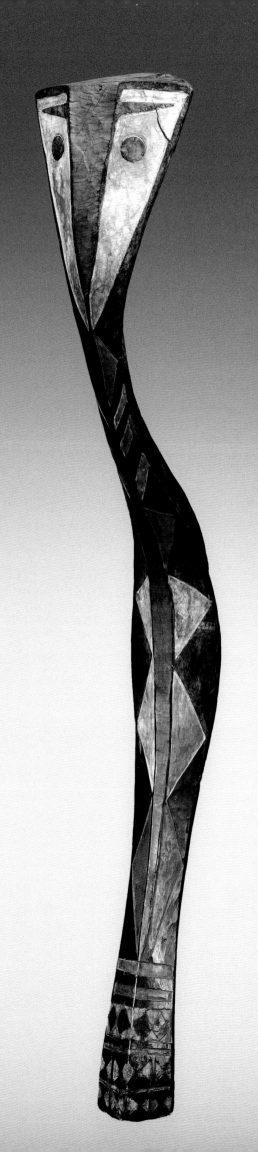

SERPENT HEADDRESS; POSSIBLY BAGA PEOPLE, GUINEA

LATE 19TH TO EARLY 20TH CENTURY; WOOD; HEIGHT 148 CM

THE NORWEB COLLECTION 1960.37

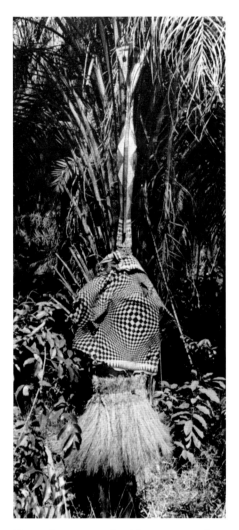

Fig. 17. Baga serpent headdress masquerader, Boké region, Guinea, 1950s. Photographer unknown.

Although generally ascribed to the Baga people, headdresses in the form of serpents have also been made by neighboring peoples such as the Landuma, Nalu, Pukur, and Buluñits. Before Frederick Lamp published his field research, the serpent headdress was generally known as *ba(n)sonyi* or *simo* among Western art scholars and collectors. The Baga Sitemu subgroup call it *a-mantsho-ña-tshol* (literally "master of medicine"), which is sometimes replaced by the name *inap*. The Baga and their cultural relatives are said to have brought the serpent headdress and other sacred masks to their present-day habitat along the Atlantic coast after they fled their homeland in the mountainous Fouta Djallon.

The massive wooden serpent figure was affixed vertically in a cylindrical receptacle at the top of a conical armature made of palm branches. The framework would be covered with a palm-fiber costume that reached the ground. Large pieces of brightly colored fabric would be wrapped over the upper part of the costume, with feathers and cloth streamers attached to the serpent's head. Resembling a python, the headdress incarnates the feared serpent spirit called Ninkinanka, which is known among widespread groups. Ninkinanka is honored for giving rain, bestowing riches, and bringing children to the infertile. The serpent headdress appeared at the end of the first level of the initiation for boys and girls among certain Baga subgroups, and just before the actual circumcision at the beginning of the boys' initiation among others. In this context the headdress was sometimes identified as the rainbow, which the Baga and their neighbors associate with beginnings and endings, life and death, and the continuation of lineages—all essential themes of the initiation cycle.

Further reading: Berliner 2002, 100–109; Curtis 2000, 68–70; Lamp 1996a, 76–85.

FACE MASK; MANO PEOPLE, LIBERIA

EARLY 20TH CENTURY; WOOD, FORMICA, CORD, METAL, SEEDS; HEIGHT 28 CM

THE HAROLD T. CLARK EDUCATIONAL EXTENSION FUND 1953.457

This mask with a movable jaw was field-collected in Liberia sometime between 1933 and 1937 by the medical missionary Dr. George Harley. During his forty-year stay in Liberia, Harley developed a keen interest in the peoples and arts of the region. He published three ethnographic monographs and collected more than 1,000 masks from the Mano and related peoples, many of which are housed today in Harvard University's Peabody Museum of Archaeology and Ethnology. The Mano are Mande-Fu–speaking, closely related neighbors of the better-known Dan people. Some scholars even think that Mano and Dan are, in fact, two names for one people.

Attributed to the Mano, this mask entered the Cleveland collection accompanied by a handwritten tag mentioning that it was owned by the late Segola of the village of Gbotai and was called *ge li du,* representing the "chief devil of the Poro." According to Harley, this mask would have been greatly feared and never appeared outside of the Poro context. Harley's association of masks and the secret Poro society has been questioned by many subsequent scholars. The Mano and the Dan differ from their Mande-Fu–speaking neighbors in that, instead of a Poro society, they have a systematically organized mask cult that represents a conscious opposition to any kind of secret society.

Generally, Mano and Dan masks are considered to be manifestations of forest spirits and can be grouped according to eleven major types, relating to aspects of social control, political and judicial matters, peace making, education, competition, and entertainment. It is important to note that the meaning and function of masks among both peoples can and do change over time, and that masks usually climb up the hierarchical ladder as they "grow older" and gain prestige.

Further reading: Fischer 1978, 16–21; Harley 1970, 129–31, 171; Himmelheber 1960, 136–95; Vandenhoute 1989, 13–46; Wells 1977, 22–24.

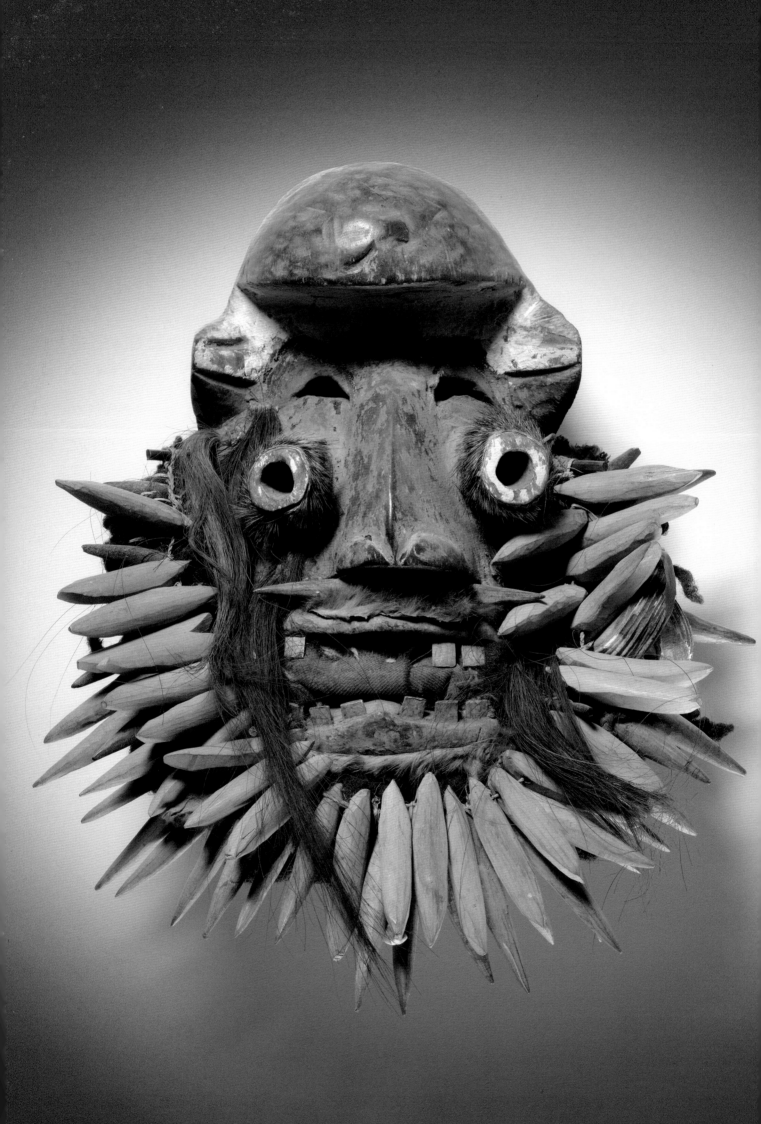

14

FACE MASK; WÈ (OR KRAN) PEOPLE, CÔTE D'IVOIRE OR LIBERIA

EARLY 20TH CENTURY; WOOD, METAL, CLOTH, FUR, HAIR, TUSKS; HEIGHT 38.1 CM

GIFT OF KATHERINE C. WHITE 1971.294

Fig. 18. Procession of "big masks" in a Wè village, Liberia, 1963. Photograph by Hans Himmelheber.

asks of the Wè people of the Upper Cavally region in the border area between Côte d'Ivoire and Liberia have been compared with those of their culturally related Dan neighbors. Although the human face is a dominant motif in the masks of both peoples, their core mask styles have been interpreted as each other's opposites, with Wè (called Kran in Liberia) masks characterized as expressionistic or even baroque, and Dan masks as realistic or even naturalistic. Both peoples' masks can be categorized as either male or female, but in performance all masks are worn by men. The features displayed by this mask, most notably its tubular eyes and the fringe of carved leopard canine teeth, identify it as an example of the male type. Nevertheless, a mask's exact name and meaning can be determined only when it is seen with its full costume, including a cap or headdress and a long skirt, and in performance with the appropriate instrumental and vocal music.

Wè masks embody spirit forces from the forest and are surrounded by secrecy and specific rules and prescriptions. They appear on various occasions, either for entertainment or to fulfill specific social or political functions. They are always accompanied by one to three unmasked and well-trained assistants, each having his own task. Male entertainment masks perform dances; their female counterparts have the exclusive right to sing. Over time, as it gains prestige, any serious mask may attain the most powerful and senior of mask ranks, *gela* ("big mask" or "great mask"). Such masks, with face painted white as a sign of beauty and peace, appear only at very important moments, with the masquerader holding an elephant tusk and wearing a leopard skin over his head and shoulders. The functions of big masks include making peace, leading soldiers into battle, and administering justice.

Further reading: Adams 1986, 46–51; Adams 1988, 97–101; Adams 1993, 42–43; Harter 1993, 187–98; Himmelheber 1963, 216–18, 222–26, 228–31; Himmelheber 1966, 100–105; Vandenhoute 1948, 6–10.

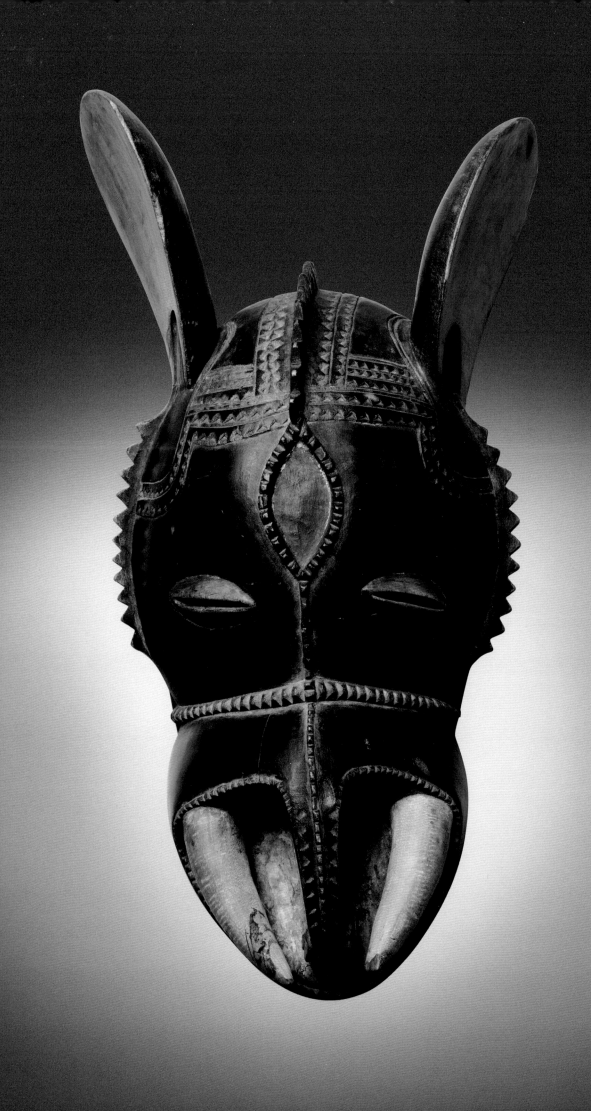

15

FACE MASK; POSSIBLY YAURE PEOPLE, CÔTE D'IVOIRE

EARLY 20TH CENTURY; WOOD; HEIGHT 31.7 CM

GIFT OF KATHERINE C. WHITE 1971.296

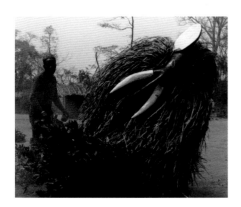

Fig. 19. Guro elephant masquerader in the village of Dabuzra, Côte d'Ivoire, 1975. Photograph by Eberhard Fischer.

Perceptions about nature and the animal kingdom are shared by the Baule, Guro, and Yaure (also spelled "Yohure") peoples, and their masks are often a blend of animal and human features. In fact, the history of the region of central Côte d'Ivoire, whose closely related cultures are generally presented as distinct ethnic groups, is characterized by assimilation and adoption. The depiction of elephant traits, most notably large ears and a trunk and tusks extending from the chin, is a recurring theme. Cleveland's composite human-animal face mask has been attributed to the Guro since it entered the collection in 1971, but the rickrack openwork along the edges is typical of Yaure masks and also occurs on Baule mask forms.

Portraying the elephant on regalia and other stationary art forms suggests an affirmation of an accepted order of supremacy. In performances, however, such images evoke the power to transform and change. Among the southwestern Guro and neighboring Yaure, elephant and other animal masks are associated with a cult called Dye (also spelled "Gye") and appear when important sacrifices must be made. Because the natural world is rarely literally reproduced but rather reinvented and transformed, we cannot be sure whether a mask depicts elephant or warthog tusks. For the Baule, the two animals are closely related by their grayish color and the combination of tusks with a snout. On central Côte d'Ivoire masks, the tusks of either animal suggest aggression and destructive power.

Further reading: Boyer 1993, 257–69; Fischer and Homberger 1985, 75–119; Ravenhill 1992, 126–32.

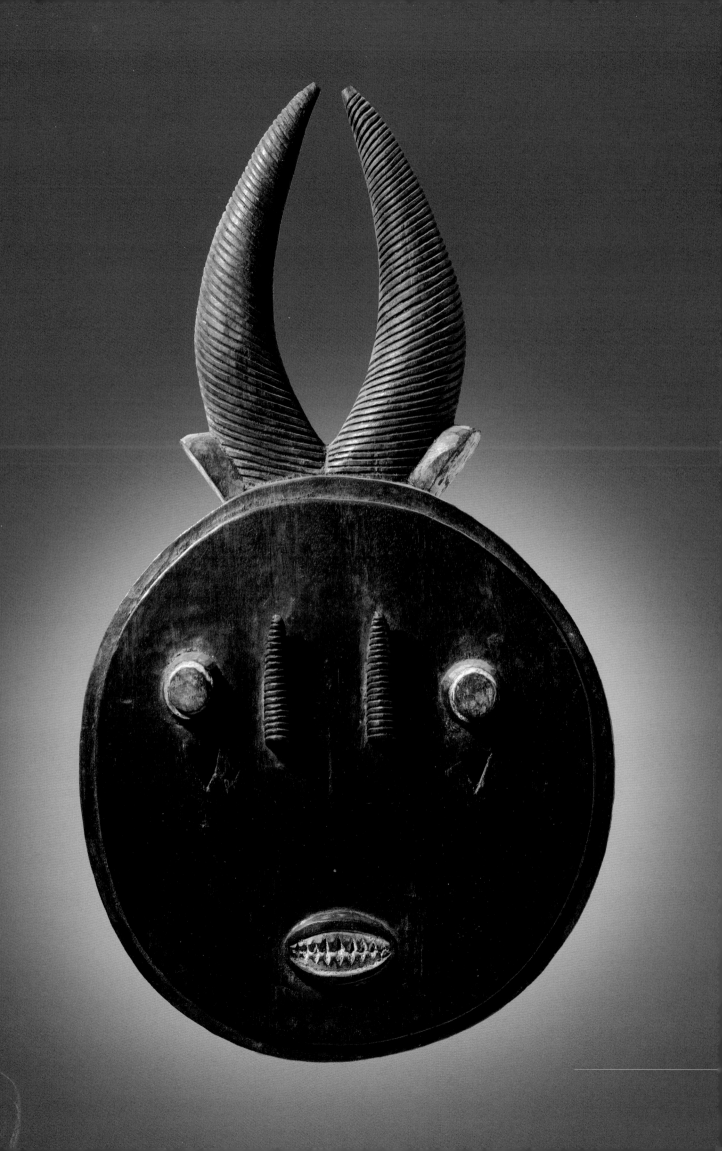

FACE MASK (*kple kple*); BAULE PEOPLE, CÔTE D'IVOIRE

LATE 19TH TO EARLY 20TH CENTURY; WOOD; HEIGHT 40.7 CM

GIFT OF KATHERINE C. WHITE 1975.155

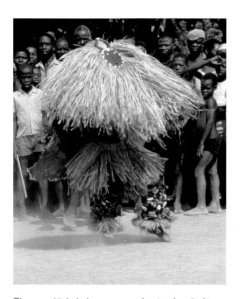

Fig. 20. *Kple kple* masquerader in the Goli dance in the village of Kongonou, Nanafwe region, Côte d'Ivoire, 1978. Photograph by Susan Mullin Vogel.

This austere example of a disc-faced mask called *kple kple* is one of a series of masks that perform in the Goli dance. Although today the Goli is gradually replacing all other Baule mask dances, the Baule adopted it from the neighboring Mande-speaking Wan people less than one hundred years ago. The mask forms used in the Goli are virtually the same among the two peoples, but the beliefs that surround them are completely different. Among the Wan, originally the Goli dance was sacred and potent, and Goli masks are still used primarily for important funeral ceremonies. Among the Baule, the masks are used exclusively as entertainment. The Baule's Goli consists of eight masks—four male-female pairs that appear in order of rank, the male in each pair dancing first. The Goli provides a model for the hierarchy the Baule perceive in nature as well as in human society. At the same time, the dance bridges the opposition between the bush and the village.

Kple kple, the name of the first pair of masks to dance in the sequence, represents the junior male character. The first two pairs are considered essentially male in character, unlike the two pairs that close the dance. Within a pair, the male and female masks and their costumes are almost identical, but the male is painted red and the female, like the Cleveland mask, is colored black. The costumes consist mainly of a netted shirt and trousers, a raffia fringe around the collar, a raffia skirt, and an animal hide on the dancer's back. The masks are worn by young boys in a rapid stamping dance. The dancers alternate with each other and watch their partner perform. Although the Baule think of the kple kple as the least beautiful and prestigious of their masks, Westerners are attracted by its simplicity of form and purity of outline.

Further reading: Ravenhill 1988, 88–92; Ravenhill 1994, cat. 22; Vogel 1997, 169–86.

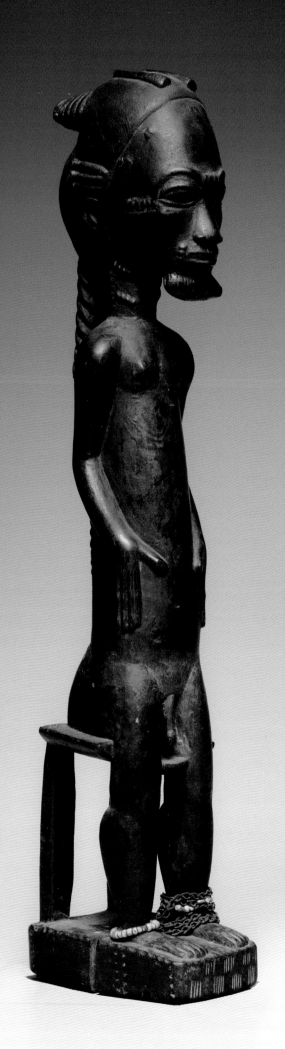
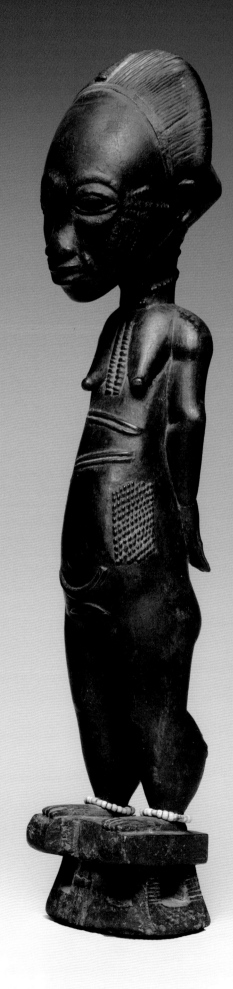

FIGURE PAIR; BAULE PEOPLE, CÔTE D'IVOIRE

LATE 19TH TO EARLY 20TH CENTURY; WOOD, BEADS, METAL; HEIGHT 49.5 CM

(MALE), 47.7 CM (FEMALE)

GIFT OF KATHERINE C. WHITE 1971.297 (MALE), 1971.298 (FEMALE)

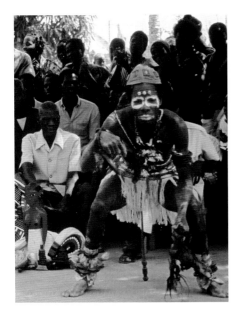

Fig. 21. Trance diviner in performance with a figure sculpture and objects on display in the village of Kami, Côte d'Ivoire, 1994. Photograph by Susan Mullin Vogel.

Among the Baule people, figures carved as pairs usually represent untamed bush spirits called *asye usu*. These spirits may intervene in the lives of individuals by taking possession of them and causing them to behave strangely. If this possession does not result in madness, it can lead to the human host's becoming a trance diviner. To be fully initiated into the technique of divination, however, the seizure by the asye usu must be followed by a long and complex apprenticeship with a ritual expert. The spirits are thought to be very unattractive and mischievous. Thus, people who feel their lives are being interrupted by the asye usu commission carved figures to attract the bush spirits, which are drawn to the grace and beauty of these objects and begin to use them as temporary homes.

The smooth patina of the Cleveland figures most likely results from frequent handling. The elaborate rendition of anatomical and decorative details and the pairing of a male and a female figure enhance the appeal of the sculptures. The elegant coiffures and intricate scarifications reflect the Baule ideal of moral and physical beauty. Scarifications in particular indicate human beauty and are therefore seen as "marks of civilization." Such artistry and beauty would have also added to the status and reputation of the diviner who employed them.

While other types of Baule figures are kept from the public eye, the asye usu pair are seen during the divination performance, displayed next to the diviner and thus contributing greatly to the impact of the ritual, which the Baule consider as much a form of entertainment as a religious act.

Further reading: Ravenhill 1994, cat. 20; Ravenhill 1996, 405; Vogel 1997, 221–39.

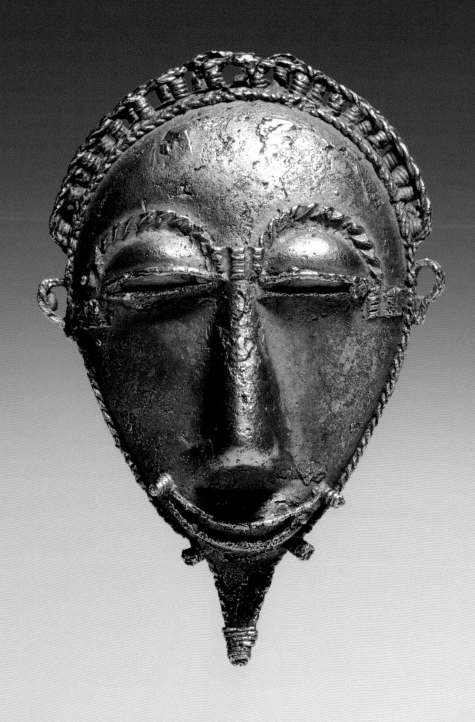

FACE PENDANT; POSSIBLY BAULE PEOPLE, CÔTE D'IVOIRE

20TH CENTURY; GOLD; HEIGHT 7.6 CM

JOHN L. SEVERANCE FUND 1954.602

Fig. 22. Kyaman (or Ebrie) goldsmith making pendants by the lost-wax method in the village of Anna, Lagoons region, Côte d'Ivoire, 1972. Photograph by Eliot Elisofon.

This refined face of a male Baule elder with a plaited beard was skillfully cast in gold using the lost-wax method. Along with stools and chairs, objects of gold are the only Baule art forms associated with the ever-present spirits of the ancestors, called *umien*. The ancestors need to be contacted through sacrifices and invocations in order to obtain their help and protection.

Objects of gold, whether solid-cast ornaments like the Cleveland face pendant, carved wooden objects covered with gold foil, or packets of unworked gold nuggets or gold dust, are hidden in pots or suitcases and preserved as a sacred family inheritance called *aja*. Dangers and interdictions surround this aja. Unworked gold is not to be handled, but gold adornments in the form of a human face, a ram's head, a crescent, and other shapes are displayed on important occasions such as funerals. Together with fine textiles they are laid out around the corpse before its burial. At the ceremony that signals the end of mourning, the widow wears these ornaments, usually on a chain around her neck or attached to her hair with fine threads.

Mainly among the eastern Baule, finely cast gold ornaments are also worn by a young girl when she is celebrated in the coming-of-age ceremony known as *atonvle,* following her first menses. While this face pendant was most likely made by a Baule smith, gold jewelry meant to augment the status of its owner circulated widely in the coastal region of Côte d'Ivoire and Ghana. Akan as well as Akan-related peoples of the Lagoons region accord the same special value to gold.

Further reading: Garrard 1989a, 100–102; Garrard 1995, cat. 5.102; Visonà 1993, 372; Vogel 1997, 195–202.

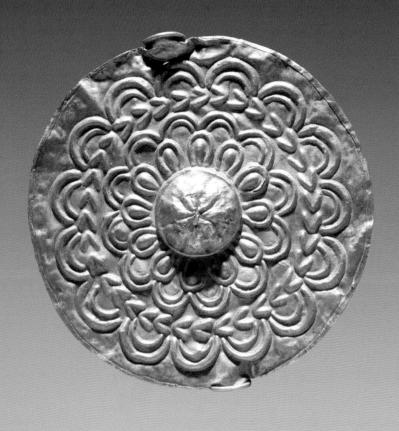

19

JEWELRY; ASANTE PEOPLE, GHANA

19TH CENTURY; GOLD; DIAMETER 9.8 CM, HEIGHT 4.3 CM, HEIGHT 6.6 CM,

HEIGHT 8.7 CM, HEIGHT 6.9 CM (TOP, LEFT TO RIGHT)

DUDLEY P. ALLEN FUND 1935.310, 1935.311, 1935.309, 1935.312, 1935.308

Fig. 23. Fante sword bearer wearing a "soul-washer's badge" in the town of Cape Coast, Ghana, 1978. Photograph by Doran H. Ross.

The Asante and the Fante peoples are among the best known of the branches that constitute the Akan family in central and coastal Ghana. Gold ornaments indicate status and wealth among different Akan and Akan-related peoples and are worn ostentatiously at public festivals by titleholders, chiefs, and kings. This set of five ornaments once belonged to the Asante king (*asantehene*) Prempeh I, who was seized and deported by the British in 1896. Between 1874 and 1896 the royal palace in the Asante capital Kumasi was repeatedly ransacked and looted during raids by the British in attempts to gain control of the area. As a result, gold objects can be found today in many public and private collections in the West. The Cleveland Museum of Art bought this set from the renowned French collector and dealer Charles Ratton shortly after it had been on view in the 1935 exhibition *African Negro Art* organized by the Museum of Modern Art. The exquisite workmanship and attention to detail confirm these ornaments' nineteenth-century date of manufacture.

Decorated with foliate and floral patterns, the Cleveland Asante gold ornaments were not cast by the lost-wax technique but hammered by the repoussé method. Pectoral disks, which were worn suspended over the chest by a white cord of pineapple fiber, are among the most beautiful examples of Asante gold. Sometimes they were integrated in a necklace, or attached to a cap or even to the hair. The majority of these pectorals were owned as insignia by the *akrafo* (sing. *okra*), young officials who were charged with the purification of the chief's soul—hence their name *akrafokonmu,* meaning "soul-washer's badges" or "soul disks." In reality, such jewelry could serve many purposes and form part of the insignia of other title bearers, such as royal messengers, linguists, war leaders, or subchiefs. Also, young women formerly wore them in puberty rituals, and in more recent times they were worn by the principal mourners at funerals.

Some scholars have suggested that the typical disk-shaped jewels would have been inspired by gold coins struck by North African Muslim dynasties between 800 and 1600. Gold disks were viewed as charms against evil among the Asante, which may also derive from the use of shiny objects in North Africa as protection against the "evil eye."

Further reading: Cole and Ross 1977, 31–38, 153–58; Garrard 1989a, 14–18, 50–52, 66–68; Ross 2002, 27–34.

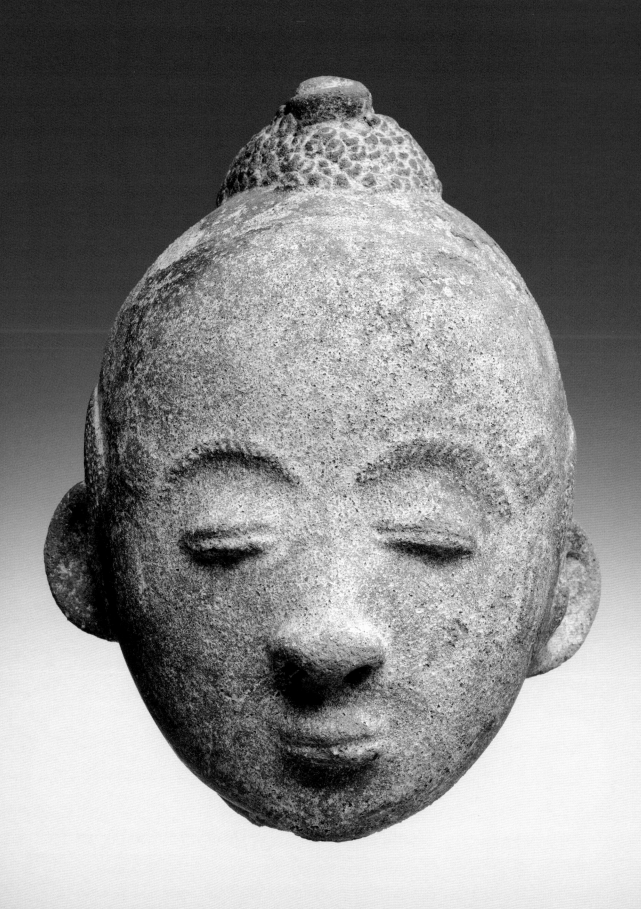

HEAD (*mma*); AKAN PEOPLES, GHANA

LATE 17TH TO EARLY 18TH CENTURY; TERRACOTTA; HEIGHT 20.3 CM

EDWIN R. AND HARRIET PELTON PERKINS MEMORIAL FUND 1990.22

Fig. 24. Terracotta grave figures and heads, probably in the region between Agona Swedru and Winneba, Ghana, 19th century. Photographer unknown.

While terracotta portraiture flourished among southern Akan peoples, it was virtually unknown to the Asante and the northern Akan. Royal family members commissioned terracotta portraits from female artists to be placed in sacred groves outside the village days or even months after they died. Periodically, rituals comprising libations, offerings, and prayers were performed at these groves in honor of the ancestors. Busts, standing and seated figures, and figuratively decorated vessels populated such groves along with commemorative heads, generally called *mma* ("infants"), of which the Cleveland head is an example. These terracotta memorials were viewed as idealized portraits of the deceased, with the ancestor's identity suggested by cosmetic adornments, including scarification patterns and symbols of rank and prestige.

The knobs on this head imitate a male Akan hairstyle, consisting of a shaved and tufted pattern, that has been out of fashion since the beginning of the twentieth century. Whether the Cleveland head is a fragment of a full figure or a bust cannot be determined. Its refined facial features are typical of a style called Twifo, referring to an old forest kingdom. Stylistically, the head is related to pieces discovered in an archaeological site at Hemang in southern Ghana dated 1690 to about 1730. Whether terracottas were made during that entire period is not known.

Further reading: Cole and Ross 1977, 122–27; Garrard 1989b, cat. 72; Preston 1981, cat. 41; Ross 1995, cat. 5.99; Soppelsa 1988, 148–52.

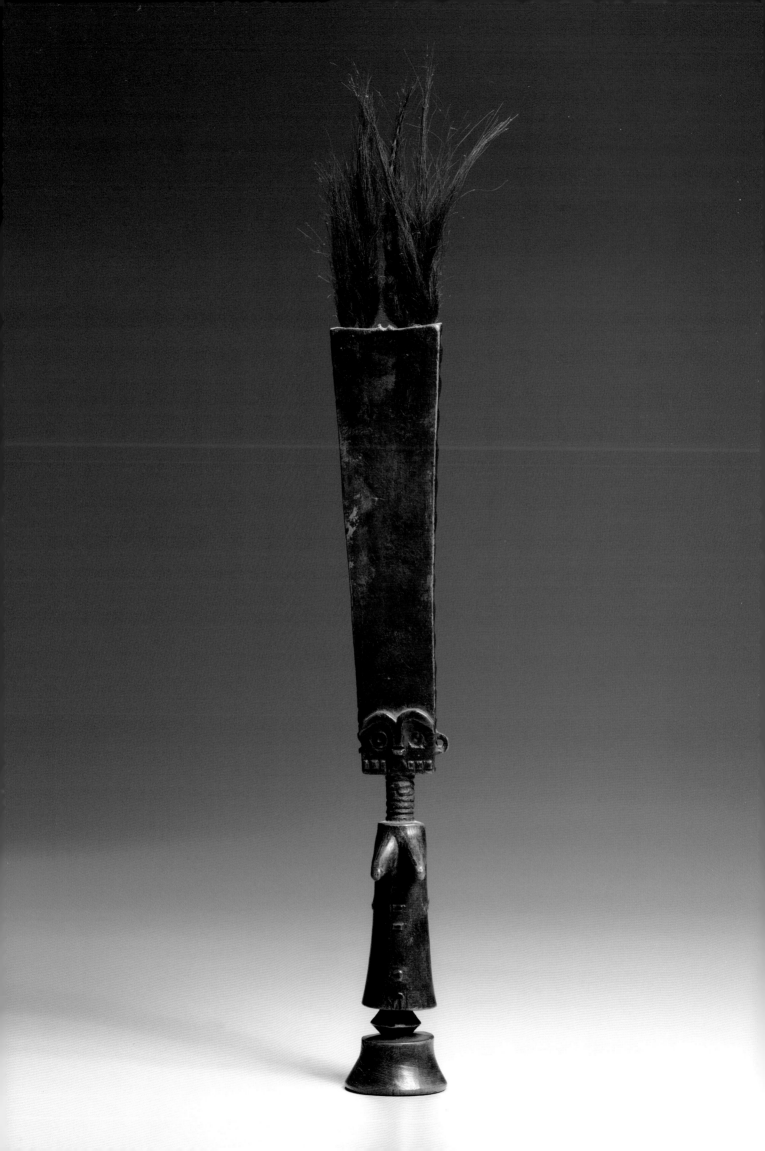

FEMALE FIGURE (*akua'ba*); POSSIBLY FANTE PEOPLE, GHANA

LATE 19TH TO EARLY 20TH CENTURY; WOOD, HAIR; HEIGHT 42.9 CM

GIFT OF KATHERINE C. WHITE 1975.158

Fig. 25. Asante *akua'mma* figures and other offerings in a public shrine to Tano, a river or water deity, near the town of Kumasi, Ghana, 1976. Photograph by Herbert M. Cole.

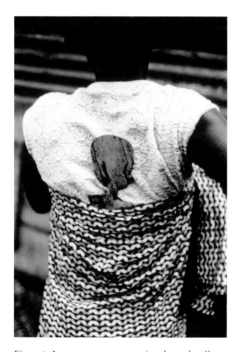

Fig. 26. Asante woman wearing her *akua'ba* wrapped on her back, Ghana, 1972. Photograph by Herbert M. Cole.

Found throughout the Akan area of West Africa, figures of this type with a rectangular-shaped head are thought to originate from the Fante region. While the Fante examples are usually left unpainted, most Asante figures are painted black. The stylization of the form may indicate that it is of some antiquity, since more modern examples are more naturalistically rendered. The shape of the head reflects the Akan ideal of female beauty, with a long neck and a high forehead, which in reality is achieved through gentle modeling of the baby's skull. The incised decorative pattern on the back of the figure's head possibly mimics a once popular hairstyle. Some designs may have had an apotropaic function, while others are merely decorative.

The name for these figures, *akua'ba* (pl. *akua'mma*), meaning "Akua's child," refers to a legend about a woman named Akua, who was experiencing difficulties conceiving a child (*ba*). To solve the problem, a priest advised her to commission a wood carving of a little child and treat it as if it were a living infant. With the aim to induce fertility or to ensure the birth of a healthy and beautiful daughter, Akua carried the carving on her back inside her wrapper, with only the head appearing above the cloth, just as she would later hold her real baby. When Akua became pregnant and gave birth to a daughter, other women who suffered the same problem followed her example. After the birth, the akua'mma figures are returned to the priest who places them on his shrine, or they are kept as heirlooms in the families that have benefited from them. Sometimes, they are even given to the child as a toy.

There are different explanations for the fact that most akua'mma figures are female. Some spokespersons have said it is because Akua's first child was a girl. Others refer to the desire of women to have female children to help with the work at home and on the farm. Still others have related it to the Akan system of matrilineal descent.

Further reading: Cole and Ross 1977, 103–7; Garrard 1989b, cat. 73; Ross 1996, 43–51.

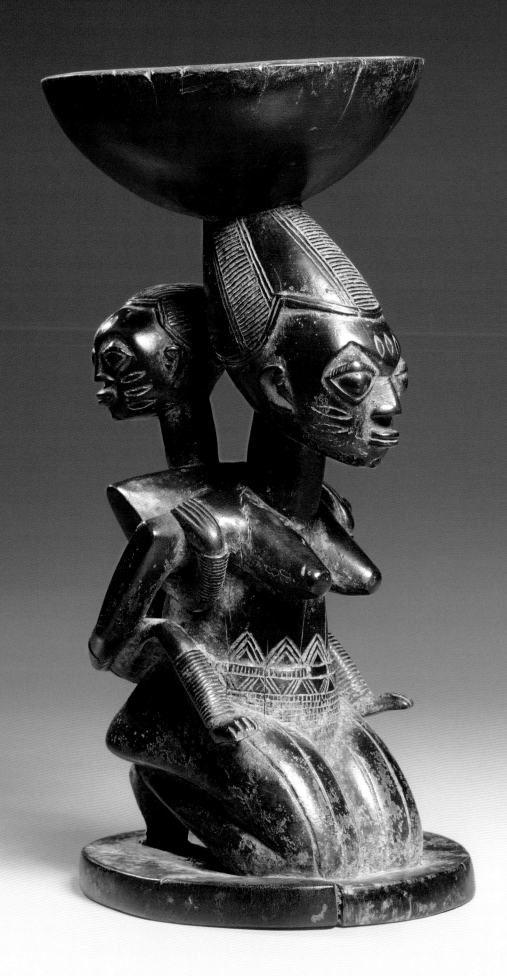

MOTHER–AND–CHILD CARYATID VESSEL (*agere ifa*); YORUBA PEOPLE, NIGERIA
MID TO LATE 19TH CENTURY; WOOD; HEIGHT 31.7 CM
LEONARD C. HANNA JR. FUND 1994.2

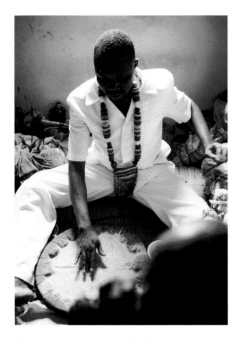

Fig. 27. *Babalawo* Kolawole Ositola beginning the divination ritual in the Porogun quarter of the town of Ijebu-Ode, Nigeria, 1982. Photograph by John Pemberton III.

The masterful design and composition of this caryatid vessel, carved in the style of the southern Ekiti region in northeast Yorubaland, establish an intimate relationship between the figure of the mother and her child. The mother represents a devotee who respectfully kneels before the gods. Just as in real life, she simultaneously adjusts the child on her back and concentrates on her religious action. Also strikingly realistic is the contrast between the mother's composed face and the child's distracted look off to the side, as if "fascinated by a buzzing fly or a dog scratching its ear," to use John Pemberton's words. The vessel on top of her head once held the sixteen sacred palm nuts (*ikin*) essential to divination rituals known as Ifa. The vessel identifies this figure as one of the implements of a diviner-priest (*babalawo*).

In order to gain insight into an individual's destiny or understand the cause of misfortune, objects such as this figure were used by Ifa priests as mediums to communicate with the god of fate, Orunmila. The two other main divination implements are a wooden or ivory tapper (*iroke*), used to initiate the session by invoking Orunmila, and a wooden board or tray (*opon ifa*) on which the diviner marks the responses of the god to the questions presented to him. The *agere* type of vessel has been identified as a miniature earthly temple of Orunmila, while the accomplished artistry of the carving, combining smooth forms and delicate surface detail, functions as a tribute to the god. Both the priests and their clients determine the iconographic and aesthetic features of a sculpture, and the varied forms supporting a vessel include both sacred and secular subjects. Reflecting the desire of the client who comes to the babalawo for divination, the maternity theme here most probably alludes to the hope to be blessed with the birth of a healthy child.

Further reading: Abiodun 1989, 109–12; Pemberton 1989, cat. 229; Walker 1999, cat. 44.

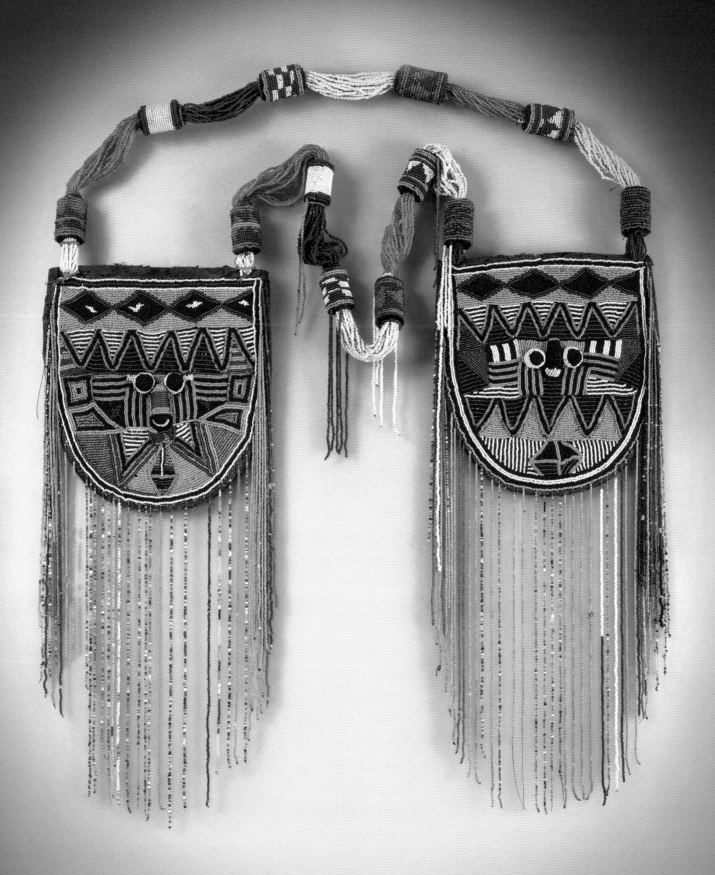

23

NECKLACE (*odigba ifa*); YORUBA PEOPLE, NIGERIA

20TH CENTURY; CLOTH, GLASS BEADS, WOOD, CARDBOARD; HEIGHT 49.5 CM

ANDREW R. AND MARTHA HOLDEN JENNINGS FUND 1995.23.1–2

The use of colorful glass beads, sometimes along with shells, underlines the high status diviners enjoy in Yoruba society and associates them with godly kingship. A wide range of colors and beaded forms connote vast spiritual knowledge. The diviner is the only person other than the king to have access to another royal substance—ivory. This material is used to make the small head that symbolizes the god Eshu (or Elegba), one of the diviner's most important accessories, and the tapper with which he invokes the deities. The fact that kings and diviners share the same or similar signs of rank and power confirms the idea that both ultimately derive their authority from the otherworld (*orun*).

An itinerant Yoruba diviner's regalia includes a beaded necklace with two beaded pouches. Substances sewn in the pouches protect him and ensure his power. The cylinders in the strap are made of a bead-covered piece of wood from a sacred tree that assures longevity and prosperity for the diviner and his family. It is no coincidence that, when worn, the pouches cover the chest and the base of the neck, two vulnerable body parts. Before being used in elaborate and dangerous Ifa initiations and annual festivals, the entire ensemble is washed and blessed through a sanctifying bath. The riches associated with the beads of many of the diviner's symbols of office also indicate that he has supernatural help.

The three dominant color groupings refer to temperature and temperament or character: *dudu* (black) and related colors are moderate tones mediating between the extremes of cold, which is associated with *funfun* (white) and related colors, and hot, which is associated with *pupa* (red) and related colors. In addition to adding luster and appeal to the divination session, the colors of their accessories indicate how diviners bridge and mediate the forces of the world of the living (*aye*) and the otherworld.

Further reading: Drewal and Mason 1998, 18, 24, 26, 228, 234–36.

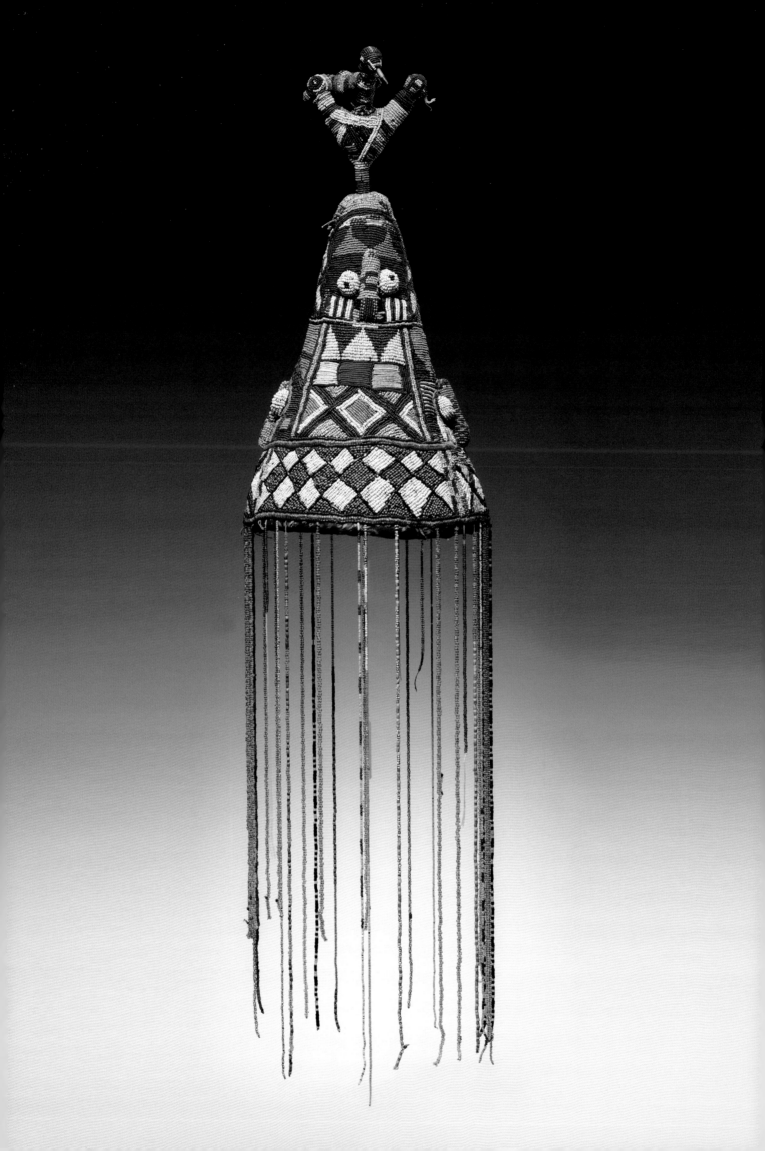

CROWN (*ade*); YORUBA PEOPLE, NIGERIA

20TH CENTURY; CLOTH, GLASS BEADS, BASKETRY, CARDBOARD, WOOD, FEATHER QUILLS; HEIGHT 105.9 CM

ANDREW R. AND MARTHA HOLDEN JENNINGS FUND 1995.22

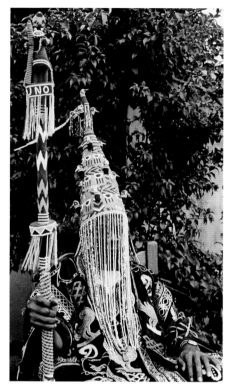

Fig. 28. The king wearing his beaded crown in the town of Ila-Orangun, Nigeria, 1977. Photograph by John Pemberton III.

O f all the king's regalia, the beaded cone-shaped crown with a fringe of colored glass beads is considered the most important. The form and materials of the crown attest to his divine nature and to his authority in both the natural and the supernatural worlds. The crown also emphasizes the king's *ori inu* (inner head) as the locus of an awesome life force, *ase;* as such, it can replace the king himself during his absence.

The birds surmounting the most prestigious crowns represent the royal bird Okin. While the abstract designs are purely ornamental, the faces depicted on the Cleveland crown could represent several figures: Oduduwa, the mythical founder and first king of the Yoruba; the actual visage of the king who wears the crown; or Obalufon, the god or *orisa* who according to Yoruba beliefs invented beads. Each of the deities is associated with a particular color. The beads underline the idea that the king is a member of all the cults honoring the different gods and link him with specific deities. In fact, the crown itself is viewed as an orisa.

Many rules and rituals accompany the making and consecration of a crown. After offering prayers to Ogun, the god of iron, gifts of snail fluid and a tortoise ensure the successful completion of the work. Before the crown is placed on the owner's head, the herbalist priest hides a packet of medicines in the top. The names associated with a crown signal the special power it embodies and the prestige of owning it. Such headdresses are worn on ceremonial and religious occasions, with the veil of beaded strings masking the identity of the wearer while protecting his subjects from the supernatural powers that radiate from his face.

Further reading: Thompson 1970, 8–10, 78; Wardwell 1989, 33–39.

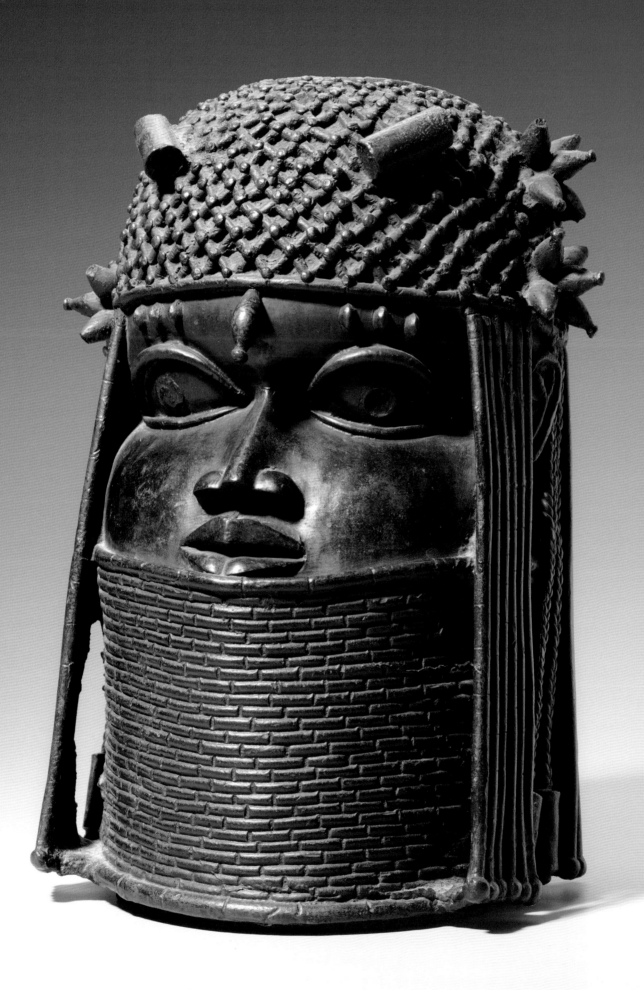

25

HEAD; EDO PEOPLE, BENIN KINGDOM, NIGERIA

MID 16TH OR EARLY 17TH CENTURY; BRASS; HEIGHT 29.9 CM

DUDLEY P. ALLEN FUND 1938.6

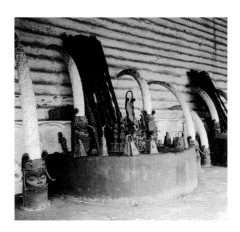

Fig. 29. Ancestral altar to the *oba*
Ovonramwen in Benin City, Nigeria, 1970.
Photograph by Eliot Elisofon.

Metal arts flourished in the Benin kingdom from the fifteenth century until 1897, when the British sacked the royal palace and exiled the reigning *oba* (divine king) in retribution for the killing of British officials. After that date thousands of objects in metal, ivory, and wood were shipped to London and later ended up in various public and private collections in Europe and the Americas. The majority of the so-called Benin bronzes are in fact brasses, made of an alloy of copper and zinc, and the Cleveland cast-metal head was made using the lost-wax method. It depicts the divine oba cloaked in a ritual headdress and collar of red coral beads. Testifying to the early contacts between the Benin kingdom and Europe, these beads were imported from the Mediterranean and only the king was allowed to wear them. Beads indicate wealth and status, and the red color served to keep evil at bay.

Heads like this one were ordered by every new oba as centerpieces for the ancestral altar in honor of his deceased predecessor. The altar commemorating the king's ancestors and glorifying the power of the kingdom was a raised earthen platform on which were displayed a wide variety of objects, such as carved ivory tusks and metal swords and bells. The memorial heads are not real portraits, but rather standardized representations meant to celebrate royal insignia. The choice to focus on this part of the body is dictated by the importance accorded to the head as seat of intelligence, willpower, character, and the senses. The Cleveland head has tentatively been dated to the mid sixteenth or early seventeenth century on stylistic grounds, and related to an intermediate or "classical" period. From that time on, altar heads were conceived to support carved ivory tusks. In recent years the chronology of the arts of Benin has been seriously questioned, however, and most of the proposed dates have not been corroborated by scientific analysis.

Further reading: Ben-Amos 1995, 52–58, 80–92; Duchâteau 1990, 33–38, 58–63, 66–72; Duchâteau 1994, 58–63, 66–72; Eisenhofer 2000, 30–34, 42–45; Willett 1999, 44–46.

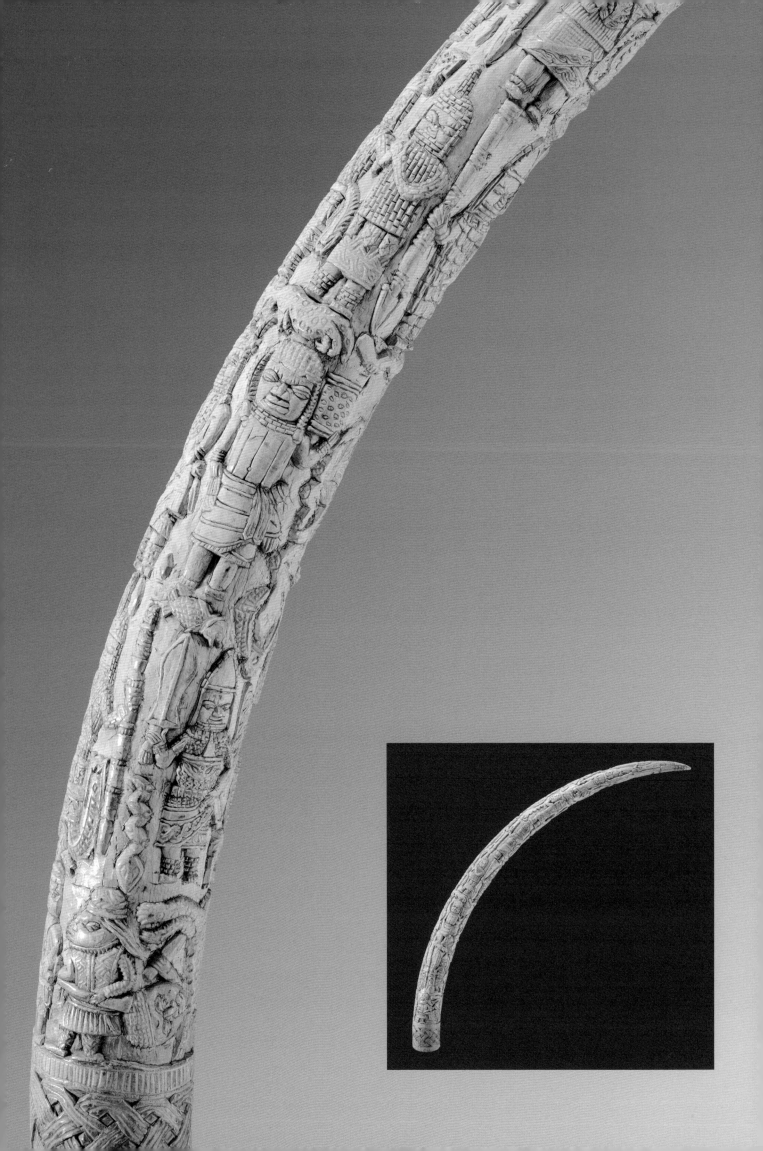

CARVED TUSK; EDO PEOPLE, BENIN KINGDOM, NIGERIA

AROUND 1820; IVORY; HEIGHT 197.4 CM

GIFT OF KATHERINE C. WHITE 1968.284

U p to this day, every male leader of an extended family in the Benin kingdom maintains an altar dedicated to his patrilineal ancestors. Ancestral altars are the focus of rituals in which past rulers are invoked and praised and blessings requested to ensure the well-being of the nation. The most important altars are in the palace of the oba, the divine king, who inherits supernatural powers from his predecessors. These altars consist of a clay platform built against a wall and are furnished with different objects of ceremonial significance, including elephant tusks covered with figural motifs like this example (see fig. 29). The Cleveland tusk belongs to a group with similar motifs, known as Set V, referring to the fifth group of tusks carved for the royal altar. The sequence started in the eighteenth century, making this tusk commissioned probably about 1820.

Within three years of his installation, a new oba commissions the highest ranking artists of the royal ivory carvers' guild to make a set of large elephant tusks. Motifs used to cover the surface are both inherited from previous generations and specific to the new reign. On the altars, the tusks are supported on brass memorial heads (see pl. 25), although this tusk was carved much later than the museum's head. Codifying ideals central to the religious and political organization of the Benin kingdom, the color of the ivory tusks alludes to a white kaolin clay extensively used for purification. Sometimes this substance is applied to tusks before major ceremonies to make them appear even whiter; with the same aim in mind, tusks are also cleaned and bleached with citrus juice. The characteristics of ivory—cool, white, and beautiful—also allude to the underwater court of Olokun, the deity of wealth, fertility, and the sea.

Because the tusks serve both statecraft and sanctity, the interpretation of the motifs on their surface is reserved first for members of the senior palace association. Full understanding of the designs is restricted to those groomed for leadership. Carved in parallel horizontal rows, they are interpreted from the bottom up. While each image has many simultaneous references, the motifs generally recall historical and mythological traditions associated with the kingdom. Those depicted on the Cleveland tusk and others in Set V refer to a civil war that temporarily unsettled the Benin kingdom after the premature death of a beloved ruler named Obanosa.

Further reading: Blackmun 1994, 88–97; Blackmun 1997, 149–52.

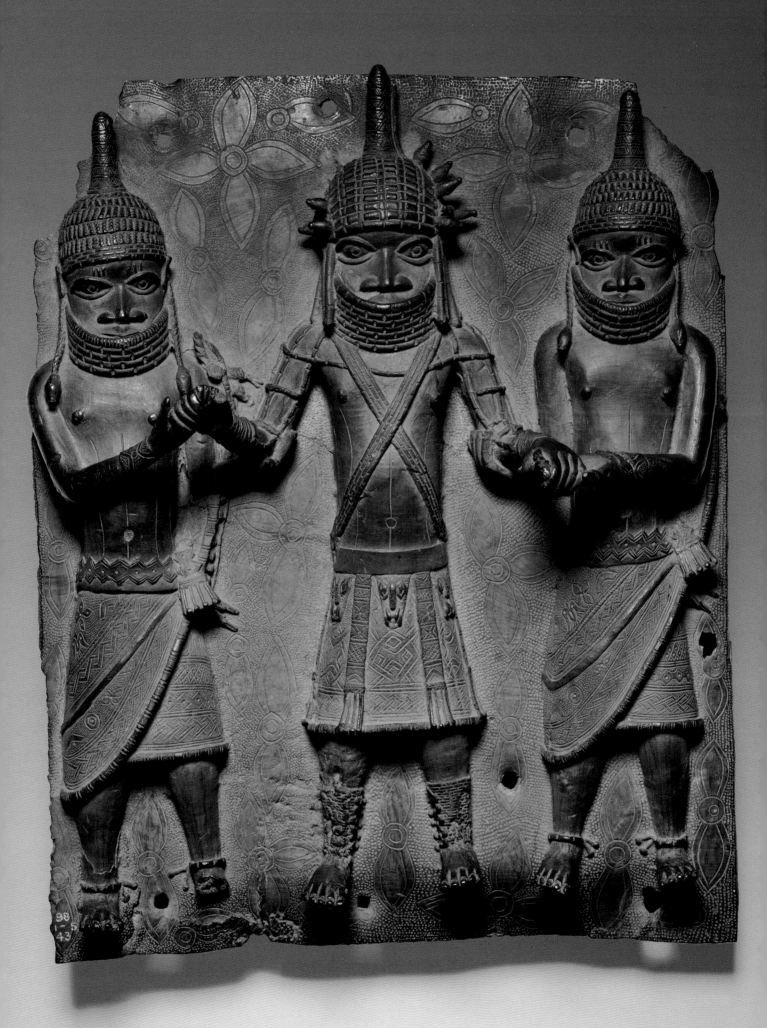

PLAQUE; EDO PEOPLE, BENIN KINGDOM, NIGERIA

POSSIBLY 16TH TO MID 17TH CENTURY; BRASS; HEIGHT 45.7 CM

JOHN L. SEVERANCE FUND 1999.1

B rass plaques with figures in high relief like this exquisite example were made to decorate the royal palace of the Benin king. Hundreds of such plaques once covered the wooden pillars of his palace courtyard. Using the lost-wax casting method, they were made by a guild of metal casters at the Benin court. Brass was traditionally considered a sacred medium and the exclusive property of the oba. Imported as a result of overseas trade with Europe, the metal was the ultimate sign of wealth and power. Yet the plaques are not mentioned in travel accounts after 1700, and in 1897, at the time of the British punitive expedition (see pl. 25), about 900 were found amassed in a palace storehouse.

Aside from displaying power and status, Benin art also served as a record of court life. Thus, most plaques also show one or more male figures, including nobles, officials, and the king himself, in court regalia and elaborate costumes. Typically, the plaques are entirely covered with imagery, with repeated incised quatrefoil leaves such as those depicted on this plaque as the preferred backdrop. Although the exact meaning of most scenes has been lost and whether this particular one reflects a ritual or ceremony cannot be confirmed, it seems unlikely to represent a historic event.

The central figure, wearing beaded anklets and wristlets, a coral-beaded collar, and a helmet with a tall protrusion, represents the oba. From the cloth at his waist hang three crocodile-head pendants. The crocodile symbolizes Olokun, god of the sea and wealth, and indicates the oba's power over life and death. In fact, Olokun is also invoked in the decorative quatrefoil motif, which suggests leaves of certain water plants used by Olokun priestesses in healing rituals. Judging from their attire, the two attendants flanking the king and supporting his arms probably represent noblemen or even priests. Because any accident that occurs to him would have an effect on the kingdom as a whole, the supporters must prevent the ruler from falling. Just as in real life, the focus of attention in the scene is entirely on the divine king.

Further reading: Ben-Amos 1995, 29–41; Duchâteau 1990, 72–82; Duchâteau 1994, 72–82; Willett 1997, 32–33; Willett 1999, 43–44.

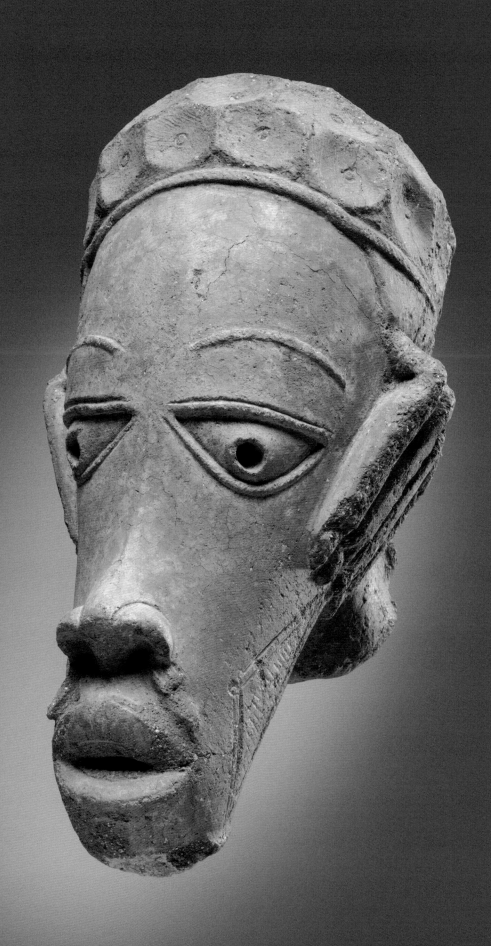

HEAD; NOK REGION, NIGERIA

AROUND 600 BC TO AD 250; TERRACOTTA; HEIGHT 38.2 CM

ANDREW R. AND MARTHA HOLDEN JENNINGS FUND 1995.21

Nok is the name of a town on the Jos Plateau in central Nigeria where fragments of terracotta sculptures were found in 1928. Many more fragments and intact figures, both animal and human, as well as heads have come to light in subsequent years. While sharing the same style, called Nok after the site where the discovery was made, a number of the findings show a striking variety. Although many are realistic in appearance, some stylized sculptures are known as well. Scholars have identified a number of stylistic subdivisions. The Cleveland head is an excellent example of the style of Katsina Ala, from the southeastern portion of the Nok civilization's distribution area.

The culture these terracotta works represent once occupied a vast territory along both sides of the Benue River, an area today inhabited by various ethnic groups. Most of the terracottas were found in open tin mines, but some were discovered in riverbeds or under the roots of trees. Radiocarbon and thermoluminescence dating methods have revealed that the sculptures were made between 600 BC and AD 250. Because some terracottas were encountered in association with stone and iron objects, the Nok civilization is considered to be the oldest Iron Age culture of sub-Saharan Africa.

Probably a fragment of an almost life-size male seated figure, the Cleveland head is exceptionally large and has detailed facial features. It is remarkably well preserved, its glossy surface largely intact. It was shaped by hand from a coarse-grained clay, covered with slip, and then burnished. The production of terracottas of this size was a challenging enterprise, requiring sophisticated technical skill. The identity of the portrayed figures remains unknown, but the adornments and elaborate hairstyles and headdresses of many of the larger figures seem to indicate that they represent notables or even leaders. Although the use and function of terracottas such as the Cleveland head is equally uncertain, some scholars have suggested they served ritual purposes and may have been part of a shrine or temple, or even placed on a tomb.

Further reading: Eyo 2000, 114–18; Willett 1997, 25–26, cat. 1.

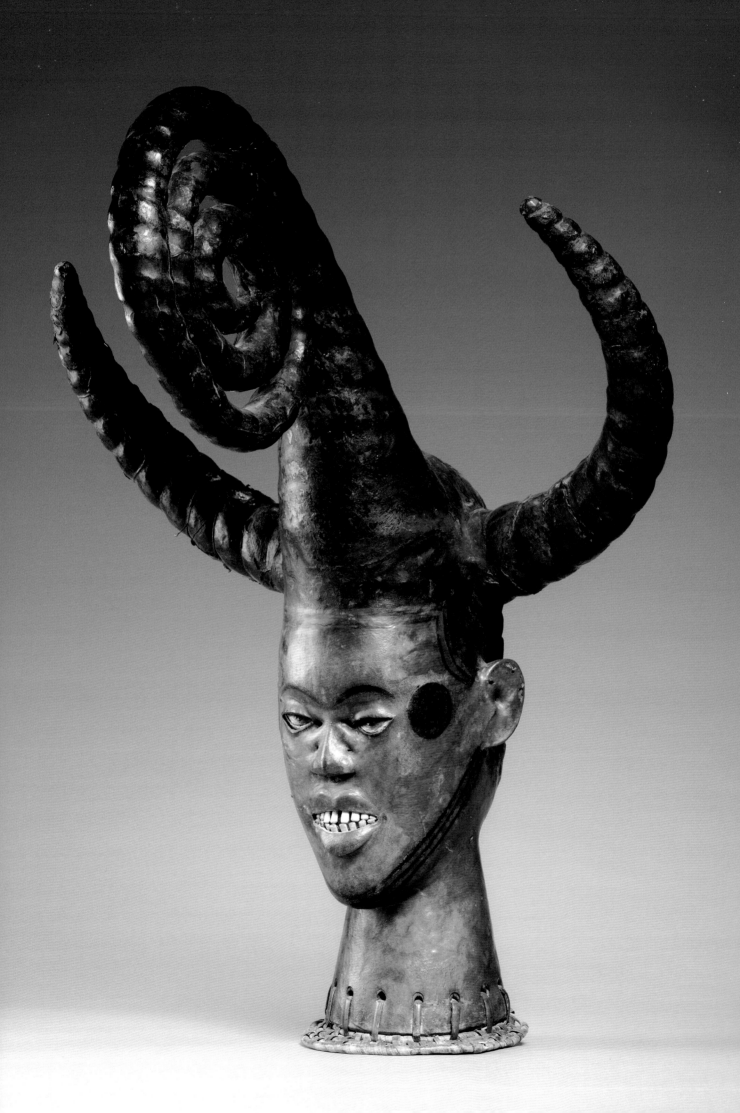

29

HEADDRESS; EJAGHAM PEOPLE, NIGERIA

LATE 19TH TO EARLY 20TH CENTURY; WOOD, ANTELOPE SKIN, BONE, BASKETRY,

CANE; HEIGHT 67.3 CM

ANDREW R. AND MARTHA HOLDEN JENNINGS FUND 1990.23

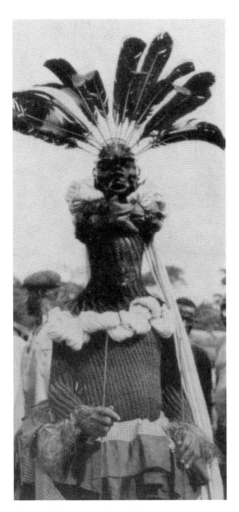

Fig. 30. Skin-covered headdress masquerader of the Leopard society in the Cross River region (possibly Ejagham people), Nigeria, 1907–12. Photograph by P. Amaury Talbot.

Skin-covered cap or crest masks, made of fresh, uncured antelope skin stretched over a softwood carved head, are a distinctive naturalistic art form of the Cross River region in the southeastern part of Nigeria and western Cameroon. This realistic headdress depicts a woman's head with a long neck, rounded facial features, realistically rendered teeth of strips of cane, and a faithful imitation of a horned coiffure. The wickerwork skullcap at the base of the neck would have been secured on the masquerader's head by a string under his chin, and his body entirely covered by a long gown. That such headdresses were originally covered with human skin is not impossible given that they are said to represent heads of enemies killed during wars, and thus attest to their owners' exceptional powers.

The style of the Cleveland headdress is characteristic of the lower Cross River region, in or around the town of Calabar in Nigeria. Skin-covered headdresses were indeed used in different secret societies of the region among various peoples. The elaborate hairstyle with curving "horns" and the head's facial features indicate that this headdress was most probably worn by a woman in the context of the Ekpa, a society of Ejagham women that was responsible for the education of the girls in preparation for marriage. The headdress could represent a girl who embodies ideal female beauty and is ready for marriage. The hairstyle depicted was actually worn during the coming-out ceremony following the girls' seclusion in the "fattening house."

In a striking example of the African diaspora to the New World, the culture of the Ejagham and their Efut and Efik neighbors is closely related to that of the male Abakua society in northwestern Cuba. The elders of this Abakua society consider skin a charm that allows the capture and control of the spirits of the dead.

Further reading: Eyo 1981, cat. 98; Eyo 1989, cat. 90; Nicklin 1981, cat. 99; Nicklin 1996, cats. 66, 67; Röschenthaler 1998, 45–48; Thompson 1981, cat. 104.

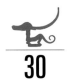

MALE FIGURE; BANGWA PEOPLE, CAMEROON

ATTRIBUTED TO ATEU ATSA

LATE 19TH TO EARLY 20TH CENTURY; WOOD; HEIGHT 92.1 CM

PURCHASE FROM THE J. H. WADE FUND 1987.62

This figure, adorned with royal attire of cap, beaded necklace, folded loincloth, and drinking horn, belongs to a group of twenty-two stylistically related works that have tentatively been attributed to a sculptor named Ateu Atsa. His work is distinguished from that of his colleagues by its sense of realism and the attention devoted to the facial expression. Usually, however, the names of carvers are forgotten, and sculptures are attributed to the chiefs or kings who commissioned them.

Ateu Atsa, whose carving activity has been dated to between 1840 and 1910, served the Bangwa *fontem* (king or chief) Assunganyi. The Bangwa are organized in nine small kingdoms or chiefdoms that were established in the seventeenth or eighteenth century. Bangwa culture and art stand in between two dominant influences: the Bamileke of the savannah in the north and east, and the Ejagham of the Cross River region in the west. The Bangwa are especially well known for their commemorative chiefly or royal figure sculptures, such as the example shown here, which represent kings, queens, princesses, and certain high dignitaries.

Although figures such as the Cleveland example are generally identified as portraits, they do not literally resemble the chief or king they represent. These commemorative works are kept by members of a secret association called Lefem, who gather weekly in a sacred bush to discuss matters related to the survival of the kingdom and perform sacred music in honor of the royal ancestors. The figures are kept in shrines, where they are silent witnesses to the sacrifices made to the skulls of the chief's ancestor. Exhibited during funerals or royal cult ceremonies, these figures are believed to safeguard the kingdom and protect the fecundity of the people, the animal world, and the soil.

Further reading: Brain 1996, 170–71; Brain and Pollock 1971, 171–72; Harter 1990, 71–75; Lintig 2001, 98–109; Northern 1984, 84–87; Notué 2000, 141–42.

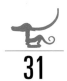

HELMET MASK; POSSIBLY KOM PEOPLE, CAMEROON
EARLY 20TH CENTURY; WOOD; HEIGHT 33 CM
GIFT OF MR. AND MRS. WILLIAM D. WIXOM IN MEMORY OF MR. AND MRS. RALPH
M. COE 1971.66

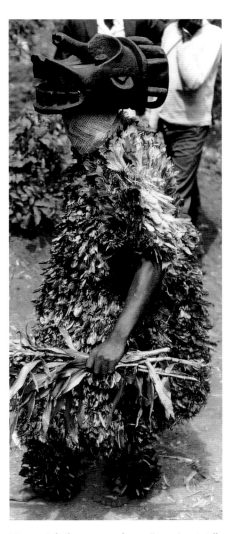

Fig. 31. *Nkieh* masquerader or "running *juju*" in the town of Oku, Cameroon, 1976. Photograph by Hans-Joachim Koloss.

Combining abstraction and naturalism in its shapes, and despite its simian characteristics, this mask represents a human with deliberately distorted and exaggerated facial features reflecting the awesome powers of a great chief. Although some spokespersons have identified the quadrupeds carved on the mask's head as chameleons, they most likely represent leopards, given the close conceptual association between this animal and the king. Throughout the Cameroon Grassfields the leopard icon is an important symbol of power and leadership.

Although this mask should most probably be attributed to the Kom people on stylistic grounds, the borrowing of motifs and stylistic traits between the Kom in the northern Grassfields and the Bangwa in the southern Grassfields makes it impossible to confirm such an attribution without additional collection data. Related masks have also been documented in the northern kingdom of Oku.

Among the different peoples of the Grassfields, masks are generally related to a regulatory society, which is variously called Kwifoyn, Kwifo(n), Ngwerong, Tifoa, and Ngumba. The agency of social control and law enforcement in the kingdom, these societies guard and maintain ancestral mores and values. They have wide-ranging responsibilities, including the pursuit of criminals and punishment of lesser transgressors. Using the anonymity of masks, society members carry out their tasks in the secrecy of the night. While the holes at the rim of this helmet mask might suggest that it was meant to be worn on the head, in more recent times this type of mask was carried in the arms or on the shoulders.

Further reading: Brain and Pollock 1971, 131–44; Koloss 2000, 236–39, 256–60; Northern 1984, 62–71.

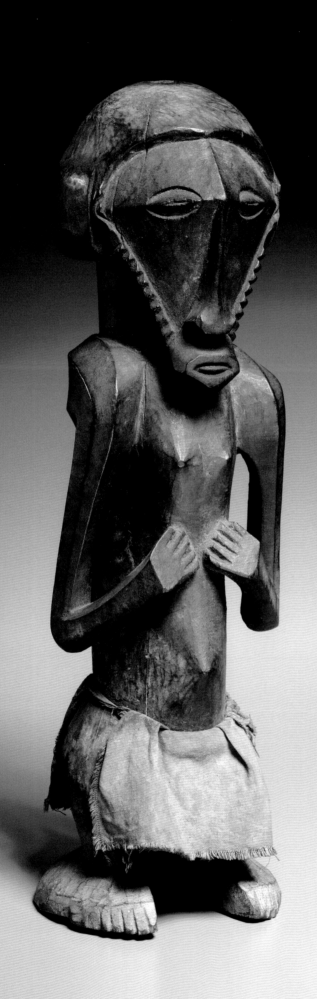

MALE FIGURE; SO-CALLED PRE-BEMBE PEOPLE, DEMOCRATIC REPUBLIC OF THE
CONGO

LATE 19TH TO EARLY 20TH CENTURY; WOOD, CORD, CLOTH; HEIGHT 48.3 CM

GIFT OF KATHERINE C. WHITE 1969.10

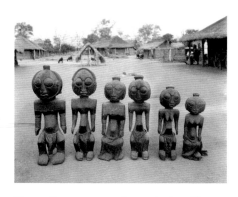

Fig. 32. Boyo ancestor figures in the village
of Kabambare, Democratic Republic of the
Congo, 1949. Photograph by Luc de Heusch.

The style of this male figure bridges the naturalistic and rounded
modes of the Luba people in the southeast and the more abstract
and angular designs of the Lega people in the northeast of the
Democratic Republic of the Congo. It is the work of a sculptor
of one of the so-called Pre-Bembe hunter groups. The Pre-Bembe
people include different groups, such as the Basikasingo, Bahutshwe,
and Babwari, and live dispersed among Bembe, the Boyo, and other
peoples near Lake Tanganyika. Figures such as this example have often
been misattributed to the Bembe proper. In fact, the Bembe as such
have never made or used any type of figure sculpture. While the Pre-
Bembe have been strongly influenced by the Bembe, the hunter groups
have preserved their cultural autonomy.

Standing Pre-Bembe figures, male or female, are used within the
framework of an ancestor cult and are dedicated to the founders of
small political groupings. They are usually kept in a shrine with a
number of stylistically related figures that represent named and
genealogically related ancestors. Such ensembles serve as intermediaries
between the ancestors and their living descendants. At times of crisis,
the custodian of the shrine, who is often the village headman, spends
the night very near the images and invokes and brings offerings to the
ancestors in exchange for their support.

Similar practices of ancestor worship have been recorded among
the neighboring and closely related Boyo (fig. 32). Among the Boyo, a
figure's size indicates chronological sequence, with the largest in an
ensemble being the oldest, depicting founding ancestors. These central
figures served as models or prototypes for the other, smaller figures,
which represented successive generations of chiefs. Often made by
different generations of carvers, the later figures were not strict copies
but show significant stylistic differences.

Further reading: Biebuyck 1981, 31–44; Zangrie 1947–50, 72–77.

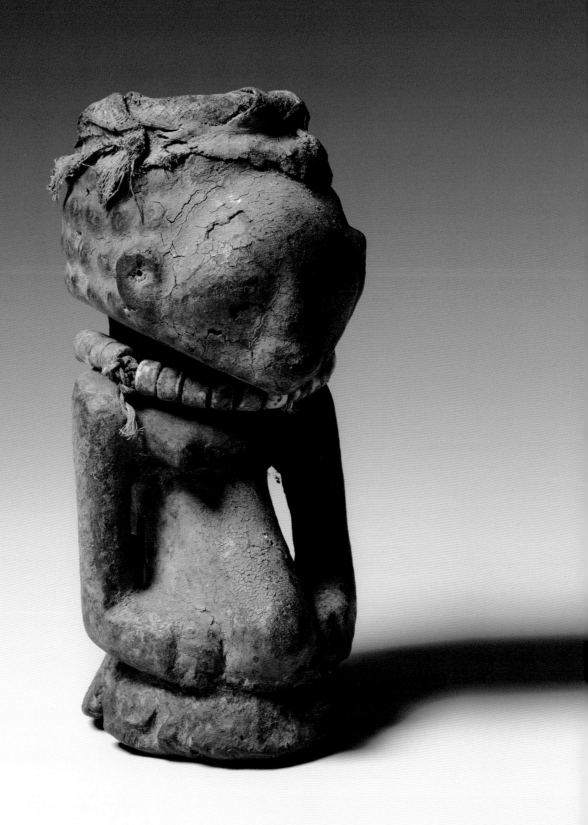

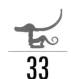

HALF FIGURE; LUBA PEOPLE, DEMOCRATIC REPUBLIC OF THE CONGO

LATE 19TH TO EARLY 20TH CENTURY; WOOD, CLOTH, BEADS; HEIGHT 27.3 CM

GIFT OF MR. AND MRS. ALVIN N. HAAS 1974.212

Public and private collections in the West contain some magnificent examples of figurative and sculptural Luba royal art forms, which are characterized by smooth and polished surfaces and a high degree of naturalism in anatomical and decorative details. Scholars and collectors have always been fascinated by the refined culture of the Luba kingdom and its prestigious political insignia, but little attention has been devoted to nonroyal Luba art forms. The Cleveland half figure is a striking example of this neglected tradition, which is represented in European and American collections by only a few objects. It may have been made in part of the vast area occupied by the Luba people that was only remotely related to the royal court.

Although little is known about plebian Luba art traditions, the red color, the crusty surface, and the substances still contained in its cloth-covered cranial cavity indicate that the Cleveland figure belongs to the broad category of power objects. Generically called *bankishi* (sing. *nkishi*), such figures were used by ritual experts in a variety of contexts, including healing, protection, divination, or jurisdiction. These power objects remain empty and meaningless without special medicinal substances (ingredients such as hair or pulverized fragments of human bones) that are believed to possess rare and enhanced life powers. Through these substances the ritual specialist invites the appropriate spirit to inhabit the receptacle, which can subsequently be used to assist with certain tasks. Some Luba figures indeed bear the name of this inhabiting spirit. Because they were often carved by ritual experts rather than by professional artists, many of these sculptures have a crude look and finish. Yet the Cleveland figure seems to have a detailed and finely carved form hidden under its surface.

Further reading: Neyt 1993, 138–66; Nooter 1992, 79–81; Petit 1996, 117–22; Roberts and Roberts 1996, 177–208.

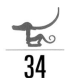

COMB; CHOKWE PEOPLE, ANGOLA OR DEMOCRATIC REPUBLIC OF THE CONGO
MID TO LATE 19TH CENTURY; WOOD, BEADS; HEIGHT 13.3 CM
THE HAROLD T. CLARK EDUCATIONAL EXTENSION FUND 1915.453

Among the peoples of Central Africa, the Chokwe are perhaps the most renowned producers of combs and hairpins in wood and ivory with animal or human decorations. They and some neighboring peoples of Angola, the Democratic Republic of the Congo, and Zambia accord great importance to hair decorations and hairstyles. Some coiffures reflect a sense of ethnic identity, while others reveal regional and temporal fashions and trends. Only chiefs or dignitaries can wear specific styles, as well as crowns, headdresses, and diadems. In combining braids, tresses, lobes, and wings, coiffures sometimes become real sculptural forms, and inserting a variety of implements in the hair greatly adds to this effect. A well-groomed hairstyle is not only a sign of beauty and a healthy body, it also suggests that the wearer can rely on the help of a friend or a family member in its creation.

This wooden comb was one of the Cleveland Museum of Art's first African acquisitions. It testifies to the Chokwe's preference for portraying animals. The birds depicted are most likely white-bellied storks, an important species in certain Chokwe myths and oral traditions that can be found on many objects. Women wear finely ornamented combs and hairpins—often together—in their hair to indicate rank and wealth. In fact, both the materials from which it is made and its elaborate shapes and decoration contribute to a comb's function as a status symbol. The beaded strings around the birds' necks that have been preserved on the Cleveland comb reinforce these ideas of prestige. In other cases, the wooden or ivory sculpture is embellished with metal tacks, shells, or strips of cloth. Treasures such as this comb were handed down from generation to generation as a lasting memorial to their first owner.

Further reading: Jordán 2000, 135–39.

HELMET MASK (*bwoom*); KUBA PEOPLE, DEMOCRATIC REPUBLIC OF THE CONGO
MID TO LATE 19TH CENTURY; WOOD; HEIGHT 43.3 CM
JAMES ALBERT FORD MEMORIAL FUND 1935.304

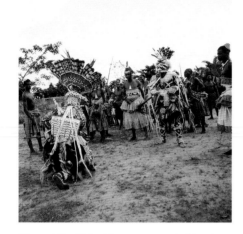

Fig. 33. The Kuba king accompanied by the *moshambwooy* and *bwoom* masqueraders in the village of Nsheng, Democratic Republic of the Congo, 1980. Photograph by Angelo Turconi.

Among the Kuba people, a name that in fact covers a confederation of eighteen different but related groups, masks represent nature spirits, *mingesh,* that act as intermediaries between the Upper Being and human society. Among the Bushoong, the central Kuba group, a wooden helmet mask like this example, called *bwoom,* forms a triad with a wooden female face mask called *ngaady amwaash* and a helmet mask not made of wood called *moshambwooy.* All three masks are related to the kingdom and are protagonists in the re-enactment of a myth about the origins of the Kuba. In this performance, moshambwooy is worn exclusively by the king himself. Bwoom, however, is also made and used in many stylistic variations by other Kuba groups outside the Bushoong capital. In these cases, it may carry the name *bongo* instead of bwoom, and appear in contexts other than the royal court, such as the men's initiation society.

While bwoom is generally considered to be the oldest of the three royal characters, the painted and relatively sober surface decoration of the Cleveland mask, along with its early acquisition date, might indicate that it is one of the oldest preserved examples of its type in the West. Yet, while more recent bwoom masks are lavishly decorated with beads, shells, and metal sheeting, some scholars believe undecorated masks to have been made and used outside the capital and thus argue that decoration is not necessarily an indication of age. Different identities have been ascribed to bwoom, with its bulbous forehead and large triangular nose: a Pygmy, a commoner, a hydrocephalous prince, or a rebellious individual. The male dancer who wears this headpiece, along with a specific body costume made of cloth and decorated with shells and beads, looks through the large holes under the nostrils rather than through the carving's eyes. With the help of a cord that he holds in his mouth, the masquerader balances the sculpture diagonally on his head. When not danced, the mask is carefully preserved by its owner as a symbol of the continuity of his family.

Further reading: Cornet 1993, 132–38; Vansina 1989, cat. 162.

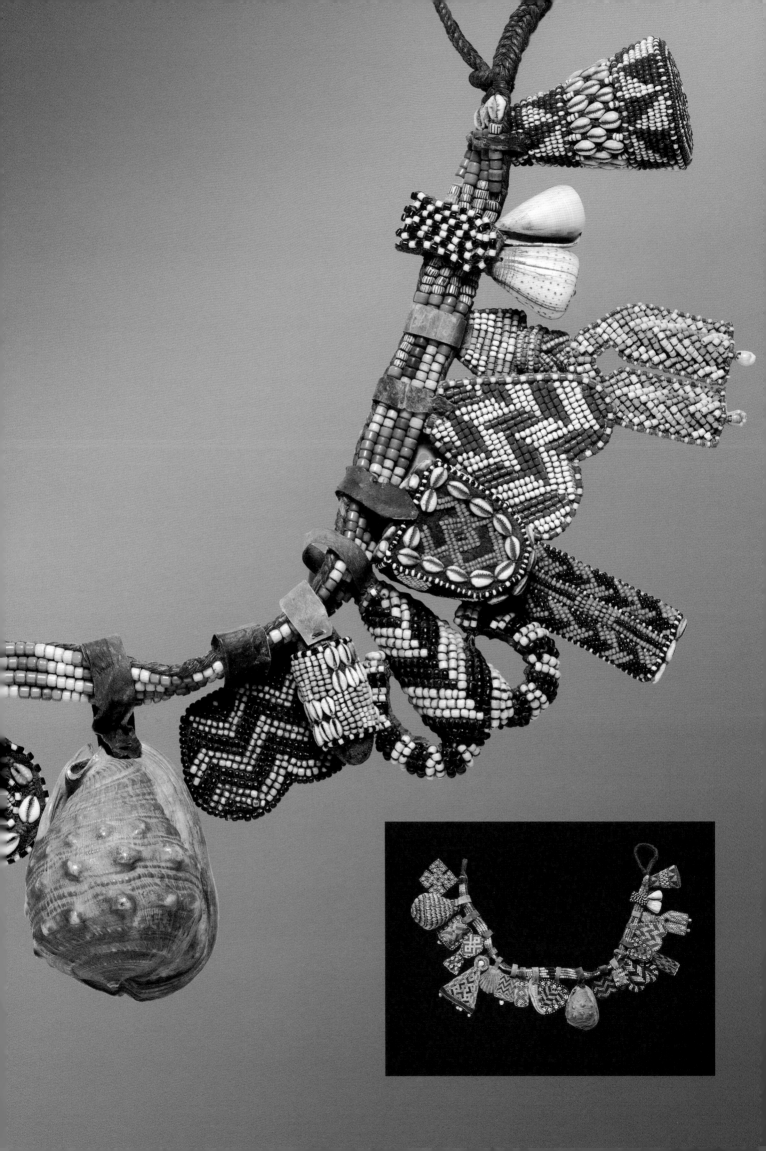

36

BELT (*yet*); KUBA PEOPLE, DEMOCRATIC REPUBLIC OF THE CONGO

POSSIBLY EARLY 20TH CENTURY; CORD, CLOTH, HIDE, GLASS BEADS, SHELLS;

LENGTH 139.5 CM

JOHN L. SEVERANCE FUND 1994.87

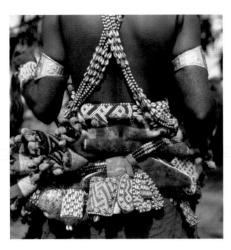

Fig. 34. Notable wearing his *yet* in the village of Nsheng, Democratic Republic of the Congo, 1980. Photograph by Angelo Turconi.

The Kuba people have impressed many a visitor with a wide range of elaborately made costumes and other attire. The most lavishly decorated items are exclusively reserved for the king, his family, and his immediate surroundings. In fact, the hierarchical organization of the Kuba kingdom is directly reflected in the different types of costumes and hats. In addition to indicating rank and status, dress adds significantly to a person's beauty. In the past, the king commissioned his wardrobe from a specialized guild of tailors, and the majority of the costumes and accessories he accumulated over the years were said to have been buried with him.

Belts are one of many accessories that accompany a wrapper. The Cleveland belt is a rare example of a *yet,* one of the most spectacular of the different types of Kuba belts. Only male or female members of the royal family are permitted to wear it, and the king himself displays it on the day following his installation. The pendants strung on the beaded strips of the belt comprise large shells of different kinds, which reached Kubaland via long-distance trade, as well as miniature imitations in beadwork and shellwork of a wide range of objects. These items include replicas of a type of shell (*iyul*), a double and single bell (*nkop* and *mwaang'l,* respectively), the fruit of a raffia tree (*lakol*), and a small adze (*ishu*). Most of these elements are merely decorative, but some such as the double bell have symbolic meaning. The stylized beaded ram's head pendant is also emblematic, for sheep are seen as a royal prerogative among the Kuba, and the king used to own two or three flocks. Forceful, dominant, and fertile, the ram is an appropriate visual metaphor of kingship. Given the subtle differences in manufacture and wear, some of the ornaments may have been replaced over time.

Further reading: Cornet 1982, 181–82, 204–7.

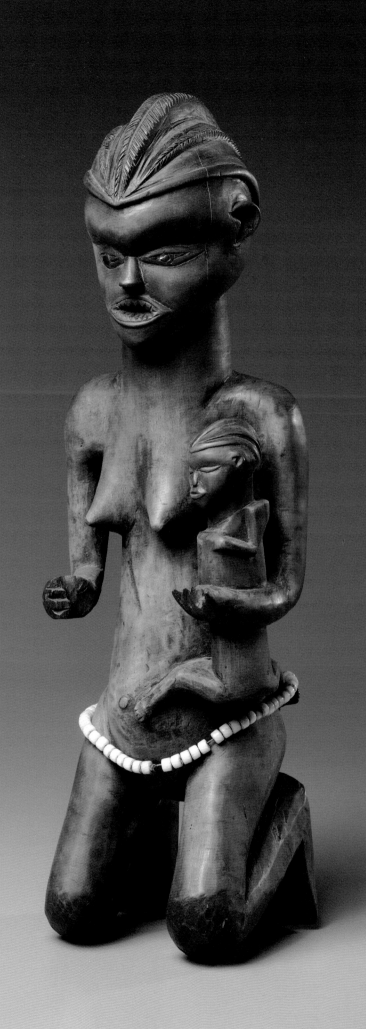

MOTHER–AND–CHILD FIGURE; POSSIBLY KWILU PENDE PEOPLE, DEMOCRATIC
REPUBLIC OF THE CONGO

LATE 19TH TO EARLY 20TH CENTURY; WOOD, GLASS BEADS, METAL; HEIGHT 53.4 CM

GIFT OF THE AFRICAN ART SPONSORS OF KARAMU HOUSE 1931.426

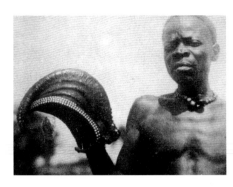

Fig. 35. Mbala chief holding his Kwilu Pende
made *mukoto* wig, Democratic Republic of
the Congo, 1930. Photograph by Paul Hoet.

Holding her child on her hip, wearing an elaborate headdress and a beaded belt, and having filed teeth and red-powdered skin, this maternity figure has been attributed to the Mbala people ever since it entered the museum's collection. However, no field documents exist to support this attribution, and both the figure's style and its iconography suggest it may be the work of an artist of the Kwilu Pende people. According to some firsthand sources, the *mukoto* lobed headdress frequently considered the hallmark of Mbala sculpture was apparently most often commissioned by the Mbala from their Kwilu Pende neighbors.

The Kwilu Pende, who live in a mixed ethnic region between the Lutshima and Kwilu Rivers in southwestern Congo, constitute one of the three major Pende cultural groups, along with the Central and the Eastern Pende. The mother-and-child theme was especially popular as a rooftop sculpture for the chief's ritual house among the Eastern Pende in the 1950s. Just as a number of Eastern Pende maternity figures, the Cleveland figure seems to have once carried in its hands an ax and a cup, the two most important chiefly attributes. Research indicates, however, that most of the ritual houses among the Kwilu Pende merely had a rooftop head. The pristine and polished surface of this mother-and-child figure, and the fact that it lacks the integrated sculptured base by which it would have been anchored to the rooftop, make it very unlikely that it served as a rooftop sculpture. Alternatively, the figure may have been placed in a small shrine, called *nganda,* that was the focus of the ancestor cult. As such, it would have belonged to the category of *mahamba,* beneficial objects that facilitate communication with the dead. It is also possible that the Cleveland maternity figure was secretly kept inside the ritual house and served as a guardian of the chief's treasure, perhaps together with a male counterpart.

Further reading: Petridis 2002, 134–36; Sousberghe 1959, 121–28, 143–51.

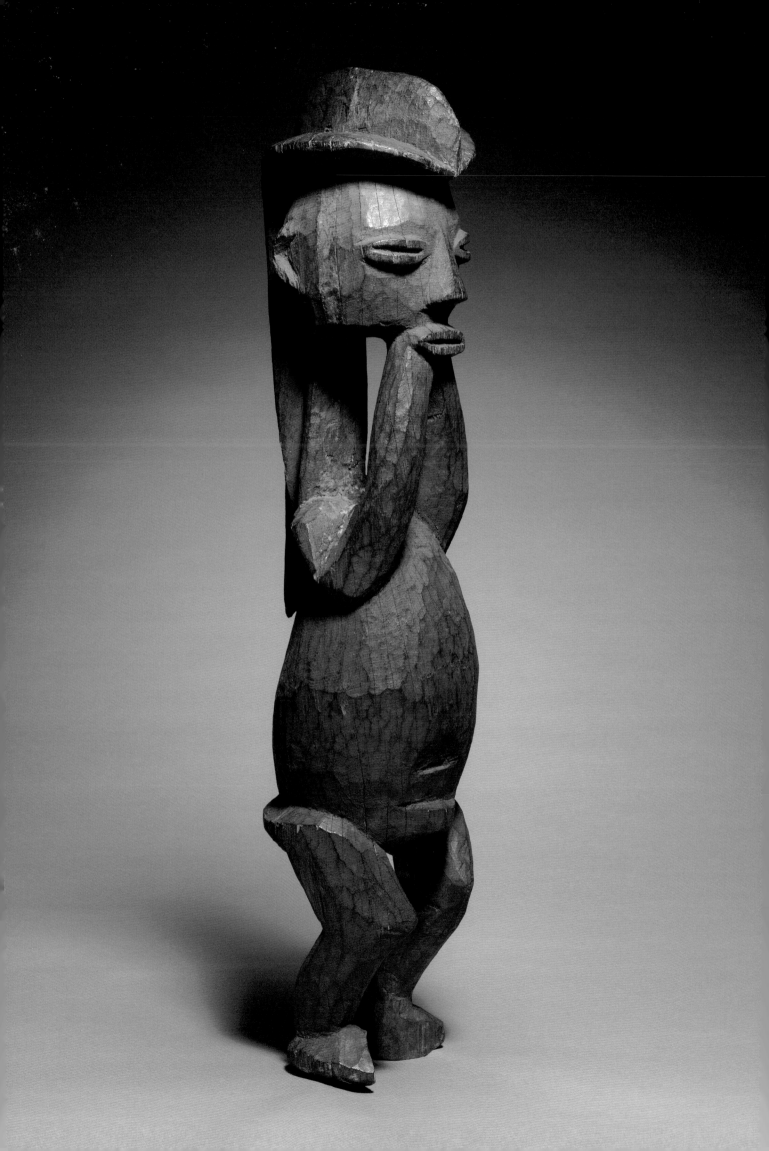

FIGURE; HUNGAAN PEOPLE, DEMOCRATIC REPUBLIC OF THE CONGO

MID TO LATE 19TH CENTURY; WOOD; HEIGHT 68 CM

ANDREW R. AND MARTHA HOLDEN JENNINGS FUND 2003.36

Hungaan figurative sculpture was generally used by ritual experts for healing, protection, and divination. In order to learn how to address certain problems, ritual experts had to undergo a prescribed initiation. They would have worked closely with chiefs, jointly managing the carvings to promote the fertility and well-being of their communities. Often, these sculptures were assembled in a shrine marked and protected by one or more larger figures that were placed on an exterior platform. The Cleveland carving may be such a guardian figure. Originally, these sculptures were accompanied by a bundle of powerful substances or other accessories. One famous example in the Berlin Museum of Ethnology holds ten miniature figures, an animal horn, and a wooden bell suspended by a cord tied around its neck. The tradition of carving figures of this style and size, which are extremely rare in Western collections, apparently came to an end in the late nineteenth century.

One of the most striking formal features of Hungaan figurative sculpture is the rendering of a crested coiffure imitating either a real headdress or a wig. This hairstyle, which is reflected in different artistic traditions and indicates high status, is common to many peoples in the Kwango-Kwilu region (see pl. 37). The Cleveland figure's remarkably intact red powdery surface probably mimics a body adornment consisting of a mixture of ground camwood and palm oil. The pose, chin supported in hands, is typical of the arts of many neighboring peoples in southwestern Congo and has been interpreted as that of a chief or other dignitary immersed in thought.

Further reading: Biebuyck 1985, 153–59.

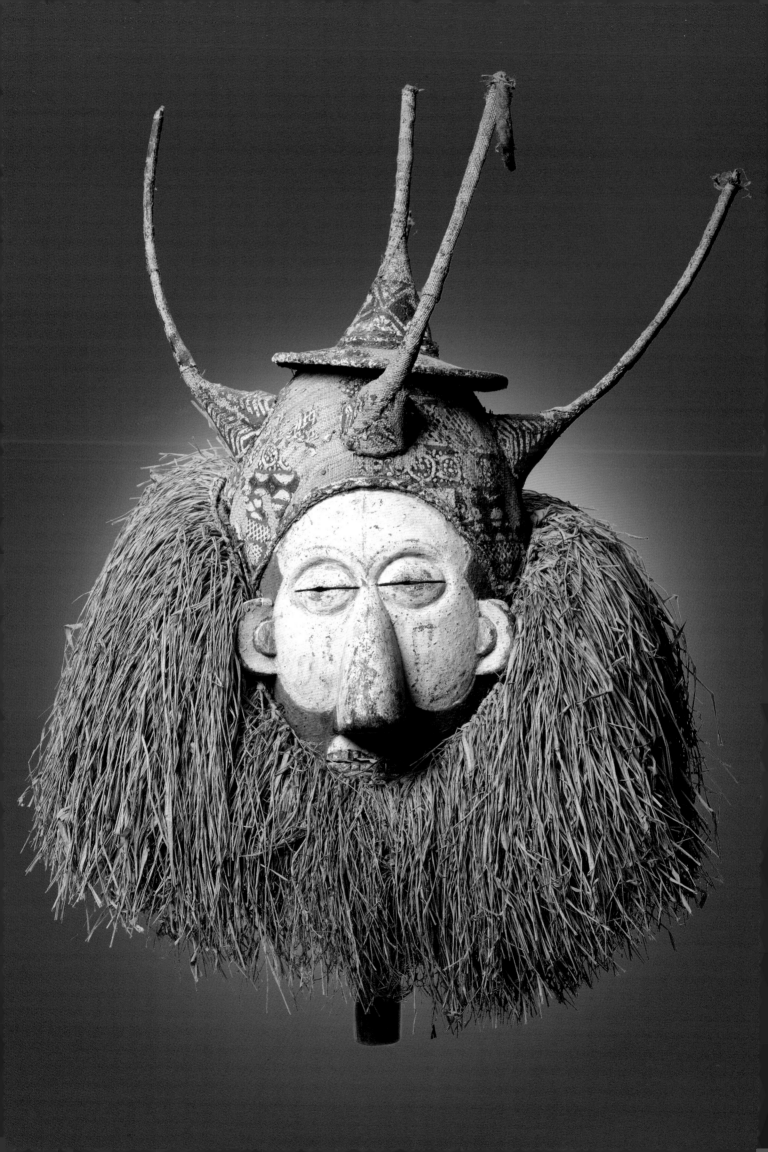

39

MASK (*tsekedi, myondo,* OR *ndeemba*); YAKA PEOPLE, DEMOCRATIC REPUBLIC OF THE CONGO

EARLY 20TH CENTURY; WOOD, CLOTH, RAFFIA FIBERS; HEIGHT 47 CM

GIFT OF KATHERINE C. WHITE 1969.8

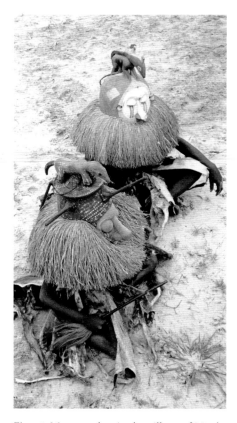

Fig. 36. Masqueraders in the village of Muela Buanda, Democratic Republic of the Congo, 1951. Photograph by Eliot Elisofon.

This mask combines carved and constructed elements, suggesting the high degree of artistic license Yaka carvers enjoyed. Probably originating from the northern part of Yakaland, it is part of a series of eight masks that appears at the end of the adolescent boys' circumcision and puberty ritual called *n-khanda.* On this occasion dances are organized to mark the boys' new status and celebrate their reintegration into the village. Embodying the ancestors who founded the ritual, masks are worn by the master of the initiation or by the newly initiated themselves. As a rule, at the end of the ceremonies, the initiation camp and the masks are burned or sold.

The Cleveland mask possibly represents one of the three masks of lesser rank that follow the appearance of *kambaandzya,* the most important mask of the series, although it is impossible to confirm this identification without data derived from firsthand field observations. Called *tsekedi, myondo,* and *ndeemba,* these masks have bulging eyes, a prominent and sometimes upturned nose, and a gaping mouth with bared teeth. They appear in pairs, held in front of each dancer's face by a handle carved from the same piece of wood. The coiffures derive from traditional headdresses and hairstyles worn by Yaka notables. Either dome- or cone-shaped and sometimes flanked by antennae-like projections, they consist of a woven raffia or cotton cloth stretched over a wooden armature that is covered with resin and brightly painted with geometric designs. The carved faces as such are also highlighted in red, orange, and/or blue. The masks' form and iconography refer to complex ideas of cosmogony and human sexuality. Ultimately, masks function as portable charms meant to assure and protect the future fertility of the young males.

Further reading: Bourgeois 1984, 125–35; Bourgeois 1985, 16–18.

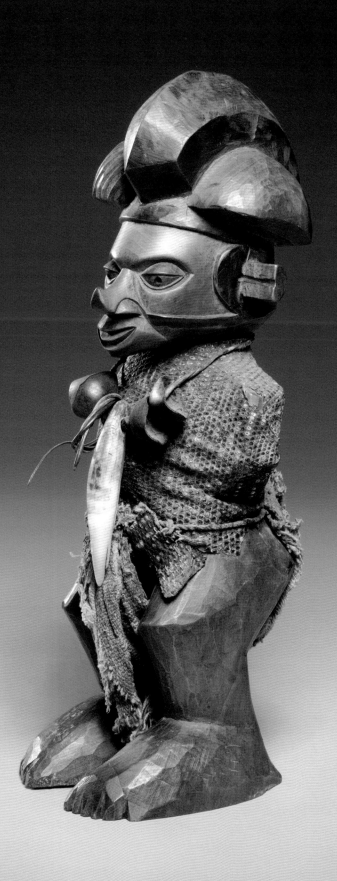

FIGURE; YAKA PEOPLE, DEMOCRATIC REPUBLIC OF THE CONGO OR ANGOLA
LATE 19TH TO MID 20TH CENTURY; WOOD, LIZARD SKIN, LEOPARD TOOTH, SHELL,
CLOTH; HEIGHT 23 CM
GIFT OF KATHERINE C. WHITE 1974.201

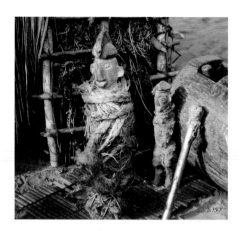

Fig. 37. A chief's power figures in the village of Kimbao, Democratic Republic of the Congo, 1976. Photograph by Arthur P. Bourgeois.

Among the Yaka, wooden figures that are used as containers or supports for magical medicines are generically called *biteki*. After being charged by a ritual specialist they become a type of *n-kisi,* a medicine-poison or power object, and gain the capacity to either cure or harm. The substances that change the sculpture into a meaningful charm are rubbed directly on the surface or inserted into a cavity made in the body, most often in the belly, or they are kept in a bag or packet that hangs from the body. After a male or female diviner reveals the curse responsible for his or her misfortune, the afflicted person seeks out the help of a ritual specialist known as *ngaanga*. He will normally treat the victim through his or her initiation into the ritual institution concerned with the curse. The initiation is a lengthy learning process that is accompanied by the imposition of many prohibitions and the teaching of specific songs and dances. Sometimes, carved figures are part of the ritual specialist's paraphernalia and are later passed on to the client for continued protection. However, most charm-curse cults do not make use of figurative carvings.

Two distinct types of figures have been described among the northern Yaka, *khosi* and *m-mbwoolu-tsyo,* but the Cleveland figure cannot be related to either. Perhaps it is an example of the separate category of figures called *phuungu,* which does not involve a special initiation or a communal ritual. Often placed in the interior of a house, against the wall or near the roof supports, phuungu mainly serve as protection against witches and other evil. While its upturned phallic nose is a feature typical of all Yaka carving predating 1930, the style of the Cleveland figure may in fact point to an origin with the western Yaka in Angola or near the Angolan border. The accoutrements, including the leopard tooth suspended from the neck and the crested headdress, allude to leadership and rank, and may indicate that the portrayed person is a chief, a notable, or an elder. The meaning of the lizard skin tightly wrapped around the armless torso remains unresolved.

Further reading: Bourgeois 1984, 97–102, 107–14.

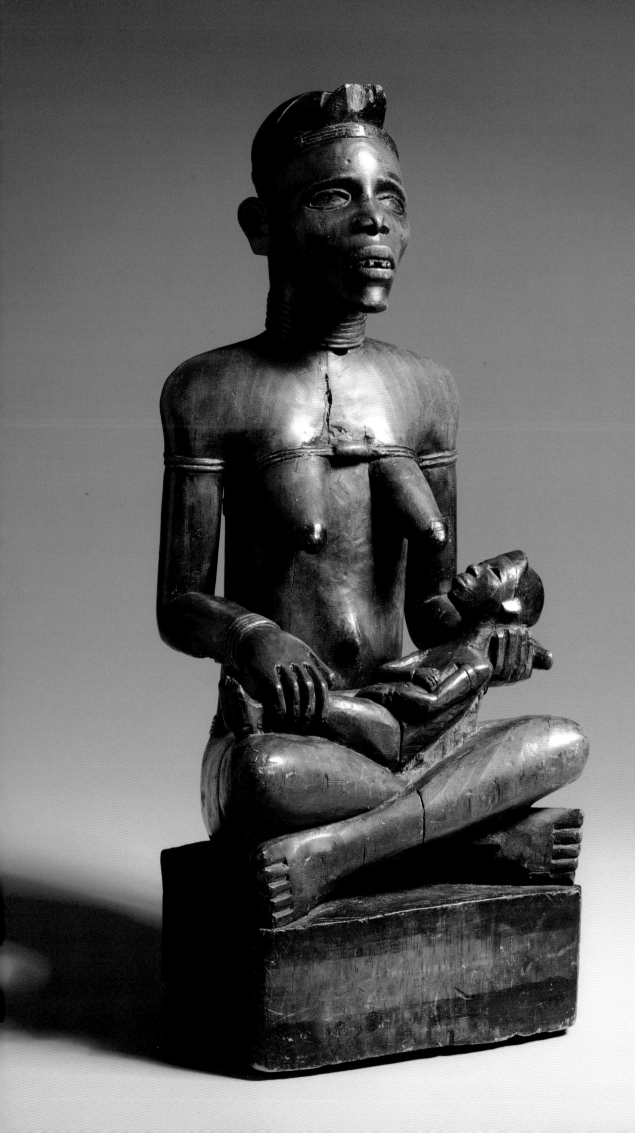

MOTHER-AND-CHILD FIGURE; YOMBE PEOPLE, DEMOCRATIC REPUBLIC OF THE CONGO

LATE 19TH TO EARLY 20TH CENTURY; WOOD; HEIGHT 64.7 CM

LEONARD C. HANNA JR. FUND 1997.149

The Yombe are one of the many Kikongo-speaking peoples that at one point in their history were part of, or strongly influenced by, the former kingdom of Kongo. This kingdom on the Atlantic Coast near the mouth of the Kongo River flourished from at least 1400 through the late 1600s. Its hilltop capital Mbanza Kongo, present-day São Salvador in Angola, was first visited by Portuguese explorers in the mid fifteenth century. Luxury goods and refined art works enhanced the divine character of the Kongo king. After the introduction of Christianity and the baptism of King Nzinga a Nkuwa on 3 May 1491, Kongo artists were influenced by the iconography of the new faith. The mother-and-child theme and the naturalism in Yombe art may also reflect the influence of European models and tastes.

This mother-and-child figure probably comes from the region around the village of Kasadi in the Democratic Republic of the Congo. It is stylistically related to three face masks and six maternity figures of smaller size. The mother-and-child figures have been attributed to a single artist whom scholars have named the "Kasadi Master." Marc Felix, however, has recently identified the Cleveland figure as the work of an unknown artist of the Sundi, another Kikongo-speaking people about which little is known. While small Yombe mother-and-child figures were mainly used in a women's cult concerned with the treatment of infertility, the size and soft wood of the Cleveland figure—which was originally brightly colored—indicate its funerary function. Since it does not show the weathering that prolonged exposure on a tomb would have caused, the figure was most likely placed in a roofed ancestral shrine. The cross-legged seated pose atop a square base and the various body adornments, including the cord tied above the breasts and the patterned cap with tab-like projection, convey high social status, and may reveal that the woman represented incarnates the founding ancestor of a descent group.

Further reading: Bassani 2001, 163–71; Felix 1995, 115; MacGaffey 1993, 30–33.

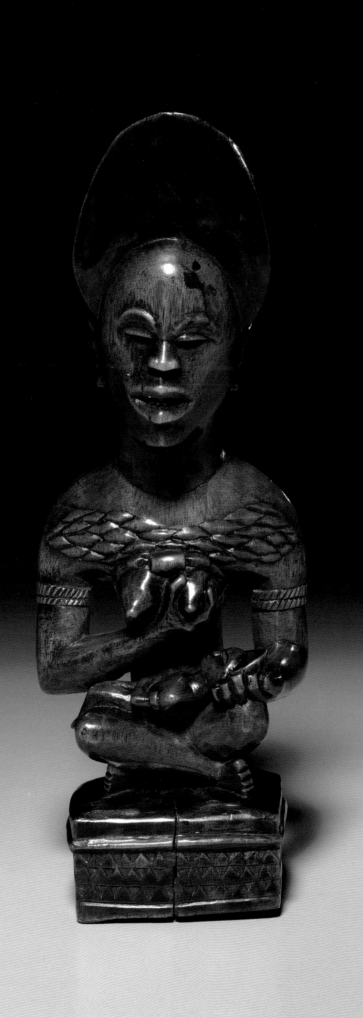

MOTHER–AND–CHILD FIGURE (*pfemba*); POSSIBLY YOMBE PEOPLE, DEMOCRATIC
REPUBLIC OF THE CONGO
MID TO LATE 19TH CENTURY; WOOD; HEIGHT 26 CM
ANDREW R. AND MARTHA HOLDEN JENNINGS FUND 2003.35

Thanks to their refined naturalism and recognizable theme, mother-and-child figures of the Yombe and related peoples of the Lower Congo region are among the most beloved types of African art in the West. Of much smaller scale than the previous mother-and-child figure (see pl. 41), this one is most probably an example of a type of sculpture called *pfemba* that is related to a women's cult concerned with enhancing fertility and the treatment of infertility. Oral tradition holds that the pfemba cult was established by a famous midwife. The very different styles of the two sculptures illustrate regional and even personal variations on the same theme.

The figure depicted here also held a high rank in society, as testified by her cross-legged pose on a pedestal and her many body adornments. The chiseled teeth, the firm breasts, the miter-shaped hairstyle, which imitates a once-popular coiffure among both men and women, and especially the raised scarification marks indicate ideals of beauty and perfection. Meant to stimulate sexual pleasure, the scars were considered both beautiful and erotic. The double bracelets around her upper arms imitate protective charms called *nsunga;* made of plaited or braided raffia fibers, they are worn by religious experts and by ill people as a cure.

During their ritual use, the surfaces of figures such as this one were rubbed with a reddish mixture of oil and camwood powder, both a cosmetic and a sign of mediation. It is no coincidence that in Yombe thought the color red indicates transitional conditions such as death and birth. The fact that some mother-and-child figures hold or carry what appears to be a dead baby alludes to the close interrelationship in Kongo beliefs between the spirit world and the world of the living. It has been suggested that the figures were thoroughly cleaned and polished after their use by their original caretakers. The resinous material on many examples in Western collections seems to have been applied not by the people who made and used them but by their first Western owners.

Further reading: Lehuard 1977, 74–86; MacGaffey 1996, cat. 15.

Documentation

WESTERN SUDAN

1. Male figure; Jenné region, Inland Niger Delta, Mali; possibly 14th to 17th century; terracotta; h. 19.7 cm. John L. Severance Fund 1985.199.
Provenance: Michael Oliver, New York, 1985.
Exhibitions: *Year in Review 1985* (1986), CMA.
Publications: CMA 1986, cat. 170; Drewal 1989, fig. 1; CMA 1991b, 32.

2. Face mask (*satimbe*); Dogon people, Mali; early to mid 20th century; wood; h. 111.1 cm. James Albert and Mary Gardiner Ford Memorial Fund 1960.169.
Provenance: Pierre Matisse, New York, to 1960.
Exhibitions: *Year in Review* (1960), CMA.
Publications: Damase 1960, cat. 40; Wixom 1961, 42; CMA 1966/1969, 302; Robbins 1966, no. 22; Wixom 1977, fig. 11; CMA 1978, 410; CMA 1991b, 153.

3. Female antelope headdress (*n'gonzon koun*); Bamana people, Mali; early 20th century; wood, beads, shells, metal; h. 44.5 cm. Gift of Mrs. Ralph M. Coe in memory of Ralph M. Coe 1965.325.
Provenance: J. J. Klejman, New York, 1954; Mr. and Mrs. Ralph M. Coe, Cleveland, 1954–65.
Exhibitions: *The Imagination of Primitive Man: A Survey of the Arts of the Non-Literate Peoples of the World* (1962), William Rockhill Nelson Gallery of Art (The Nelson-Atkins Museum of Art), Kansas City, Mo.; *Year in Review* (1965), CMA.
Publications: Drewal 1989, fig. 16; CMA 1991b, 147; May 2001, no. 68.

4. Head of a hobbyhorse (*korèduga so*); Bamana people, Mali; late 19th to early 20th century; wood, metal; h. 40.7 cm. James Albert Ford Memorial Fund 1935.307.
Provenance: Louis Carré, Paris, before 1935.
Exhibitions: *African Negro Art* (1935–36), The Museum of Modern Art, New York, and tour; *Art Marches On!* (1941), Flint Institute of Arts, Mich.; *The African Image* (1959), The Toledo Museum of Art, Ohio; *Bambara Sculpture from the Western Sudan* (1960), Museum of Primitive Art, New York; *Perfect Documents: Walker Evans and African Art, 1935*

(2000), The Metropolitan Museum of Art, New York.
Publications: Sweeney 1935, dust jacket and pl. 10; *Art Marches On!* 1941, cat. 43; Plass 1959a, cat. 25; Radin and Sweeney 1952, pl. 36; CMA 1958, no. 385; Goldwater 1960, pl. 37; CMA 1966/1969, 302; Drewal 1989, fig. 29; Webb 2000, fig. 57.

5. Bush buffalo mask; possibly Bwa people, Burkina Faso; early 20th century; wood, cord, fibers; h. 69.8 cm. Gift of Katherine C. White 1969.2.
Provenance: Katherine C. White, Cleveland/ Los Angeles, to 1969.
Exhibitions: *African Tribal Images: The Katherine White Reswick Collection* (1968), CMA; *Year in Review 1969* (1970), CMA; *A Cleveland Bestiary* (1981), CMA.
Publications: Fagg 1968, cat. 31; CMA 1970, cat. 128; CMA 1978, 411; Kathman 1981, fig. 11; Drewal 1989, fig. 17; CMA 1991b, 153; Connell 1998, acetate 43; May 2001, no. 70.

6. Face mask (*kpeliyehe*); Senufo people, Côte d'Ivoire; attributed to Sabarikwo of Ouazumon village; early 20th century; wood; h. 31.1 cm. John L. Severance Fund 1989.48.
Provenance: James Freeman, Kyoto, 1989.
Exhibitions: *Notable Acquisitions* (1991), CMA.
Publications: CMA 1991a, 114; CMA 1991b, 143; Young-Sánchez 1997, 69.

7. Helmet (*dagu*); Senufo people, Côte d'Ivoire; early to mid 20th century; wood, metal; h. 34.9 cm. Gift of Katherine C. White 1975.152.
Provenance: J. J. Klejman, New York, 1963; Katherine C. White, Cleveland/Los Angeles, 1963–76.
Exhibitions: *African Tribal Images: The Katherine White Reswick Collection* (1968), CMA; *Year in Review 1975* (1976), CMA.
Publications: Fagg 1968, cat. 22; CMA 1976, cat. 29; Drewal 1989, fig. 12.

8. Mother-and-child figure; Senufo people, Côte d'Ivoire; late 19th to mid 20th century; wood; h. 63.6 cm. James Albert and Mary Gardiner Ford Memorial Fund 1961.198.
Provenance: Mathias Komor, New York, 1961.

Exhibitions: *Year in Review* (1961), CMA; *The Imagination of Primitive Man: A Survey of the Arts of the Non-Literate Peoples of the World* (1962), William Rockhill Nelson Gallery of Art (The Nelson-Atkins Museum of Art), Kansas City, Mo.; *Traditions and Revisions: Themes from the History of Sculpture* (1975), CMA; *Icon and Symbol* (1975), Cranbrook Academy, Bloomfield Hills, Mich.
Publications: CMA 1961, cat. 24; CMA 1966/1969, 302; *Icon and Symbol* 1975, cat. 9; Weisberg 1975, cat. 54; CMA 1978, 410; Drewal 1989, fig. 21; CMA 1991b, 149; CMA 1991c, no. 42.

GUINEA COAST

9. Female figure; possibly Bondoukou region, Côte d'Ivoire; late 19th to early 20th century; wood, metal; h. 52.7 cm. Gift of Katherine C. White 1972.343.
Provenance: Henri Kamer, Paris; Katherine C. White, Cleveland/Los Angeles, to 1973.
Exhibitions: *African Tribal Images: The Katherine White Reswick Collection* (1968), CMA; *Year in Review 1972* (1973), CMA.
Publications: Fagg 1968, cat. 91; *African Arts* 1973, 85; CMA 1973, cat. 25.

10. Figure; possibly so-called Sapi people, Sierra Leone or Guinea; possibly early 15th century; soapstone; h. 23.8 cm. Gift of Lucile Munro in memory of her husband, Thomas Munro 1976.29.
Provenance: Béla Hein, Paris; Dr. and Mrs. Thomas Munro, Cleveland, to 1976.
Exhibitions: *The Imagination of Primitive Man: A Survey of the Arts of the Non-Literate Peoples of the World* (1962), William Rockhill Nelson Gallery of Art (The Nelson-Atkins Museum of Art), Kansas City, Mo.; *African Sculpture* (1970), National Gallery of Art, Washington; *Year in Review 1976* (1977), CMA; *African Art: Permutations of Power* (1997–98), Samuel P. Harn Museum of Art, Gainesville, Fla.
Publications: Coe 1962, cat. 25; Munro 1970, fig. 63; CMA 1977, cat. 36; Drewal 1989, fig. 2; *African Art* 1997b, fig. 32.

11. Headdress (*tabakän*); possibly Landuma people, Guinea; early 20th century; wood, fibers; h. 76.2 cm. Gift of Katherine C. White 1969.3.

Provenance: Katherine C. White, Cleveland/ Los Angeles, to 1969.
Exhibitions: *African Tribal Images: The Katherine White Reswick Collection* (1968), CMA; *Year in Review 1969* (1970), CMA.
Publications: Robbins 1966, no. 50.

12. Serpent headdress; possibly Baga people, Guinea; late 19th to early 20th century; wood; h. 148 cm. The Norweb Collection 1960.37.
Provenance: Mathias Komor, New York; Mrs. R. Henry Norweb, Cleveland, to 1960.
Exhibitions: *Year in Review* (1960), CMA; *The Imagination of Primitive Man: A Survey of the Arts of the Non-Literate Peoples of the World* (1962), William Rockhill Nelson Gallery of Art (The Nelson-Atkins Museum of Art), Kansas City, Mo.; *Traditions and Revisions: Themes from the History of Sculpture* (1975), CMA; *Images of the Mind* (1987), CMA.
Publications: CMA 1960, cat. 13; Wixom 1961, figs. 1–3; CMA 1966/1969, 302; Weisberg 1975, cat. 117; Wixom 1977, fig. 11; CMA 1978, 410; CMA 1987 (unpaginated); Drewal 1989, fig. 28; CMA 1991b, 151; Perani and Smith 1998, fig. 3.6.

13. Face mask; Mano people, Liberia; early 20th century; wood, Formica, cord, metal, seeds; h. 28 cm. The Harold T. Clark Educational Extension Fund 1953.457.
Provenance: Field-collected by Dr. George Harley, before 1937 to 1946; Charles Morrow Wilson; Ralph C. Altman, Los Angeles, to 1953.

14. Face mask; Wè (or Kran) people, Côte d'Ivoire or Liberia; early 20th century; wood, metal, cloth, fur, hair, tusks; h. 38.1 cm. Gift of Katherine C. White 1971.294.
Provenance: Harry Franklin, Los Angeles; Katherine C. White, Cleveland/Los Angeles, to 1971.
Exhibitions: *African Tribal Images: The Katherine White Reswick Collection* (1968), CMA; *Year in Review 1972* (1973), CMA.
Publications: Fagg 1968, cat. 60; *African Arts* 1972a, 78; Drewal 1989, fig. 8; Connell 1998, acetate 44.

15. Face mask; possibly Yaure people, Côte d'Ivoire; early 20th century; wood; h. 31.7 cm. Gift of Katherine C. White 1971.296.
Provenance: Harry Franklin, Los Angeles, 1965; Katherine C. White, Cleveland/Los Angeles, 1965–71.
Exhibitions: *African Tribal Images: The Katherine White Reswick Collection* (1968), CMA; *Year in Review 1972* (1973), CMA.
Publications: Fagg 1968, cat. 73; *African Arts* 1972b, 75; CMA 1973, cat. 22.

16. Face mask (*kple kple*); Baule people, Côte d'Ivoire; late 19th to early 20th century; wood; h. 40.7 cm. Gift of Katherine C. White 1975.155.
Provenance: Katherine C. White, Cleveland/ Los Angeles, to 1976.
Exhibitions: *African Tribal Images: The Katherine White Reswick Collection* (1968), CMA; *Year in Review 1975* (1976), CMA.
Publications: Fagg 1968, cat. 80; CMA 1976, cat. 22.

17. Figure pair; Baule people, Côte d'Ivoire; late 19th to early 20th century; wood, beads, metal; h. 49.5 cm (male), 47.7 cm (female). Gift of Katherine C. White 1971.297 (male), 1971.298 (female).
Provenance: Katherine C. White, Cleveland/ Los Angeles, to 1971.
Exhibitions: *African Tribal Images: The Katherine White Reswick Collection* (1968), CMA; *Year in Review 1972* (1973), CMA; *Object in Focus: Male and Female Spirit Spouse Figures* (2003), CMA.
Publications: Fagg 1968, cat. 85; CMA 1973, cat. 38; Drewal 1989, fig. 15.

18. Face pendant; possibly Baule people, Côte d'Ivoire; 20th century; gold; h. 7.6 cm. John L. Severance Fund 1954.602.
Provenance: Stephen Chauvet; C. Géraudel; Nasli Heeramaneck, New York, 1954.
Exhibitions: *Exhibition of Masks* (1959), Royal Ontario Museum of Archaeology, Toronto; *The Seven Metals of Africa* (1959–60), University of Pennsylvania Museum, Philadelphia, and tour; *The Imagination of Primitive Man: A Survey of the Arts of the Non-Literate Peoples of the World* (1962), William Rockhill Nelson Gallery of Art (The Nelson-Atkins Museum of Art), Kansas City, Mo.; *Object Lessons: Cleveland Creates an Art Museum* (1991), CMA; *Baule: African Art, Western Eyes* (1997–99), Yale University Art Gallery, New Haven, and tour.
Publications: Chauvet 1930, fig. 15; CMA 1958, no. 391; *Masks* 1959, 49; Plass 1959b, cat. F-5; CMA 1966/1969, 302; Wixom 1977, fig. 2; CMA 1978, 410; Drewal 1989, fig. 23; CMA 1991b, 151; Vogel 1997, 201.

19. Jewelry; Asante people, Ghana; 19th century; gold. Dudley P. Allen Fund. Ornament, h. 6.9 cm, 1935.308; ornament h. 6.6 cm, 1935.309; pendant, diam. 9.8 cm, 1935.310; ornament, h. 4.3 cm, 1935.311; ornament, h. 8.7 cm, 1935.312.
Provenance: Armitage, after 1896; Louis Carré, Paris, before 1935.
Exhibitions: *African Negro Art* (1935–36), The Museum of Modern Art, New York, and tour (1935.308); *Exhibition of Jewelry* (1952),

Portland Art Museum, Maine (1935.308); *Masterpieces of African Art* (1954–55), The Brooklyn Museum, New York (1935.308, 1935.310); *African Textiles and Decorative Arts* (1972–73), The Museum of Modern Art, New York, and tour (1935.310); *The Arts of Ghana* (1977–78), University of California, Dickson Art Center, Los Angeles, and tour (1935.310); *African Emblems of Authority* (1982–83), National Museum of African Art, Smithsonian Institution, Washington (1935.310); *African Art in the Cycle of Life* (1987–88), National Museum of African Art, Smithsonian Institution, Washington (1935.310); *Elmina: Art and Trade on the West African Coast* (1992–93), National Museum of African Art, Smithsonian Institution, Washington (1935.310); *Perfect Documents: Walker Evans and African Art, 1935* (2000), The Metropolitan Museum of Art, New York (1935.308, 1935.309).
Publications: *L'Art nègre* 1951, no. 101 (1935.308); Sieber 1972, 137 (1935.310); Wixom 1977, 21 (1935.308–312); Walker 1987, cat. 53 (1935.310); Geary and Nicolls 1992, 8 (1935.310); Blier 1998, fig. 118 (1935.310); Webb 2000, cat. 18 (1935.308–309).

20. Head (*mma*); Akan peoples, Ghana; late 17th to early 18th century; terracotta; h. 20.3 cm. Edwin R. and Harriet Pelton Perkins Memorial Fund 1990.22.
Provenance: Arts Primitifs, Paris, 1990.
Publications: CMA 1991a, cat. 62; Young-Sánchez 1997, 68.

21. Female figure (*akua'ba*); possibly Fante people, Ghana; late 19th to early 20th century; wood, hair; h. 42.9 cm. Gift of Katherine C. White 1975.158.
Provenance: Katherine C. White, Cleveland/ Los Angeles, to 1976.
Exhibitions: *African Tribal Images: The Katherine White Reswick Collection* (1968), CMA; *Year in Review 1975* (1976), CMA; *The Arts of Ghana* (1977–78), University of California, Dickson Art Center, Los Angeles.
Publications: Fagg 1968, cat. 106; Cole and Ross 1977, cat. 212.

NIGERIA

22. Mother-and-child caryatid vessel (*agere ifa*); Yoruba people, Nigeria; mid to late 19th century; wood; h. 31.7 cm. Leonard C. Hanna Jr. Fund 1994.2.
Provenance: Davis Gallery, New Orleans, La., 1994.
Exhibitions: *Shapes of Power, Belief and Celebration* (1989), New Orleans Museum of Art, La., and tour; *Yoruba: Nine Centuries of African Art and Thought* (1989–91), The

Center for African Art, New York, and tour.
Publications: Holcombe 1982, pl. 15; Fagaly
1989, cat. 72; Wardwell 1989, fig. 229; Young-
Sánchez 1997, 71.

23. Necklace (odigba ifa); Yoruba people,
Nigeria; 20th century; cloth, glass beads,
wood, cardboard; h. 49.5 cm. Andrew R. and
Martha Holden Jennings Fund, 1995.23.1–2.
Provenance: Pace Primitive, New York, 1995.
Publications: Young-Sánchez 1997, 70.

24. Crown (ade); Yoruba people, Nigeria; 20th
century; cloth, glass beads, basketry,
cardboard, wood, feather quills; h. 105.9 cm.
Andrew R. and Martha Holden Jennings
Fund 1995.22.
Provenance: Douglas Dawson, Chicago, 1995.

25. Head. Edo people, Benin kingdom,
Nigeria; mid 16th or early 17th century;
brass; h. 29.9 cm. Dudley P. Allen Fund
1938.6.
Provenance: Louis Carré, Paris, before 1938.
Exhibitions: Ivories and Bronzes from the
Ancient Kingdom of Benin (1937), CMA;
African Negro Art (1953), Founders Library
Art Gallery, Howard University, Washington;
Seaway Luncheons (1959), East Ohio Gas
Company Building, Cleveland.
Publications: Milliken 1937, 34; Foote 1938,
48; CMA 1958, no. 386; Burton 1964, fig. 70;
CMA 1966/1969, 303; Fricke 1975, 102;
CMA 1978, 411; Anderson and Perry 1984,
fig. 6:5; Drewal 1989, fig. 5; CMA 1991b, 103;
CMA 1991c, no. 41; Perani and Smith 1998,
fig. 6.7; May 2001, no. 69.

26. Carved tusk; Edo people, Benin
kingdom, Nigeria; around 1820; ivory; h.
197.4 cm. Gift of Katherine C. White
1968.284.
Provenance: Katherine C. White, Cleveland/
Los Angeles, to 1969.
Exhibitions: African Tribal Images: The
Katherine White Reswick Collection (1968),
CMA; Year in Review 1968 (1969), CMA.
Publications: Fricke 1975, 102; Fagg 1968, cat.
144; Drewal 1989, fig. 6; Blackmun 1994,
covers, figs. 2, 7–31; Perani and Smith 1998,
fig. 6.7.

27. Plaque; Edo people, Benin kingdom,
Nigeria; possibly 16th to mid 17th century;
brass; h. 45.7 cm. John L. Severance Fund
1999.1.
Provenance: The British Museum, London
(acc. no. 98/1-15/43), 1897–1950; Sidney (or
Charles?) Burney, London; Edward A.
Bragaline, New York; private collection;
Entwistle, London; Mitchell-Innes & Nash,
New York, 1999.

Exhibitions: Twentieth Century Masters from the
Bragaline Collection (1963), M. Knoedler &
Co., Inc., New York.
Publications: Twentieth Century Masters 1963,
cat. 48; Davidson 1963, fig. 6; Dark 1982, cat.
59; Gustafson 1999, 778.

28. Head; Nok region, Nigeria; around 600
BC to AD 250; terracotta; h. 38.2 cm. Andrew
R. and Martha Holden Jennings Fund
1995.21.
Provenance: Emile Deletaille, Brussels, 1995.
Publications: Young-Sánchez 1997, 69;
Wilkins, Schultz, and Linduff 2001, fig. 2.7.

29. Headdress; Ejagham people, Nigeria; late
19th to early 20th century; wood, antelope
skin, bone, basketry, cane; h. 67.3 cm. Andrew
R. and Martha Holden Jennings Fund
1990.23.
Provenance: Pace Gallery, New York; private
collection; Entwistle, London, 1990.
Exhibitions: Notable Acquisitions (1991),
CMA.
Publications: CMA 1991a, 113; Young-
Sánchez 1997, 67.

CAMEROON GRASSFIELDS

30. Male figure; Bangwa people, Cameroon;
attributed to Ateu Atsa; late 19th to early
20th century; wood; h. 92.1 cm. Purchase
from the J. H. Wade Fund 1987.62.
Provenance: Pace Primitive and Ancient Art,
New York, 1987.
Exhibitions: Year in Review 1987 (1988), CMA.
Publications: Northern 1984, cat. 7; CMA
1988, cat. 180; Drewal 1989, fig. 18; CMA
1991b, 143.

31. Helmet mask; possibly Kom people,
Cameroon; early 20th century; wood; h. 33
cm. Gift of Mr. and Mrs. William D. Wixom
in memory of Mr. and Mrs. Ralph M. Coe
1971.66.
Provenance: Georges D. Rodrigues, 1971.
Exhibitions: Year in Review 1971 (1972), CMA;
Traditions and Revisions: Themes from the
History of Sculpture (1975), CMA.
Publications: African Arts 1972a, 69; CMA
1972, cat. 21; Mitchell and Sica 1973, 8;
Drewal 1989, fig. 31; CMA 1991b, 143.

CONGO BASIN

32. Male figure; so-called pre-Bembe people,
Democratic Republic of the Congo; late
19th to early 20th century; wood, cord, cloth;
h. 48.3 cm. Gift of Katherine C. White
1969.10.

Provenance: J. J. Klejman, New York, 1962;
Katherine C. White, Cleveland/Los Angeles,
1962–69.
Exhibitions: African Tribal Images: The
Katherine White Reswick Collection (1968),
CMA; Year in Review 1969 (1970), CMA.
Publications: Fagg 1968, cat. 269; CMA 1970,
cat. 131; Wixom 1977, fig. 10; CMA 1978, 412;
Drewal 1989, fig. 7; CMA 1991b, 149;
Connell 1998, acetate 41; May 2001, no. 71.

33. Half figure; Luba people, Democratic
Republic of the Congo; late 19th to early
20th century; wood, cloth, beads; h. 27.3 cm.
Gift of Mr. and Mrs. Alvin N. Haas 1974.212.
Provenance: Loed van Bussel, The Hague,
Netherlands.
Exhibitions: Year in Review 1974 (1975), CMA.
Publications: CMA 1975, cat. 16.

34. Comb; Chokwe people, Angola or
Democratic Republic of the Congo; mid to
late 19th century; wood, beads; h. 13.3 cm.
The Harold T. Clark Educational Extension
Fund 1915.453.
Provenance: F. M. Rapp, before 1915.
Publications: Wixom 1977, fig. 1.

35. Helmet mask (bwoom); Kuba people,
Democratic Republic of the Congo; mid to
late 19th century; wood; h. 43.3 cm. James
Albert Ford Memorial Fund 1935.304.
Provenance: Charles Ratton, Paris, before
1935.
Exhibitions: African Negro Art (1935–36), The
Museum of Modern Art, New York, and
tour; The African Image (1959), The Toledo
Museum of Art, Ohio; The Imagination of
Primitive Man: A Survey of the Arts of the Non-
Literate Peoples of the World (1962), William
Rockhill Nelson Gallery of Art (The
Nelson-Atkins Museum of Art), Kansas City,
Mo.; Perfect Documents: Walker Evans and
African Art (2000), The Metropolitan
Museum of Art, New York.
Publications: CMA 1958, no. 387; Plass 1959a,
cat. 164; CMA 1966/1969, 303; CMA 1966a,
no. 239; Robbins 1966, no. 300; Mitchell and
Sica 1973, 9; CMA 1978, 412; CMA 1991b,
139; Buser 1995, figs. 18–22; Connell 1998,
acetate 42; Webb 2000, figs. 15 (right), 18
(left).

36. Belt (yet); Kuba people, Democratic
Republic of the Congo; possibly early 20th
century; cord, cloth, hide, glass beads, shells; l.
139.5 cm. John L. Severance Fund 1994.87.
Provenance: Jacques Hautelet, La Jolla, Calif.,
1994.
Exhibitions: Object in Focus: African Beaded
Belt (1998), CMA.
Publications: Young-Sánchez 1997, 66.

37. Mother-and-child figure; possibly Kwilu
Pende people, Democratic Republic of the
Congo; late 19th to early 20th century;
wood, glass beads, metal; h. 53.4 cm. Gift of
the African Art Sponsors of Karamu House
1931.426.
Provenance: Guillaume De Hondt, Brussels,
before 1931.
Exhibitions: *African Art* (1960), Karamu
House, Cleveland; *Object-in-Focus: Mother-
and-Child Figure* (2002), CMA.
Publications: Wixom 1977, fig. 10 (center);
Petridis 2002, fig. 1.

38. Figure; Hungaan people, Democratic
Republic of the Congo; mid to late 19th
century; wood; h. 68 cm. Andrew R. and
Martha Holden Jennings Fund 2003.36.
Provenance: Private collection, Belgium,
before 1920; Mr. and Mrs. W. Vranken-Hoet,
Brussels, to 2003.
Exhibitions: *Utotombo: l'art d'Afrique noire
dans les collections privées belges* (1988), Palais
des Beaux-Arts, Brussels.
Publications: *Utotombo* 1988, cat. 171; Cornet
1989, 384.

39. Mask (*tsekedi, myondo,* or *ndeemba*); Yaka
people, Democratic Republic of the Congo;
early 20th century; wood, cloth, raffia fibers;
h. 47 cm. Gift of Katherine C. White 1969.8.
Provenance: Robert Stolper, New York, 1962;
Katherine C. White, Cleveland/Los Angeles,
1962–69.
Exhibitions: *African Tribal Images: The
Katherine White Reswick Collection* (1968),
CMA; *Year in Review 1969* (1970), CMA.
Publications: Fagg 1968, cat. 231; CMA 1970,
cat. 132; CMA 1978, 412; Drewal 1989, fig. 10;
CMA 1991b, 151.

40. Figure; Yaka people, Democratic
Republic of the Congo or Angola; late 19th
to mid 20th century; wood, lizard skin,
leopard tooth, shell, cloth; h. 23 cm. Gift of
Katherine C. White 1974.201.
Provenance: Katherine C. White, Cleveland/
Los Angeles, to 1975.
Exhibitions: *African Tribal Images: The
Katherine White Reswick Collection* (1968)
CMA; *Year in Review 1974* (1975), CMA.
Publications: Fagg 1968, cat. 232; CMA 1975,
cat. 23; Wixom 1977, fig. 6; Drewal 1989, fig.
9; CMA 1991b, 141.

41. Mother-and-child figure; Yombe people,
Democratic Republic of the Congo; late
19th to early 20th century; wood; h. 64.7 cm.
Leonard C. Hanna Jr. Fund 1997.149.
Provenance: F. Burniaux, Dinant, Belgium,
before 1930 to 1980; Mr. and Mrs. Barry A.

Kitnick, Los Angeles; private collection;
Anthony Slayter-Ralph, Santa Barbara, to
1997.
Exhibitions: *Masterpieces of the People's
Republic of the Congo* (1980), The African-
American Institute, New York; *The Mother
and Child in African Sculpture* (1985–86), Los
Angeles County Museum of Art.
Publications: Duponcheel 1980, cat. 10;
Bassani 1981, fig. 24; Cole 1985b, cover and
cat. 15; Robbins and Nooter 1989, no. 932;
Felix 1995, 115, no. 1; May 2001, no. 72.

42. Mother-and-child figure (*pfemba*);
possibly Yombe people, Democratic
Republic of the Congo; mid to late 19th
century; wood; h. 26 cm. Andrew R. and
Martha Holden Jennings Fund 2003.35.
Provenance: Field-collected by Capt. Isidore
Mesmaekers, before 1940; Mr. and Mrs. W.
Vranken-Hoet, Brussels, to 2003.
Exhibitions: *Utotombo: l'art d'Afrique noire
dans les collections privées belges* (1988), Palais
des Beaux-Arts, Brussels.
Publications: Kerchache, Paudrat, and
Stéphan 1988, fig. 233; *Utotombo* 1988, cat.
159.

References

Abiodun 1989
Abiodun, Rowland. "The Kingdom of Owo." In Wardwell 1989, 91–113.

Abiodun 1990
Abiodun, Rowland, et al. *African Art Studies: The State of the Discipline.* Washington: National Museum of African Art, 1990.

Adams 2001
Adams, Henry. *Paul Travis (1891–1975),* exh. cat., Beck Center for the Arts. Cleveland: Cleveland Artists Foundation, 2001.

Adams 1986
Adams, Monni. "Women and Masks among the Western Wè of Ivory Coast." *African Arts* 19, no. 2 (1986): 46–55, 90.

Adams 1988
Adams, Monni. "Double Perspectives: Village Masking in Canton Boo, Ivory Coast." *Art Journal* 47, no. 2 (1988): 95–102.

Adams 1993
Adams, Monni. "Women's Art as Gender Strategy among the Wè of Canton Boo." *African Arts* 26, no. 4 (1993): 32–43, 84–85.

Africa: The Art of a Continent 1996
Africa: The Art of a Continent. 100 Works of Power and Beauty, exh. cat., Solomon R. Guggenheim Museum, 26–32. New York: Solomon R. Guggenheim Foundation, 1996.

African Art 1997a
African Art at the Art Institute of Chicago. Chicago: Art Institute of Chicago, 1997 (*Museum Studies* 23, no. 2).

African Art 1997b
African Art: Permutations of Power, exh. cat. Gainesville: Samuel P. Harn Museum of Art, University of Florida, 1997.

African Arts 1972a
"New Acquisitions." *African Arts* 5, no. 4 (1972): 78.

African Arts 1972b
"New Acquisitions." *African Arts* 6, no. 1 (1972): 75.

African Arts 1973
"New Acquisitions." *African Arts* 6, no. 4 (1973): 85.

Anderson and Perry 1983
Anderson, Ross, and Barbara Perry. *The Diversions of Keramos: American Clay Sculpture 1925–1950,* exh. cat. Syracuse, N.Y.: Everson Museum of Art, 1983.

Art Marches On! 1941
Art Marches On! exh. cat. Flint, Mich.: Flint Institute of Arts, 1941.

Barbier 1993
Barbier, Jean-Paul, ed. *Art of Côte d'Ivoire from the Collections of the Barbier-Mueller Museum.* 2 vols. Geneva: Musée Barbier-Mueller, 1993.

Bassani 1976
Bassani, Ezio. "Il Maestro delle capigliature a cascata." *Critica d'Arte* 51, nos. 148–49 (1976): 75–87.

Bassani 1978
Bassani, Ezio. "Una bottega di grandi artisti Bambara." *Critica d'Arte* 53, nos. 157–59 (1978): 209–28; nos. 160–62 (1978): 181–99.

Bassani 1981
Bassani, Ezio. "Due grandi artisti Yombe: Il 'Maestro della maternità Roselli-Lorenzini' e il 'Maestro della maternità de Briey.'" *Critica d'Arte* 56, no. 178 (1981): 66–84.

Bassani 1982
Bassani, Ezio. "Un cimier Bambara." *Connaissance des Arts Tribaux* 15 (1982) (unpaginated).

Bassani 1990
Bassani, Ezio. "The Warua Master." *Quaderni Poro* 6 (1990): 101–19.

Bassani 2001
Bassani, Ezio. "Un grand sculpteur du Congo: le Maître de Kasadi." In Grunne 2001, 163–71.

Bastin 1997
Bastin, Marie-Louise. "Le réceptacle au pays des Tshokwe: utilitaire, rituel ou de prestige." In Christiane Falgayrettes-Leveau, ed. *Réceptacles,* exh. cat., Musée Dapper, 117–38. Paris: Éditions Dapper, 1997.

Beek 1991
Beek, Walter E. A. van. "Enter the Bush: A Dogon Mask Festival." In Vogel 1991, 56–73.

Ben-Amos 1995
Ben-Amos, Paula Girshick. *The Art of Benin.* Rev. ed. London: Trustees of the British Museum, 1995.

Berliner 2002
Berliner, David. " 'A Callè Never Dies': On the Subject of the Bansonyi among the Bulongic Baga (Guinea-Conakry)." *Arts & Cultures* 3 (2002): 99–111.

Berns 1995
Berns, Marla C. *Ceramic Gestures: New Vessels by Magdalene Odundo,* exh. cat. Santa Barbara: University Art Museum, University of California, 1995.

Bickford and Smith 1997
Bickford, Kathleen E., and Cherise Smith. "Art of the Western Sudan." In *African Art* 1997a, 105–19, 196.

Biebuyck 1969
Biebuyck, Daniel P., ed. *Tradition and Creativity in Tribal Art.* Berkeley/Los Angeles: University of California Press, 1969.

Biebuyck 1981
Biebuyck, Daniel P. *Statuary from the Pre-Bembe Hunters: Issues in the Interpretation of Ancestral Figurines Ascribed to the Basikasingo-Bembe-Boyo.* Tervuren: Musée Royal de l'Afrique Centrale, 1981.

Biebuyck 1985
Biebuyck, Daniel P. *The Arts of Zaire,* vol. 1, *Southwestern Zaire.* Berkeley/Los Angeles: Regents of the University of California, 1985.

Blackmun 1994
Blackmun, Barbara Winston. "History and Statecraft on a Tusk from Old Benin." *Bulletin of The Cleveland Museum of Art* 81, no. 4 (1994): 87–115.

Blackmun 1997
Blackmun, Barbara Winston. "Icons and Emblems in Ivory: An Altar Tusk from the Palace of Old Benin." In *African Art* 1997a, 149–63, 197–98.

Blier 1988
Blier, Suzanne Preston. "Words about Words about Icons: Iconology and the Study of African Art." *Art Journal* 47, no. 2 (1988): 75–87.

Blier 1990
Blier, Suzanne Preston. "African Art Studies at the Crossroads: An American Perspective." In Abiodun 1990, 91–107.

Blier 1996
Blier, Suzanne Preston. "Enduring Myths of African Art." In *Africa: The Art of a Continent* 1996, 26–32.

Blier 1998
Blier, Suzanne Preston. *Royal Arts of Africa: The Majesty of Form.* London: Calman & King, 1998.

Blier 2001
Blier, Suzanne Preston. "Africa, Art, and History: An Introduction." In Visonà 2001, 14–23.

Bochet 1981
Bochet, Gilbert. "Mother and Child." In Vogel 1981, 45–46.

Boger 1982
Boger, Ann C. *Paul B. Travis 1927–1928,* exh. cat. Cleveland: Cleveland Museum of Art, 1982.

Bourgeois 1984
Bourgeois, Arthur P. *Art of the Yaka and Suku.* Meudon: Alain et Françoise Chaffin, 1984.

Bourgeois 1985
Bourgeois, Arthur P. *The Yaka and Suku.* Leiden: E. J. Brill, 1985 (Iconography of Religions 7, fasc. D, 1).

Bourgeois 1996
Bourgeois, Arthur P. "Central Africa." In Turner 1996, 1: 400–406.

Boyer 1993
Boyer, Alain-Michel. "Art of the Yohure." In Barbier 1993, 1: 246–88.

Brain 1980
Brain, Robert. *Art and Society in Africa.* London/New York: Longman Group, 1980.

Brain 1996
Brain, Robert. "Bangwa." In Turner 1996, 3: 170–72.

Brain and Pollock 1971
Brain, Robert, and Adam Pollock. *Bangwa Funerary Sculpture.* Toronto/Buffalo: University of Toronto Press, 1971.

Bravmann 1973
Bravmann, René A. *Open Frontiers: The Mobility of Art in Black Africa.* Seattle/London: University of Washington Press, 1973.

Bravmann 1974
Bravmann, René A. *Islam and Tribal Art in West Africa.* London/New York: Cambridge University Press, 1974 (Africa Study Series 11).

Brett-Smith 1994
Brett-Smith, Sarah C. *The Making of Bamana Sculpture: Creativity and Gender.* Cambridge/New York: Cambridge University Press, 1994 (RES Monographs on Anthropology and Aesthetics).

Brink 1981
Brink, James T. "Antelope Headdress (chi wara)." In Vogel 1981, 24–25.

Burssens 1987
Burssens, Herman. "Aantekeningen bij de kandidatuurscolleges etnische kunst. Tweede deel: Inleiding tot de Afrikaanse kunst." 2 vols. Textbook, Ghent University, 1987.

Burssens 1988
Burssens, Herman. "Le sculpteur sur bois en Afrique noire." In *Utotombo* 1988, 19–36.

Burton 1964
Burton, Richard. "In Cleveland: The Idea of a Museum." *Museums Journal* 63, no. 4 (1964): 263–73.

Buser 1995
Buser, Thomas. *Experiencing Art Around Us.* St. Paul, Minn.: West Publishing Company, 1995.

Chauvet 1930
Chauvet, Stephen. "Objets d'or, de bronze et d'ivoire dans l'art nègre." *Cahiers d'Art* 5 (1930): 33–40.

Cissé 1995
Cissé, Youssouf Tata. "Aperçu sur les masques Bambara." In Christiane Falgayrettes-Leveau, ed. *Masques,* exh. cat., Musée Dapper, 165–99. Paris: Éditions Dapper, 1995.

Cissé 2000
Cissé, Youssouf Tata. "Les dieux et les hommes: permanence du sacré dans les arts Bambara." In Falgayrettes-Leveau 2000, 135–52.

Clarke 1997
Clarke, Christa. "*African Art,* The Barnes Foundation, Merion, Pennsylvania [exh. review]." *African Arts* 30, no. 1 (1997): 77–78, 96–97.

Coe 1962
Coe, Ralph T. *The Imagination of Primitive Man: A Survey of the Arts of the Non-Literate Peoples of the World,* exh. cat. Kansas City: University Trustees, W. R. Nelson Trust, 1962 (*Nelson Gallery and Atkins Museum Bulletin* 4, no. 1).

Cole 1985a
Cole, Herbert M. "Introduction: The Mask, Masking, and Masquerade Arts in Africa." In Herbert M. Cole, ed. *I Am Not Myself: The Art of African Masquerade,* exh. cat., Museum of Cultural History, 15–27. Los Angeles: University of California, 1985 (Monograph Series 26).

Cole 1985b
Cole, Herbert M. *The Mother and Child in African Sculpture,* exh. cat. Los Angeles: Museum Associates, Los Angeles County Museum of Art, 1985 (Ethnic Arts Series 4).

Cole 1989
Cole, Herbert M. *Icons: Ideals and Power in the Art of Africa,* exh. cat., National Museum of African Art. Washington/London: Smithsonian Institution Press, 1989.

Cole and Ross 1977
Cole, Herbert M., and Doran H. Ross. *The Arts of Ghana,* exh. cat., Museum of Cultural History. Los Angeles: University of California, 1977.

Colleyn 2001
Colleyn, Jean-Paul. "Ntomo and Korè." In Jean-Paul Colleyn, ed. *Bamana: The Art of Existence in Mali,* exh. cat., 95–99. New York/Zurich: Museum for African Art/Museum Rietberg; Ghent: Snoeck-Ducaju & Zoon, 2001.

Connell 1998
Connell, Timothy C. *World Art Transparencies.* Cincinnati: West Educational Publishing, 1998.

Coote and Mack 1996
Coote, Jeremy, and John Mack. "East Africa." In Turner 1996, 1: 406–13.

Cornet 1982
Cornet, Joseph-Aurélien. *Art royal Kuba.* Milan: Grafica Sipiel, 1982.

Cornet 1989
Cornet, Joseph-Aurélien. *Zaïre: peuples / art / culture.* Antwerp: Fonds Mercator, 1989.

Cornet 1993
Cornet, Joseph-Aurélien. "Masks Among the Kuba Peoples." In Frank Herreman and Constantine Petridis, eds. *Face of the Spirits: Masks from the Zaire Basin,* exh. cat., 129–42. Antwerp: Ethnographic Museum; Ghent: Snoeck-Ducaju & Zoon, 1993.

Curtis 2000
Curtis, Marie-Yvonne. "Sculpture Nalu." In Kerchache 2000, 68–70.

Damase 1960
Damase, Jacques. *Sculpture of the Tellem and the Dogon,* exh. cat. New York: Pierre Matisse Gallery, 1960.

Damme 1987
Damme, Wilfried van. *A Comparative Analysis Concerning Beauty and Ugliness in Sub-Saharan Africa.* Ghent: Rijksuniversiteit Gent, 1987 (Africana Gandensia 4).

Damme 1990
Damme, Wilfried van. "African Art from an African Perspective." In Toos van Kooten and Gerard van den Heuvel, eds. *Sculpture from Africa and Oceania,* exh. cat., 23–32. Otterlo: Rijksmuseum Kröller-Müller, 1990.

Damme 1996
Damme, Wilfried van. *Beauty in Context: Towards an Anthropological Approach to Aesthetics.* Leiden/New York/Cologne: E. J. Brill, 1996 (Philosophy of History and Culture 7).

Dark 1982
Dark, Philip J. C. *An Illustrated Catalogue of Benin Art.* Boston: G. K. Hall & Co, 1982.

Davidson 1963
Davidson, Ruth. 1963. "Paintings and Antiques: The New York Apartment of Edward A. Bragaline." *Antiques* 84, no. 5 (1963): 556–61.

d'Azevedo 1973
d'Azevedo, Warren L., ed. *The Traditional Artist in African Societies.* Bloomington/London: Indiana University Press, 1973.

Dieterlen 1989
Dieterlen, Germaine. "Masks and Mythology among the Dogon." *African Arts* 22, no. 3 (1989): 34–43, 87–88.

Drewal 1988
Drewal, Henry John. "Object and Intellect: Interpretations of Meaning in African Art." *Art Journal* 47, no. 2 (1988): 71–74.

Drewal 1989
Drewal, Henry John. *African Art: A Brief Guide to the Collection.* Cleveland: Cleveland Museum of Art, 1989.

Drewal 1990
Drewal, Henry John. "African Art Studies Today." In Abiodun 1990, 29–62.

Drewal and Mason 1998
Drewal, Henry John, and John Mason. *Beads, Body, and Soul: Art and Light in the Yorùbá Universe,* exh. cat., Fowler Museum of Cultural History. Los Angeles: University of California, 1998.

Duchâteau 1990
Duchâteau, Armand. *Benin: Hofkunst uit Afrika,* exh. cat., Galerij van het Gemeentekrediet. Brussels: Gemeentekrediet, 1990.

Duchâteau 1994
Duchâteau, Armand. *Benin: Royal Art of Africa from the Museum für Völkerkunde, Vienna,* exh. cat. Houston/Vienna: Museum of Fine Arts/Museum für Völkerkunde; Munich: Prestel Verlag, 1994.

Duponcheel 1980
Duponcheel, Christian. *Masterpieces of the People's Republic of the Congo,* exh. cat. New York: Africa-American Institute, 1980.

Eisenhofer 2000
Eisenhofer, Stefan. "Le royaume de Bénin et ses arts de cour." In Falgayrettes-Leveau 2000, 27–45, 324.

Eyo 1981
Eyo, Ekpo. "Headdresses." In Vogel 1981, 167, 173.

Eyo 1989
Eyo, Ekpo. "Dance Headdress." In Schmalenbach 1989, 159.

Eyo 2000
Eyo, Ekpo. "Sculpture Nok." In Kerchache 2000, 114–18.

Ezra 1988
Ezra, Kate. *Art of the Dogon: Selections from the Lester Wunderman Collection,* exh. cat. New York: Metropolitan Museum of Art, 1988.

Ezra 1996
Ezra, Kate. "Dogon." In Turner 1996, 9: 64–70.

Fagaly 1989
Fagaly, William A. *Shapes of Power, Belief and Celebration: African Art from New Orleans Collections,* exh. cat. New Orleans: New Orleans Museum of Art, 1989.

Fagg 1965
Fagg, William. *Tribes and Forms in African Art.* Paris/New York: Fernand Hazan/Tudor Publishing Co., 1965

Fagg 1968
Fagg, William. *African Tribal Images: The Katherine White Reswick Collection,* exh. cat. Cleveland: Cleveland Museum of Art, 1968.

Falgayrettes-Leveau 2000
Falgayrettes-Leveau, Christiane, ed. *Arts d'Afrique,* exh. cat. Paris: Éditions Gallimard/Musée Dapper, 2000.

Felix 1995
Felix, Marc Leo. "Sundi de l'Ouest." In Marc Leo Felix, Charles Meur, and Niangi Batulukisi. *Art et Kongos: les peuples kongophones et leur sculpture,* 111–18. Brussels: Zaïre Basin Art History Research Center, 1995.

Fischer 1978
Fischer, Eberhard. "Dan Forest Spirits: Masks in Dan Villages." *African Arts* 11, no. 2 (1978): 16–23, 94.

Fischer and Homberger 1985
Fischer, Eberhard, and Lorenz Homberger. *Die Kunst der Guro, Elfenbeinküste,* exh. cat. Zurich: Museum Rietberg, 1985.

Fliegel 2000
Fliegel, Stephen N. "St. Luke in Ethiopia." *Members Magazine of the Cleveland Museum of Art* 40, no. 4 (2000): 4–5.

Foote 1938
Foote, Helen S. "Two Bronzes from Benin." *Bulletin of The Cleveland Museum of Art* 25, no. 3 (1938): 48–50.

Förster 1988
Förster, Till. *Die Kunst der Senufo: Aus Schweizer Sammlungen,* exh. cat. Zurich: Museum Rietberg, 1988.

Förster 1996
Förster, Till. "Senufo." In Turner 1996, 28: 418–23.

Fricke 1975
Fricke, Berthold, ed. *The Cleveland Museum of Art.* Ahrbeck/Hannover: Knorr & Hirth Verlag GmbH, 1975.

Garrard 1989a
Garrard, Timothy F. *Gold of Africa: Jewellery and Ornaments from Ghana, Côte d'Ivoire, Mali, and Senegal in the Collection of the Barbier-Mueller Museum,* exh. cat., National Museum of African Art, Smithsonian Institution, Washington. Munich: Prestel Verlag, 1989.

Garrard 1989b
Garrard, Timothy F. "Royal Memorial Head" and "Female Figure." In Schmalenbach 1989, 134, 136.

Garrard 1995
Garrard, Timothy F. "Female Figure with Anklets." In Phillips 1995, 448.

Geary and Nicolls 1992
Geary, Christraud, and Andrea Nicolls. *Elmina: Art and Trade on the West African Coast,* exh. cat. Washington: National Museum of African Art, Smithsonian Institution, 1992.

Glaze 1975
Glaze, Anita J. "Woman Power and Art in a Senufo Village." *African Arts* 8, no. 3 (1975): 25–29, 64–68, 90–91.

Glaze 1981
Glaze, Anita J. *Art and Death in a Senufo Village.* Bloomington: Indiana University Press, 1981 (Traditional Arts of Africa).

Glaze 1983
Glaze, Anita J. " 'The Children of Poro': A Re-examination of the Rhythm-Pounder in Senufo Art, Its Form and Meaning." *Connaissance des Arts Tribaux* 20 (1983) (unpaginated).

Glaze 1986
Glaze, Anita J. "Dialectics of Gender in Senufo Masquerades." *African Arts* 19, no. 3 (1986): 30–39, 82.

Glaze 1993
Glaze, Anita J. "Cap with Female Figure," "Healer's Society Cap Mask, noo," and "Ceremonial Headdress, kworo." In Barbier 1993, 2: 16–18.

Goldwater 1960
Goldwater, Robert. *Bambara Sculpture from the Western Sudan,* exh. cat. New York: Museum of Primitive Art, 1960.

Griaule 1983
Griaule, Marcel. *Masques Dogons.* 3rd ed. Paris: Institut d'Ethnologie, 1983 (Travaux et Mémoires 33).

Grierson 1993
Grierson, Roderick, ed. *African Zion: The Sacred Art of Ethiopia,* exh. cat., Walters Art Gallery, Baltimore. New Haven/London: Yale University Press, 1993.

Grunne 1988
Grunne, Bernard de. "Ancient Sculpture of the Inland Niger Delta and Its Influence on Dogon Art." *African Arts* 21, no. 4 (1988): 50–55, 92.

Grunne 1995
Grunne, Bernard de. "An Art Historical Approach to the Terracotta Figures of the Inland Niger Delta." *African Arts* 23, no. 4 (1995): 70–79, 112.

Grunne 2001
Grunne, Bernard de, ed. *Mains de maîtres: à la découverte des sculpteurs d'Afrique,* exh. cat., Espace Culturel BBL. Brussels: BBL, 2001.

Guillaume and Munro 1926
Guillaume, Paul, and Thomas Munro. *Primitive Negro Sculpture.* New York: Harcourt, Brace & Company, 1926.

Gustafson 1999
Gustafson, Eleanor H. "Museum Accessions." *Magazine Antiques* 156, no. 6 (1999): 778.

Harley 1970
Harley, George W. *Native African Medicine: With Special Reference to Its Practice in the Mano Tribe of Liberia.* Cambridge, Mass.: Harvard University Press, 1941. Reprint, London: Frank Cass & Co., 1970.

Hart 1995
Hart, William. "Figure" and "Reclining Figure." In Phillips 1995, 468–69.

Harter 1990
Harter, Pierre. "Royal Commemorative Figures in the Cameroon Grasslands: Ateu Atsa, a Bangwa Artist." *African Arts* 23, no. 4 (1990): 70–77, 96.

Harter 1993
Harter, Pierre. "We Masks." In Barbier 1993, 1: 184–221, 414.

Himmelheber 1960
Himmelheber, Hans. *Negerkunst und Negerkünstler.* Brunswick: Klinkhardt & Biermann, 1960 (Bibliothek für Kunst- und Antiquitätenfreunde 50).

Himmelheber 1963
Himmelheber, Hans. "Die Masken der Guéré im Rahmen der Kunst des oberen Cavally-Gebietes." *Zeitschrift für Ethnologie* 88, no. 2 (1963): 216–33.

Himmelheber 1966
Himmelheber, Hans. "Masken der Guéré II." *Zeitschrift für Ethnologie* 91, no. 1 (1966): 100–108.

Holcombe 1982
Holcombe, Bryce, ed. *Yoruba: Sculpture of West Africa.* New York: Alfred A. Knopf, 1982.

Icon and Symbol 1975
Icon and Symbol: The Cult of the Ancestor in African Art. Bloomfield Hills, Mich.: Cranbrook Academy of Art/Museum, 1975.

Imperato 1970
Imperato, Pascal James. "The Dance of the Tyi Wara." *African Arts* 6, no. 1 (1970): 8–13, 71–80.

Jordán 2000
Jordán, Manuel. "Hair Matters in South Central Africa." In Roy Sieber and Frank Herreman, eds. *Hair in African Art and Culture,* exh. cat., 135–45. New York: Museum for African Art/Prestel Verlag, 2000.

Kan and Sieber 1995
Kan, Michael, and Roy Sieber. *African Masterworks in the Detroit Institute of Arts.* Washington/London: Smithsonian Institution Press, 1995.

Kasfir 1984
Kasfir, Sidney Littlefield. "One Tribe, One Style? Paradigms in the Historiography of African Art." *History in Africa* 11 (1984): 163–93.

Kasfir 1999
Kasfir, Sidney Littlefield. *Contemporary African Art.* London: Thames & Hudson Ltd., 1999.

Kathman 1981
Kathman, Barbara A. *A Cleveland Bestiary,* exh. cat. Cleveland: Cleveland Museum of Art, 1981.

Kerchache, Paudrat, and Stéphan 1988
Kerchache, Jacques, Jean-Louis Paudrat, and Lucien Stéphan. *L'Art africain.* Paris: Citadelles & Mazenod, 1988 (L'Art et les Grandes Civilisations).

Kerchache 2000
Kerchache, Jacques, ed. *Sculptures: Afrique, Asie, Océanie, Amériques,* exh. cat., Musée du Louvre. Paris: Réunion des Musées Nationaux, 2000.

Kjersmeier 1935–38
Kjersmeier, Carl. *Centres de style de la sculpture nègre africaine.* 4 vols. Paris: Éditions Albert Morancé, 1935–38.

Koloss 1999
Koloss, Hans-Joachim. "Traditionen afrikanischer Kunst: Wissenschaftliche Erfassung und ästhetische Bewertung." In Hans-Joachim Koloss, ed. *Afrika: Kunst und Kultur. Meisterwerke afrikanischer Kunst, Museum für Völkerkunde Berlin,* exh. cat., 8–31. Berlin: Museum für Völkerkunde-Staatliche Museen zu Berlin; Munich: Prestel Verlag, 1999.

Koloss 2000
Koloss, Hans-Joachim. *World-View and Society in Oku (Cameroon),* trans. Emily Schalk. Berlin: Staatliche Museen zu Berlin–Preussischer Kulturbesitz/Dietrich Reimer Verlag GmbH, 2000 (Baessler-Archiv 10).

LaGamma 1998–99
LaGamma, Alisa, ed. *Authorship in African Art.* Los Angeles: Regents of the University of California, 1998–99 (*African Arts* 31, no. 4 and 32, no. 1).

Lamp 1996a
Lamp, Frederick. *Art of the Baga: A Drama of Cultural Reinvention,* exh. cat. New York: Museum for African Art/Prestel Verlag, 1996.

Lamp 1996b
Lamp, Frederick. "Guinea Coast." In Turner 1996, 1: 386–93.

Lamp 2000
Lamp, Frederick. "Shrine Piece, Dance Mask or Headdress: Tönköngba." In Frank Herreman, ed. *In the Presence of Spirits: African Art from the National Museum of Ethnology, Lisbon,* exh. cat., 20–21. New York: Museum for African Art; Ghent: Snoeck, Ducaju & Zoon, 2000.

L'Art nègre 1951
L'Art nègre. Paris: Éditions du Seuil, 1951.

Lehuard 1977
Lehuard, Raoul. *Les Phemba du Mayombe: les figures sculptées dites 'phemba' du Mayombe.* Arnouville: Arts d'Afrique Noire, 1977.

Lintig 2001
Lintig, Bettina von. "Ateu Atsa, les sculpteurs, les prêtres-rois et la mémoire iconographique des Bangwa au Cameroun." In Grunne 2001, 95–110.

Luschan 1901
Luschan, Felix von. *Die Karl Knorrsche Sammlung von Benin-Altertümern im Museum für Länder- und Völkerkunde in Stuttgart.* Stuttgart: Württembergisches Vereins für Handelsgeographie, 1901 (*Jahresbericht 17/18*).

MacGaffey 1993
MacGaffey, Wyatt M. "The Eyes of Understanding: Kongo Minkisi." In Wyatt M. MacGaffey and Michael D. Harris. *Astonishment and Power,* exh. cat., 21–103, National Museum of African Art. Washington: Smithsonian Institution, 1993.

MacGaffey 1996
MacGaffey, Wyatt M. "Pfemba Maternity Statue." In Gustaaf Verswijver et al., eds. *The Tervuren Museum Masterpieces from Central Africa,* exh. cat., Canadian Museum of Civilization, Ottawa/Hull, 146–47. Tervuren: Royal Museum for Central Africa; Munich/New York: Prestel Verlag, 1996.

Magnin and Soulillou 1996
Magnin, André, and Jacques Soulillou, eds. *Contemporary Art of Africa.* New York: Harry N. Abrams, 1996.

Mark 1996
Mark, Peter. "Historical Contacts and Cultural Interaction: Sub-Saharan Africa, Northern Africa, the Muslim World, and Southern Europe, Tenth–Nineteenth Century A.D." In *Africa: The Art of a Continent* 1996, 15–21.

Masks 1959
Masks: The Many Faces of Man, exh. cat. Toronto: Royal Ontario Museum, 1959.

May 2001
May, Sally Ruth. *Knockouts: A Pocket Guide.* Cleveland: Cleveland Museum of Art, 2001.

McClusky 1984
McClusky, Pamela, et al. *Praise Poems: The Katherine White Collection,* exh. cat. Seattle: Seattle Art Museum, 1984.

McClusky 2002
McClusky, Pamela. *Art from Africa: Long Steps Never Broke a Back,* exh. cat. Seattle: Seattle Art Museum, 2002.

McNaughton 1995
McNaughton, Patrick R., ed. *Protecting Mali's Cultural Heritage.* Los Angeles: Regents of the University of California, 1995 (*African Arts* 28, no. 4).

McNaughton 1996
McNaughton, Patrick R. "Western Sudan." In Turner 1996, 1: 380–86.

Milliken 1937
Milliken, William M. "Treasure of Ivories and Bronzes from the Ancient Kingdom of Benin." *Bulletin of The Cleveland Museum of Art* 24, no. 3 (1937): 35–36.

Mitchell and Sica 1973
Mitchell, Evely, and Emelia Sica. *An Introduction to the Arts of Africa and Oceania.* Cleveland: Cleveland Museum of Art, 1973.

Munro 1970
Munro, Thomas. *Form and Style in the Arts: An Introduction to Aesthetic Morphology.* Cleveland: Press of Case Western Reserve University, 1970.

Ndiaye 2001
Ndiaye, Francine, ed. *Masques du pays Dogon.* Paris: Société Nouvelle Adam Biro, 2001.

Nettleton 1996
Nettleton, Anitra. "Southern Africa." In Turner 1996, 1: 413–20.

Neyt 1993
Neyt, François. *Luba: aux sources du Zaïre,* exh. cat., Musée Dapper. Paris: Éditions Dapper, 1993.

Nicklin 1981
Nicklin, Keith. "Headdresses." In Vogel 1981, 167–68.

Nicklin 1996
Nicklin, Keith. "Ejagham." In Turner 1996, 10: 122–25.

Nooter 1992
Nooter, Mary H. "Fragments of Forsaken Glory: Luba Royal Culture Invented and Represented (1883-1992) (Zaire)." In Erna Beumers and Hans-Joachim Koloss, eds. *Kings of Africa: Art and Authority in Central Africa. Collection Museum für Völkerkunde Berlin,* exh. cat., MECC, 79–89. Maastricht: Foundation Kings of Africa, 1992.

Northern 1984
Northern, Tamara. *The Art of Cameroon,* exh. cat., National Museum of Natural History. Washington: Smithsonian Institution, 1984.

Notué 2000
Notué, Jean-Paul. "Sculpture Bangwa." In Kerchache 2000, 141–42.

Olbrechts 1943
Olbrechts, Frans M. "Contribution to the Study of the Chronology of African Plastic Art." *Africa* 14, no. 4 (1943): 183–93.

Paudrat 2000
Paudrat, Jean-Louis. "Les classiques de la sculpture africaine au palais du Louvre." In Kerchache 2000, 44–57.

Paulme 1981
Paulme, Denise. "Figure (Pomdo)." In Vogel 1981, 61–62.

Pemberton 1989
Pemberton, John, III. "Agere Ifa, Southern Ekiti Area, 19th century." In Wardwell 1989, 196.

Perani and Smith 1998
Perani, Judith, and Fred T. Smith. *The Visual Arts of Africa: Gender, Power, and Life Cycle Rituals.* Upper Saddle River, N. J.: Prentice Hall, 1998.

Perrois 1989
Perrois, Louis. "Toward an Anthropology of Black African Art." In Schmalenbach 1989, 27–43.

Petit 1996
Petit, Pierre. "Hunters, Mediums, and Chiefs: Variations on the Theme of the Luba Ritual Object." In Mireille Holsbeke, ed. *The Object as Mediator: On the Transcendental Meaning of Art in Traditional Cultures,* exh. cat., 117–28. Antwerp: Etnografisch Museum, 1996.

Petridis 1999
Petridis, Constantine. "Tree Altars, Spirit-Trees, and 'Ghost-Posts' among the Luluwa and Neighboring Peoples." *Baessler-Archiv* 57, no. 1 (1999): 115–50.

Petridis 2000
Petridis, Constantine. "Les arts du bassin du Congo." In *Arts d'Afrique* 2000, 285–316, 331–33.

Petridis 2001
Petridis, Constantine. "Olbrechts and the Morphological Approach to African Sculptural Art." In Constantine Petridis, ed. *Frans M. Olbrechts (1899–1958): In Search of Art in Africa,* exh. cat., 118–40. Antwerp: Ethnographic Museum, 2001.

Petridis 2002
Petridis, Constantine. "Mbala, Tsaam, or Kwilu Pende? A Mother-and-Child Figure from the Kwango-Kwilu Region of the Democratic Republic of the Congo." *Cleveland Studies in the History of Art* 7 (2002): 127–41.

Phillips 1995
Phillips, Tom, ed. *Africa: The Art of a Continent,* exh. cat. London: Royal Academy of Arts; Munich: Prestel Verlag, 1995.

Plass 1959a
Plass, Margaret. *The African Image: A New Selection of Tribal Art,* exh. cat. Toledo: Toledo Museum of Art, 1959.

Plass 1959b
Plass, Margaret, et al. *Seven Metals of Africa,* exh. cat. Philadelphia: University Museum, 1959.

Preston 1981
Preston, George Nelson. "Head." In Vogel 1981, 81.

Preston 1985
Preston, George Nelson, et al. *Sets, Series, and Ensembles in African Art,* exh. cat. New York: Center for African Art, 1985.

Radin and Sweeney 1952
Radin, Paul, and James Johnson Sweeney. *African Folktales and Sculpture.* New York: Pantheon Books, 1952 (Bollingen Series 32).

Ravenhill 1988
Ravenhill, Philip L. "An African Triptych: On the Interpretation of Three Parts and the Whole." *Art Journal* 47, no. 2: 88–94.

Ravenhill 1992
Ravenhill, Philip L. "Of Pachyderms and Power: Ivory and the Elephant in the Art of Central Côte d'Ivoire." In Doran H. Ross, ed. *Elephant: The Animal and Its Ivory in African Culture,* exh. cat., Fowler Museum of Cultural History, 115–33. Los Angeles: University of California, 1992.

Ravenhill 1994
Ravenhill, Philip L. "Bush Spirit Figures, Baule, Côte d'Ivoire" and "Mask, Baule; Côte d'Ivoire." In Doran H. Ross, ed. *Visions of Africa: The Jerome L. Joss Collection of African Art at UCLA,* exh. cat., Fowler Museum of Cultural History, 54–57. Los Angeles: University of California, 1994.

Ravenhill 1996
Ravenhill, Philip L. "Baule." In Turner 1996, 5: 404–9.

Ravenhill 1999
Ravenhill, Philip L. "Helmet." In *Selected Works 1999,* 48.

Roberts and Roberts 1996
Roberts, Mary Nooter, and Allen F. Roberts, eds. *Memory: Luba Art and the Making of History,* exh. cat. New York: Museum for African Art, 1996.

Robbins 1966
Robbins, Warren M. *African Art in American Collections.* New York/London: Frederick A. Praeger, Inc., 1966.

Robbins and Nooter 1989
Robbins, Warren M., and Nancy Ingram Nooter. *African Art in American Collections: Survey 1989.* Washington/London: Smithsonian Institution Press, 1989.

Röschenthaler 1998
Röschenthaler, Ute M. "Honoring Ejagham Women." *African Arts* 31, no. 2 (1998): 38–49, 92–93.

Ross 1995
Ross, Doran H. "Memorial Head." In Phillips 1995, 438–39.

Ross 1996
Ross, Doran H. "Akua's Child and Other Relatives: New Mythologies for Old Dolls." In Elisabeth L. Cameron. *Isn't S/He a Doll? Play and Ritual in African Sculpture,* exh. cat., Fowler Museum of Cultural History, 43–57. Los Angeles: Regents of the University of California, 1996.

Ross 2002
Ross, Doran H. "Misplaced Souls: Reflections on Gold, Chiefs, Slaves, and Death Among the Akan of Ghana." *Bulletin of the Detroit Institute of Arts* 76, nos. 1/2 (2002): 21–37.

Roy 1985
Roy, Christopher D. *Art and Life in Africa: Selections from the Stanley Collection,* exh. cat. Iowa City: University of Iowa Museum of Art, 1985.

Roy 1987
Roy, Christopher D. *Art of the Upper Volta Rivers.* Meudon: Alain et Françoise Chaffin, 1987.

Roy 1996
Roy, Christopher D. "Bwa and Gurunsi." In Turner 1996, 5: 328–31.

Rubin 1974
Rubin, Arnold. *African Accumulative Sculpture: Power and Display,* exh. cat. New York: Pace Gallery, 1974.

Schmalenbach 1989
Schmalenbach, Werner, ed. *African Art from the Barbier-Mueller Collection, Geneva,* exh. cat., Kunstsammlung Nordrhein-Westfalen, Düsseldorf. Munich: Prestel Verlag, 1989.

***Selected Works* 1999**
Selected Works from the Collection of the National Museum of African Art. Washington: National Museum of African Art, Smithsonian Institution, 1999.

Sieber 1968
Sieber, Roy. "Introduction." In Roy Sieber and Arnold Rubin. *Sculpture of Black Africa: The Paul Tishman Collection,* exh. cat., 10–16. Los Angeles: Los Angeles County Museum of Art, 1968.

Sieber 1972
Sieber, Roy. *African Textiles and Decorative Arts,* exh. cat. New York: Museum of Modern Art, 1972.

Sieber 1987
Sieber, Roy. "Introduction." In Roy Sieber and Roslyn Adele Walker. *African Art in the Cycle of Life,* exh. cat., 11–27. Washington/London: Smithsonian Institution Press, 1987.

Sieber 1995
Sieber, Roy. "An Introduction to African Art." In Kan and Sieber 1995, 1–15.

Sieber 1999
Sieber, Roy. "Introduction to the Collection." In *Selected Works 1999,* 11–12.

Siegmann 1989
Siegmann, William. "Figures" and "Head." In Schmalenbach 1989, 104–5.

Siroto 1995
Siroto, Leon. "Reflections on the Sculpture of a Region: The Dwight and Blossom Strong Collection." In Leon Siroto and Alisa LaGamma. *East of the Atlantic, West of the Congo: Art from Equatorial Africa,* exh. cat., 6–23. San Francisco: Fine Arts Museums of San Francisco, 1995.

Siroto 1996
Siroto, Leon. "Western Equatoria." In Turner 1996, 1: 393–400.

Soppelsa 1988
Soppelsa, Robert T. "Western Art-Historical Methodology and African Art: Panofsky's Paradigm and Ivoirian Mma." *Art Journal* 47, no. 2 (1988): 147–53.

Sousberghe 1959
Sousberghe, Léon de. *L'Art Pende.* Brussels: Académie Royale de Belgique, 1959 (Mémoires de la Classe des Beaux-Arts 9, fasc. 2).

Strother 1998
Strother, Z. S. *Inventing Masks: Agency and History in the Art of the Central Pende.* Chicago: University of Chicago Press, 1998.

Sweeney 1935
Sweeney, James Johnson. *African Negro Art,* exh. cat. New York: Museum of Modern Art, 1935.

Thompson 1968
Thompson, Robert Farris. "Esthetics in Traditional Africa." *Artnews* 66, no. 9 (1968): 44–45, 63–66.

Thompson 1970
Thompson, Robert Farris. "The Sign of the Divine King: An Essay on Yoruba Bead-Embroidered Crowns with Veil and Bird Decorations." *African Arts* 3, no. 3 (1970): 8–17, 74–80.

Thompson 1973
Thompson, Robert Farris. "Yoruba Artistic Criticism." In d'Azevedo 1973, 18–61.

Thompson 1974
Thompson, Robert Farris. *African Art in Motion: Icon and Act in the Collection of Katherine Coryton White,* exh. cat., Frederick S. Wight Art Gallery. Los Angeles: University of California Press, 1974.

Thompson 1981
Thompson, Robert Farris. "Headdress." In Vogel 1981, 175–76.

Turner 1996
Turner, Jane, ed. *The Dictionary of Art.* 34 vols. London: Macmillan, 1996.

Twentieth Century Masters 1963
Twentieth Century Masters from the Bragaline Collection, exh. cat. New York: M. Knoedler & Co., 1963.

Utotombo 1988
Utotombo: l'art d'Afrique noire dans les collections privées belges, exh. cat., Palais des Beaux-Arts. Brussels: Société des Expositions, 1988.

Vandenhoute 1948
Vandenhoute, Pieter Jan Leo. *Classification stylistique du masque Dan et Guéré de la Côte d'Ivoire occidentale (A.O.F.).* Leiden: E. J. Brill, 1948 (Mededelingen van het Rijksmuseum voor Volkenkunde 4).

Vandenhoute 1989
Vandenhoute, Pieter Jan. *Poro and Mask: A Few Comments on Masks as Agents of Social Control in Northeast Liberia by Dr. G. W. Harley,* trans. Peter Noteboom. Ghent: State University of Ghent (now Ghent University), 1989 (Working Papers in Ethnic Art 4).

Vangheluwe 2001
Vangheluwe, Sam. *The Artist Himself in African Art Studies: Jan Vandenhoute's Investigation of the Dan Sculptor in Côte d'Ivoire.* Ghent: Ghent University, Research Unit of Ethnic Art, 2001 (Working Papers in Ethnic Art 9).

Van Noten 1972
Van Noten, Francis. "La plus ancienne sculpture sur bois de l'Afrique centrale?" *Africa-Tervuren* 8, no. 3/4 (1972): 133–36.

Vansina 1984
Vansina, Jan. *Art History in Africa: An Introduction to Method.* New York/London: Longman, 1984.

Vansina 1989
Vansina, Jan. "Bwoom Mask." In Schmalenbach 1989, 255.

Veirman 2002
Veirman, Anja. "The Art of Living: Some Aspects of the Art and Culture of the Senufo." In Jan-Lodewijk Grootaers and Ineke Eisenburger, eds. *Forms of Wonderment: The History and Collections of the Afrika Museum, Berg en Dal,* 1: 109–30. Berg en Dal: Afrika Museum, 2002.

Visonà 1993
Visonà, Monica Blackmun. "The Lagoons Peoples." In Barbier 1993, 1: 368–83.

Visonà 2001
Visonà, Monica Blackmun, et al. *A History of Art in Africa.* New York: Harry N. Abrams, 2001.

Vogel 1979
Vogel, Susan Mullin. "Baule and Yoruba Art Criticism: A Comparison." In Justine M. Cordwell, ed., *The Visual Arts: Plastic and Graphic,* 309–25. The Hague: Mouton, 1979 (World Anthropology).

Vogel 1980
Vogel, Susan Mullin. *Beauty in the Eyes of the Baule: Aesthetics and Cultural Values.* Philadelphia: Institute for the Study of Human Issues, 1980 (Working Papers in the Traditional Arts 6).

Vogel 1981
Vogel, Susan Mullin, ed. *For Spirits and Kings: African Art from the Paul and Ruth Tishman Collection,* exh. cat. New York: Metropolitan Museum of Art, 1981.

Vogel 1986
Vogel, Susan Mullin. *African Aesthetics: The Carlo Monzino Collection,* exh. cat. New York: Center for African Art, 1986.

Vogel 1988
Vogel, Susan Mullin. "Introduction." In Arthur Danto et al., *Art/Artifact: African Art in Anthropology Collections,* exh. cat., 11–17. New York: Center for African Art, 1988.

Vogel 1991
Vogel, Susan Mullin. *Africa Explores: Twentieth Century African Art,* exh. cat. New York/Munich: Center for African Art/Prestel Verlag, 1991.

Vogel 1997
Vogel, Susan Mullin. *Baule: African Art, Western Eyes,* exh. cat., Yale University Art Gallery. New Haven/London: Yale University Press, 1997.

Vogel 1999
Vogel, Susan Mullin. "Known Artists but Anonymous Works: Fieldwork and Art History." *African Arts* 32, no. 1 (1999): 40–55, 93–94.

Walker 1987
Walker, Roslyn Adele. "Soul-Washer's Disk (Akrafokonmu)." In Roy Sieber and Roslyn Adele Walker. *African Art in the Cycle of Life,* exh. cat., National Museum of African Art, 102. Washington/London: Smithsonian Institution Press, 1987.

Walker 1999
Walker, Roslyn Adele. "Divination Cup (agere ifa)." In *Selected Works* 1999, 71.

Wardwell 1986
Wardwell, Allen, ed. *African Sculpture from the University Museum, University of Pennsylvania,* exh. cat. for *Noble Ancestors: Images from Africa.* Philadelphia: Philadelphia Museum of Art, 1986.

Wardwell 1989
Wardwell, Allen, ed. *Yoruba: Nine Centuries of African Art and Thought,* exh. cat. New York: Center for African Art, 1989.

Webb 2000
Webb, Virginia-Lee. *Perfect Documents: Walker Evans and African Art, 1935,* exh. cat. New York: Metropolitan Museum of Art, 2000.

Weisberg 1975
Weisberg, Gabriel P. *Traditions and Revisions: Themes from the History of Sculpture.* Cleveland: Cleveland Museum of Art, 1975.

Wells 1977
Wells, Louis T., Jr. "The Harley Masks of Northeast Liberia." *African Arts* 10, no. 2 (1977): 22–27, 91–92.

Wilkins, Schultz, and Linduff 2001
Wilkins, David G., Bernard Schultz, and Katheryn M. Linduff. *Art Past, Art Present.* 4th ed. Upper Saddle River, N. J.: Prentice-Hall, Inc., 2001.

Willett 1997
Willett, Frank. "Nok" and "L'Archéologie de l'art nigérian." In Frank Willett and Ekpo Eyo, eds. *Arts du Nigéria,* exh. cat., Musée des Arts d'Afrique et d'Oceanie, 22, 23–43. Paris: Réunion des Musées Nationaux, 1997.

Willett 1999
Willett, Frank. "Benin." In Hans-Joachim Koloss, ed. *Afrika: Kunst und Kultur. Meisterwerke afrikanischer Kunst, Museum für Völkerkunde Berlin,* exh. cat., 41–46. Munich/London/New York: Prestel Verlag; Berlin: Museum für Völkerkunde–Staatliche Museen zu Berlin, 1999.

Wixom 1961
Wixom, William D. "Two African Tribal Sculptures." *Bulletin of The Cleveland Museum of Art* 48, no. 3 (1961): 38–45.

Wixom 1977
Wixom, William D. "African Art in the Cleveland Museum of Art." *African Arts* 10, no. 3 (1977): 16–25, 88.

Wooten 2000
Wooten, Stephen R. "Antelope Headdresses and Champion Farmers: Negotiating Meaning and Identity through the Bamana Ciwara Complex." *African Arts* 33, no. 2 (2000): 19–33, 89–90.

Young-Sánchez 1997
Young-Sánchez, Margaret. "The Cleveland Museum of Art." *African Arts* 30, no. 1 (1997): 66–71.

Zahan 1980
Zahan, Dominique. *Antilopes du soleil: arts et rites agraires d'Afrique noire.* Vienna: Édition A. Schendl, 1980.

Zahan 2000
Zahan, Dominique. "The Two Worlds of Ciwara." *African Arts* 33, no. 2 (2000): 35–45, 90–91.

Zangrie 1947–50
Zangrie, Luc [Luc de Heusch]. "Les institutions, la religion et l'art des Ba Buye: groupes Ba Sumba, du Ma Nyéma (Congo belge)." *L'Ethnographie* 45, no. 50 (1947–50): 54–80.

THE CLEVELAND MUSEUM OF ART

PUBLICATIONS

CMA 1958
Handbook of The Cleveland Museum of Art.

CMA 1960
"Year in Review." *Bulletin of The Cleveland Museum of Art* 47, no. 10.

CMA 1961
"Year in Review 1961." *Bulletin of The Cleveland Museum of Art* 48, no. 9.

CMA 1966/1969
Handbook of The Cleveland Museum of Art.

CMA 1966a
Selected Works: The Cleveland Museum of Art.

CMA 1970
"1969 Year in Review." *Bulletin of The Cleveland Museum of Art* 57, no. 1.

CMA 1972
"1971 Year in Review." *Bulletin of The Cleveland Museum of Art* 59, no. 1.

CMA 1973
"1972 Year in Review." *Bulletin of The Cleveland Museum of Art* 60, no. 3.

CMA 1975
"1974 Year in Review." *Bulletin of The Cleveland Museum of Art* 62, no. 3.

CMA 1976
"1975 Year in Review." *Bulletin of The Cleveland Museum of Art* 63, no. 3.

CMA 1977
"1976 Year in Review." *Bulletin of The Cleveland Museum of Art* 64, no. 2.

CMA 1978
Handbook of The Cleveland Museum of Art.

CMA 1986
"The Year in Review for 1985." *Bulletin of The Cleveland Museum of Art* 73, no. 2.

CMA 1987
Images of the Mind, exh. cat.

CMA 1988
"1987 Year in Review." *Bulletin of The Cleveland Museum of Art* 75, no. 2.

CMA 1991a
"Notable Acquisitions." *Bulletin of The Cleveland Museum of Art* 78, no. 3.

CMA 1991b
Handbook of The Cleveland Museum of Art.

CMA 1991c
Interpretations.

Photography Credits

Fig. 1: courtesy Museum of Modern Art, New York; fig. 8: courtesy Fonds P. J. Vandenhoute, Ghent; fig. 9: Pascal James Imperato, Brooklyn, N.Y.; fig. 10: from Dominique Zahan, *The Bambara* (Leiden: E. J. Brill, 1974); fig. 11: Christopher D. Roy, Iowa City; figs. 12, 14: Anita J. Glaze, Champaign, Ill.; fig. 13: National Museum of African Art, Smithsonian Institution, Washington; fig. 15: from Susan Mullin Vogel, ed., *For Spirits and Kings: African Art from the Tishman Collection* (New York: Metropolitan Museum of Art, 1981), fig. 14; fig. 16: Frederick Lamp, Baltimore; fig. 17: Musée de l'Homme, Paris; fig. 18: from Lorenz Homberger, ed., *Masken der Wè und Dan, Elfenbeinküste* (Zurich: Museum Rietberg, 1997), courtesy Museum Rietberg and Hans Himmelheber; fig. 19: Eberhard Fischer, Zurich; figs. 20, 21: Susan Mullin Vogel, New York; figs. 22, 29, 36: courtesy Eliot Elisofon Photographic Archives, National Museum of African Art, Smithsonian Institution, Washington; fig. 23: Doran H. Ross, Los Angeles; fig. 24: courtesy Basler Missions-Archiv, Basel; figs. 25, 26: Herbert M. Cole, Santa Barbara, Calif.; figs. 27, 28: John Pemberton III, Amherst, Mass.; fig. 30: from P. Amaury Talbot, *In The Shadow of the Bush* (London: William Heinemann, 1912), facing page 38; fig. 31: Hans-Joachim Koloss, Berlin; fig. 32: Luc de Heusch, Brussels; figs. 33, 34: Angelo Turconi, Milan; fig. 35: from Louis Wilmet, *Un broussard héroïque: Le R. P. Ivan de Pierpont, s.j., 1879–1937* (Charleroi/Paris: Edition J. Dupuis, Fils & Cie, 1939), between pp. 208 and 209; fig. 37: Arthur P. Bourgeois, University Park, Ill.